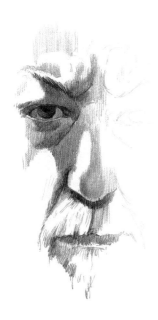

PORTRAIT
DRAWING

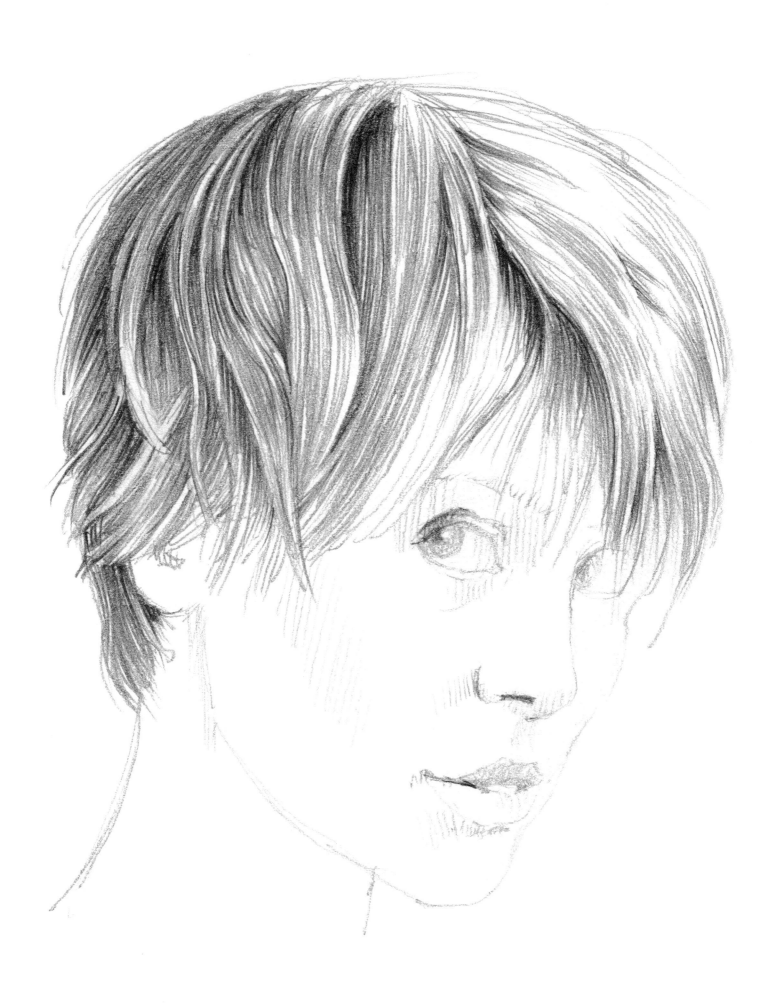

PORTRAIT
DRAWING

ANDRÁS SZUNYOGHY

h.f.ullmann

© h.f.ullmann publishing GmbH
Original title: *Porträtzeichnen*
ISBN 978-3-8480-0279-5

Art director: Jolanta Szuba
Editor: Nikolett Hollósi
Layout, typography, reproduction: György Filakowszky
Project coordination for h.f.ullmann: Lars Pietzschmann

© András Szunyoghy
© Kossuth Publishing

© for the English edition: h.f.ullmann publishing GmbH

Translation from German by Rae Walter in association with
First Edition Translations Ltd, Cambridge
Edited by Robert Anderson in association with
First Edition Translations Ltd, Cambridge
Typeset by The Write Idea in association with
First Edition Translations Ltd, Cambridge

Overall responsibility for production: h.f.ullmann publishing GmbH,
Potsdam, Germany

Printed in Hungary, 2015

ISBN 978-3-8480-0280-1

10 9 8 7 6 5 4 3 2
X IX VIII VII VI V IV III II I

www.ullmann-publishing.com
newsletter@ullmann-publishing.com
facebook.com/ullmann.social

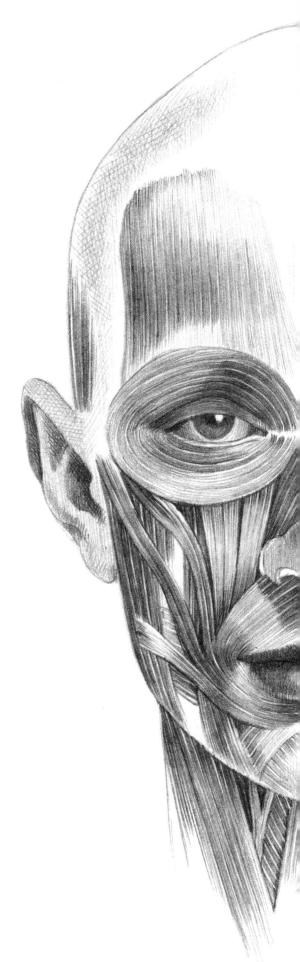

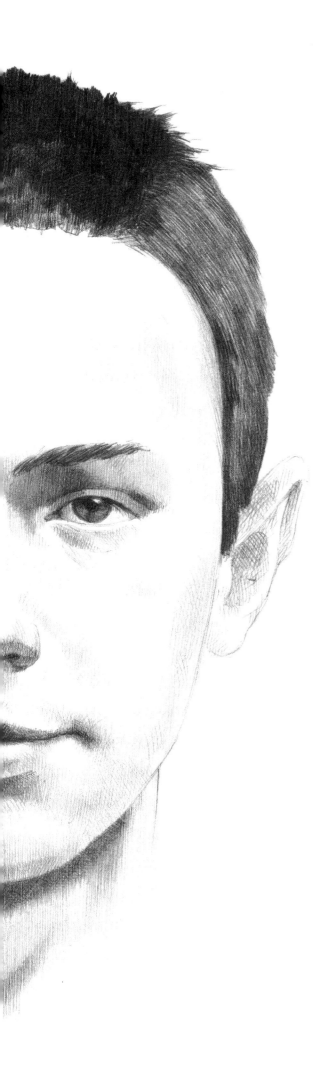

Contents

Foreword
_____ 7

General Basics
_____ 9
Chapter 1

Tricks of Drawing
_____ 59
Chapter 2

Gallery
_____ 191
Chapter 3

Foreword

Drawing gives great pleasure. You can become so engrossed in your work that you forget everything around you. Whether the model is a cabbage or a beautifully formed human body, the joy of creation is the most wonderful of all feelings. This book is about drawing the human head and the face, which is very expressive and therefore represents a particularly important part of any composition containing human figures.

Drawing the head requires thorough preparatory studies, so you will use everything that you might have previously learned about drawing—ways of measuring, the rules of perspective, and all the tricks for depicting simple forms and objects and drawing draperies. In order to complete all the study drawings, you must know all the rules, both old and new!

What do you need in order to draw heads and hands?

The answer varies according to age. For a small child a sheet of paper is enough—or even a wall or the smooth surface of a piece of furniture!—and an instrument that leaves traces. Later, as a more critical teenager you realize that drawing a head requires detailed preliminary studies. As well as knowing and using the rules, capturing and reproducing traits of character can be a real challenge. You have to remember everything you have learned about perspective and drawing draperies and apply it in the right way, and applying the rules is not that simple! You throw yourself into your work, but when you concentrate on just one detail, the nose for instance, you often come to realize that the proportions of that beautiful detail, in this case the nose, do not match those of the rest of the face. This happens to professionals as well as beginners. So the drawing has to be corrected, though resorting to an eraser is not always easy. It is often hard to decide what is better: to erase the nose or the rest of the face. Sometimes the nose stays put and the other parts of the head are discarded. By way of consolation, let me say that with time you will apply the rules automatically, almost without noticing. However, until you reach this level, you will need plenty of practice.

So what do you need in order to draw a head?

First of all, a model. It should be a head with character, a head that is good to draw. However strange it may sound, a face that is striking or old and wrinkled is easier to draw than a younger one that is softer and less striking. Of course, you can always be your own model—at least that way model and artist get tired at the same time.

Secondly, an artistic streak and talent. If you believe in yourself, you will also be able to get through less successful phases. Belief in their own talent gives artists strength and helps them to realize their ideas.

Thirdly, a fair amount of patience and tenacity—and, of course, good observational skills. The latter will get sharper with practice. For drawing, you also need to be able to distinguish tonal values, and this, too, will improve if you persist.

Fourthly, good tools. Drawing with good pens or pencils is quite different from working with bad ones. Your finished drawing will give you incomparable pleasure. You feel pride when looking at your work for a long time after, and of course it is always rewarding when other people praise it, too!

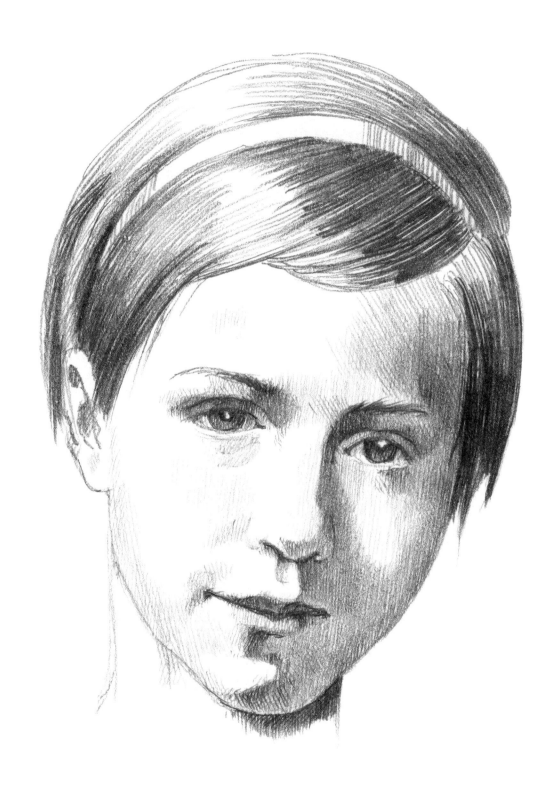

General basics

The head consists of the skull, which is composed of many bones and has muscles attached to it, with skin covering the layer of muscle. You do not need any great observational skill to realize that skulls alone can be of very different shapes. For instance, the skull shape of Europeans is clearly distinguishable from the skulls of Asians or Africans. Nevertheless, there are some very important common features. In the past, artists compared the shape of the human head to an egg and consequently characterized it as being oval. So it is reasonable for me to take an egg as my example, to illustrate part of what you need to know for drawing the head.

Use longitudinal and transverse axes to help you with this—the main axis, as well as the eyebrow, eye, nose, and mouth axes. When marking them in, bear in mind the symmetry of the human body as well as the perspective.

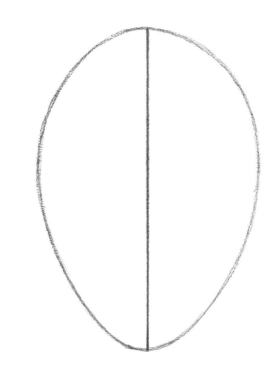

The rounder end of the egg corresponds to the upper, broader part of the head—the cranium—while the lower, more pointed part of the head with the chin can be compared with the more pointed end of the egg.

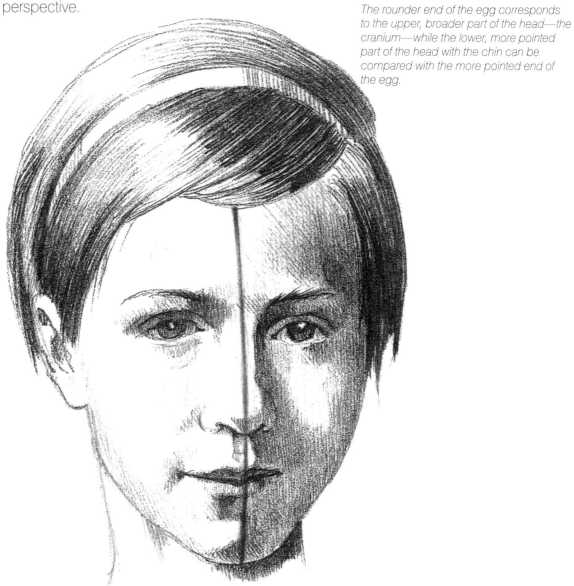

The **main axis** cuts the head in half lengthwise. It can also be described as the bisector or the line of symmetry. The latter description is particularly accurate, as the human body is symmetrical. Every part of the body on one side has a corresponding, laterally inverted part on the other side. Similarly, we have two of each organ, with the exception of those lying right in the middle on the bisector, such as the frontal bone, the nose, the occipital bone, and the breastbone.

In order to see for yourself why the main axis is important in drawing, mark it in on an egg. You will see that there is a particular position where the main axis is straight—that is, when you look at the face from directly in front. Incidentally, it still functions as a straight bisector even when the head is turned to the right or left or inclined forward or backward.

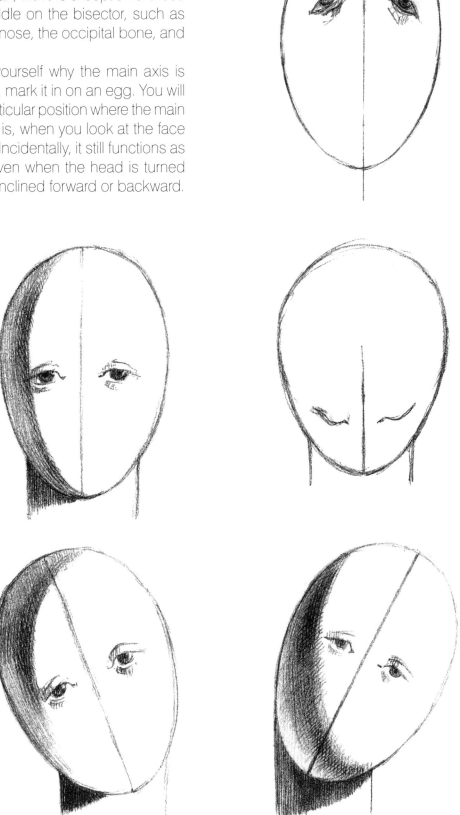

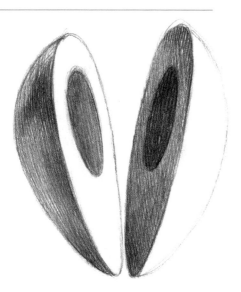 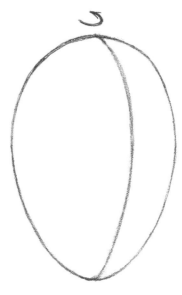

Now cut a hard-boiled egg in half lengthwise. The two halves are the shape of an irregular ellipse. When you turn them, you see a simplified version of what happens to the main axis when the head is turned. It takes on the shape of the curved surface and must be drawn as an elliptical curve. This rule applies to any model, regardless of gender, age, or ethnicity.

People inexperienced in drawing often forget to mark in the main axis and draw a straight bisector on the turned head. The drawing below clearly shows how the turned head relates to the front-on view of the face and the straight, longitudinal bisector.

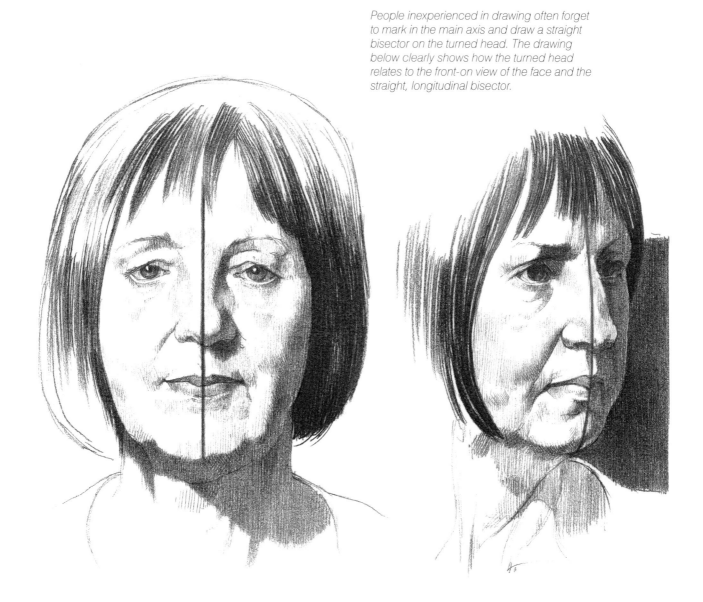

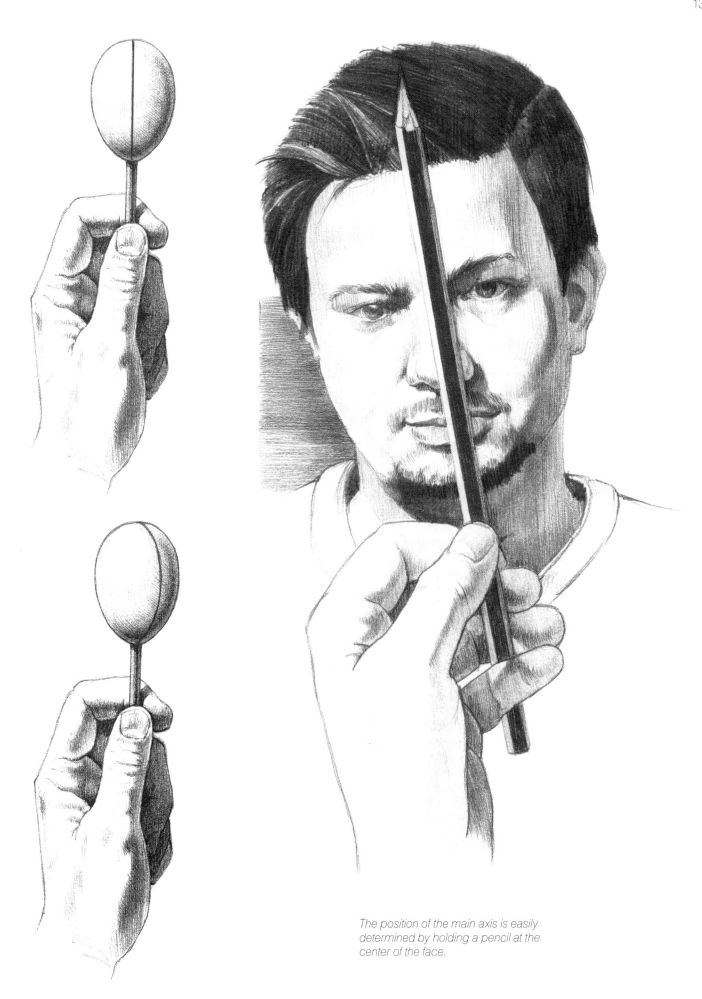

The position of the main axis is easily determined by holding a pencil at the center of the face.

Drawing the head is made easier by drawing transverse axes perpendicular to the main axis. These include the **eye axis**, which bisects the head—that is, the distance between the tip of the chin and the skull without the hair.

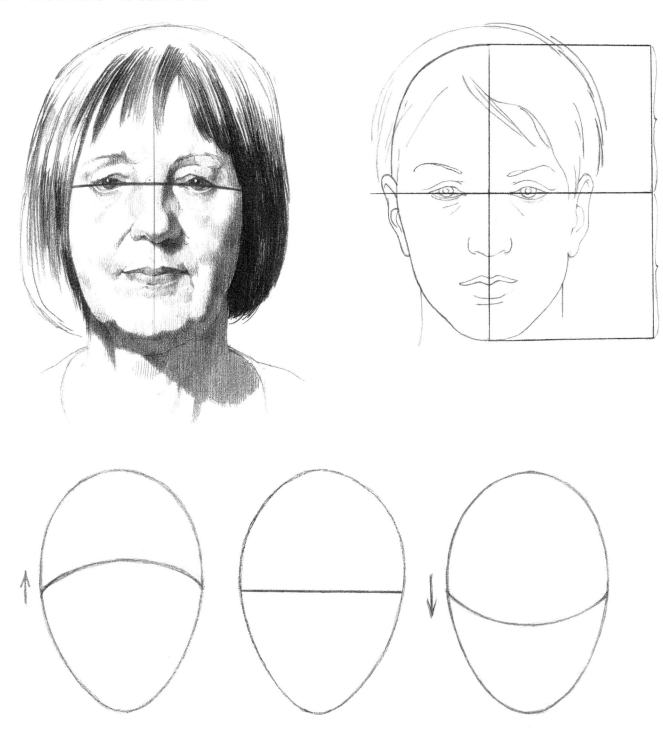

Of course, this means that the upper and lower parts are the same size only if you are looking straight at the model from the front. In all other cases, the rules of perspective come into play. All details that are closer to the observer will appear bigger and all those that are farther away will appear smaller, even though, in reality, they are the same size. Similarly, if you look at the model from above, the section between the eye axis and the chin will be smaller whereas, if you look at the model from below, the distance between the eye axis and the skull will appear smaller.

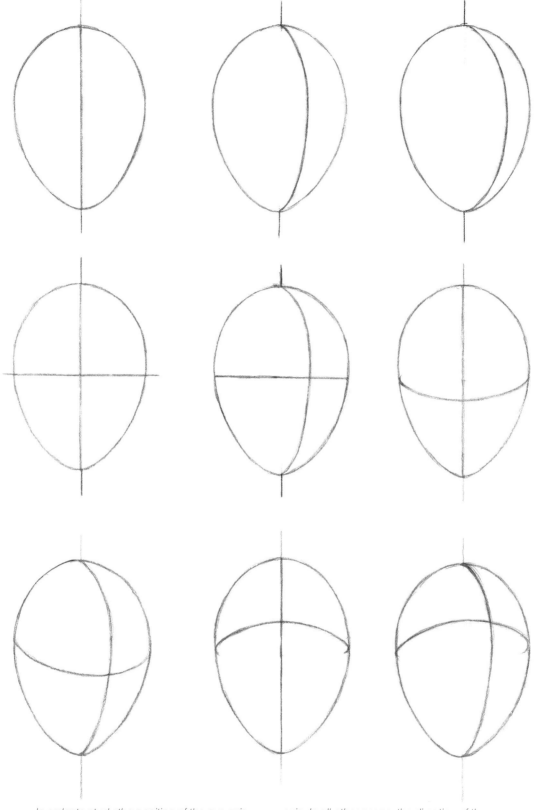

In order to study the position of the eye axis in more detail, cut a hard-boiled egg in half crosswise. The cut surface will be in the shape of a circle, which—as you will know from learning about perspective—usually appears to be elliptical in shape. In one particular position—that is, when looking at the head from directly in front—the eye axis is straight and runs perpendicular to the main axis. In all other cases, the direction of the curve of the ellipse is determined by the attitude of the head. If you look at the head from below, the ellipse arches upward, while it curves downward when seen from above. With the help of the illustrations above, you can study the way the shape of the elliptical eye axis changes with the different attitudes of the head.

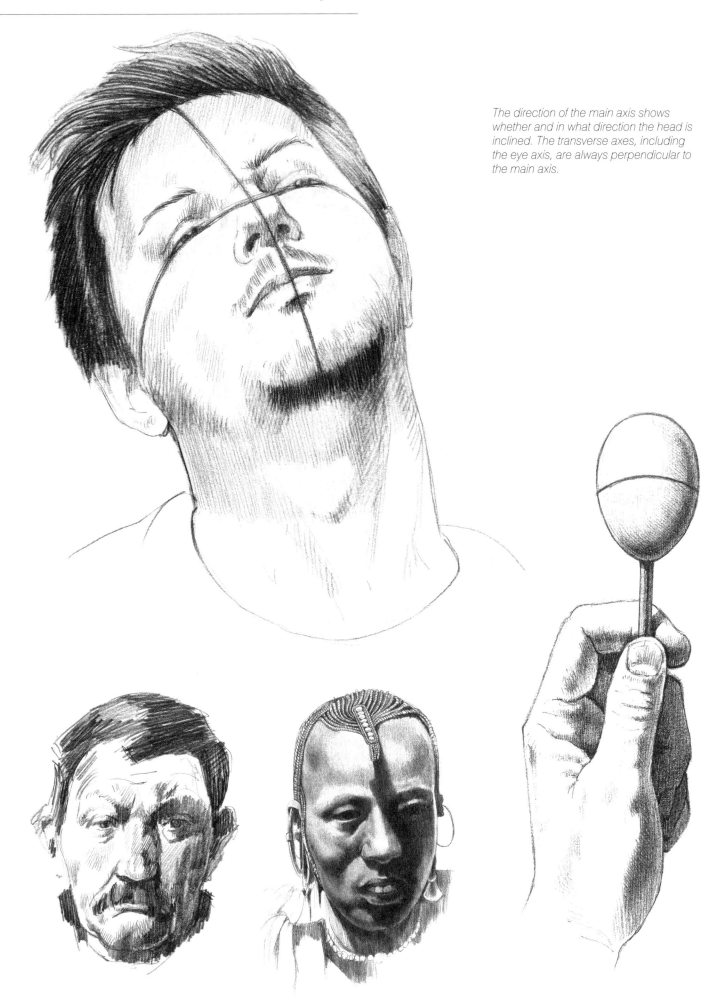

The direction of the main axis shows whether and in what direction the head is inclined. The transverse axes, including the eye axis, are always perpendicular to the main axis.

The rules above apply to all models, irrespective of age, gender, and ethnicity. Note: The curve of the eye axis is always determined by the attitude of the head, and, if you are not looking at the model from directly in front, you must always draw an elliptical curve. It is a common and serious mistake to mark the position of the eyes with a straight line, because they most often lie on an elliptical curve.

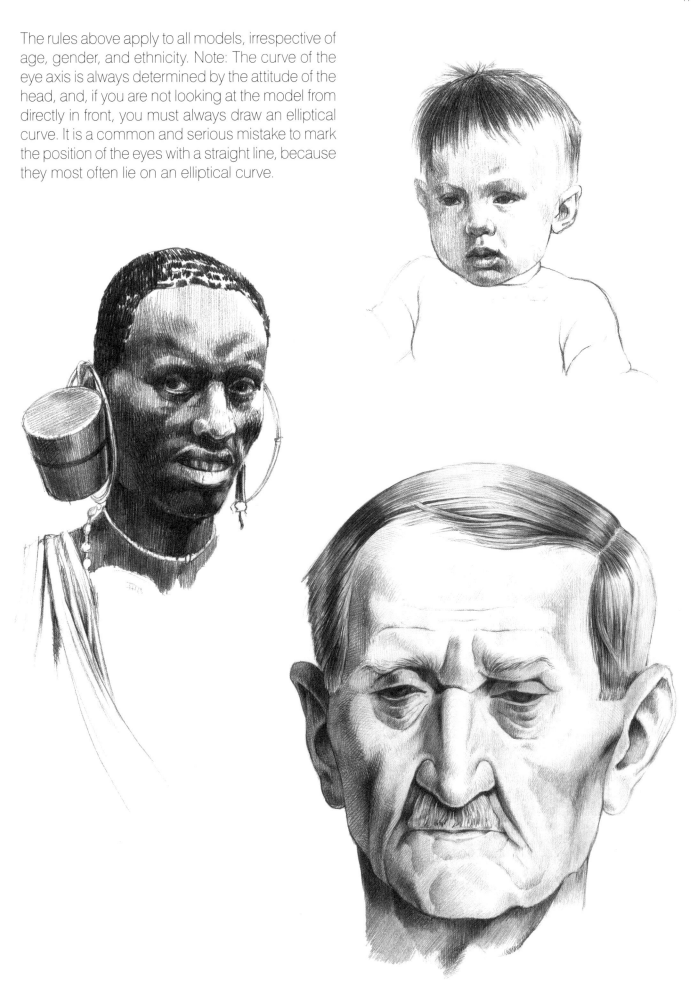

The **nose axis** links the point immediately below the nose with the tips of the earlobes and runs parallel to the eye axis. If you are looking at the model from straight in front, it will be a straight line. However, if the head is turned, there will be a corresponding change to the nose axis—something that can also best be demonstrated with a hard-boiled egg.

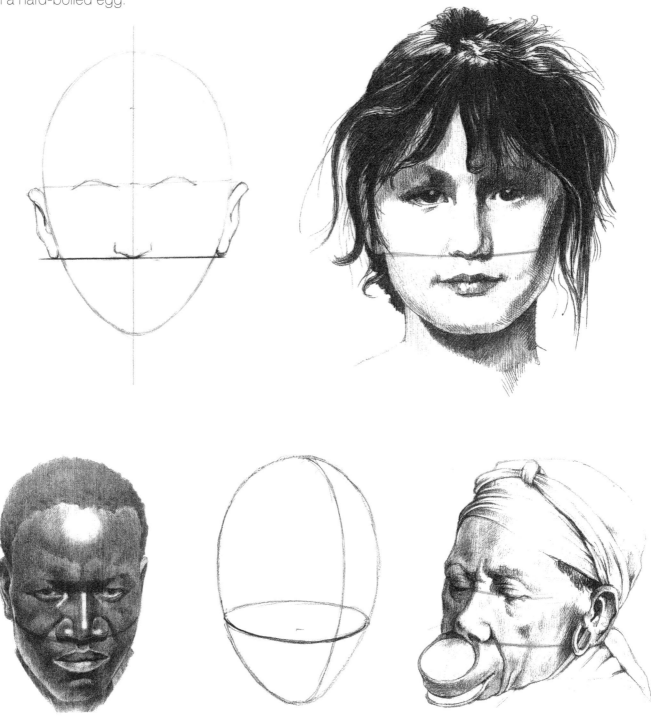

The following trick is useful for determining the nose axis. If you place a pencil on the imaginary straight line linking the tips of the earlobes, you can immediately see whether the area beneath the nose lies under it or above it. If it is above the pencil, you are looking at the head from below and you must draw an upward curve. If it is below the imaginary straight line, you are looking at the model from above and you must draw a downward-curving line. The nose axis is particularly important in drawing, because the three fixed points—the earlobes and the point just below the nose—that determine it make it the easiest of all the transverse axes to position and, as the transverse axes are parallel to one another, the curves of the others can be found from it. Of course, it may happen that only one earlobe is visible. In this case, the solution is to determine the curve of the axis by laying a pencil on the eye axis, transferring this to the paper (keeping the hand steady), and using this to determine the nose axis.

The head can be divided into three subsections of equal size, which are determined with the help of one further axis, the **eyebrow axis**. The distance between the hairline and the eyebrow axis is exactly the same as for the section between the eyebrow axis and the nose axis, which is in turn the same as the distance between the nose axis and the tip of the chin.

The axes run parallel to one another, even if they are drawn as elliptical curves. The size of these three equal sections varies as the head is turned in accordance with the rules of perspective. Whatever is closest to the viewer is biggest, and anything farther away gradually becomes smaller. The ears lie between the eyebrow axis and the nose axis.

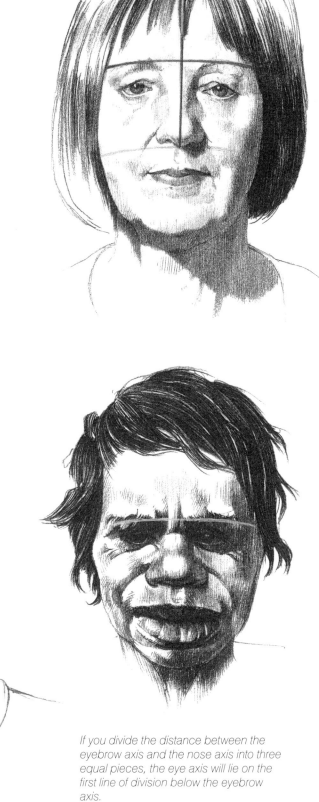

If you divide the distance between the eyebrow axis and the nose axis into three equal pieces, the eye axis will lie on the first line of division below the eyebrow axis.

The **mouth axis** runs parallel to the other transverse axes and perpendicular to the main axis, which bisects the mouth. The position of the mouth axis must be marked within the section between the nose axis and the tip of the chin. If the direction of the mouth axis is incorrect—which often happens—it will not run parallel to the nose axis.

If the head is turned, the curve of the mouth axis will change in the same way as for the previously mentioned transverse axes, in accordance with the rules of perspective—that is, the parts of the turned head that are closest to the viewer will appear bigger than those that are farther away.

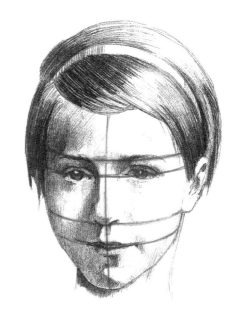

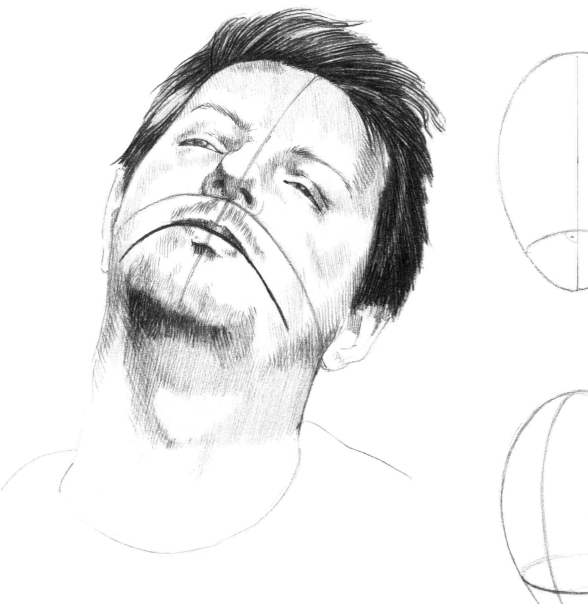

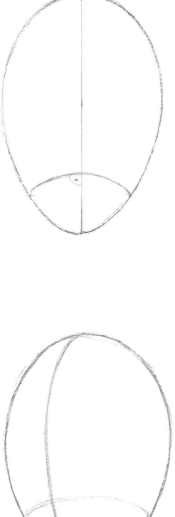

Three sections of exactly equal size can be distinguished in the face. The distance between the hairline and the eyebrow axis is the same as that between the eyebrow axis and the nose axis and between the nose axis and the tip of the chin.

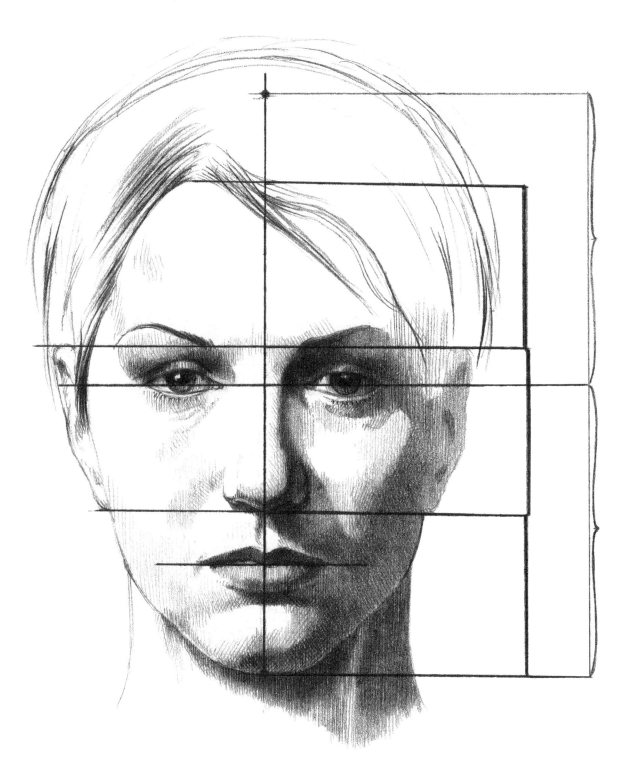

When you are drawing, you will notice that the rules of perspective also apply to the three equal sections. Viewed from the front, the axes become elliptical curves when the head is turned or inclined and the elements that are closer to the viewer appear bigger than those farther away. Practice by marking the main axis and the axes for the hairline, eyebrows, eyes, and mouth on a hard-boiled egg. The tip of the chin is the pointed end of the egg. Turn the egg in various directions and observe how the curve of the axes changes. The human face changes in the same way.

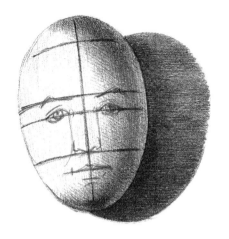

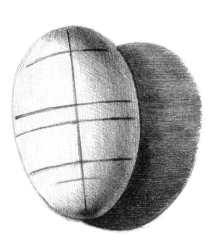

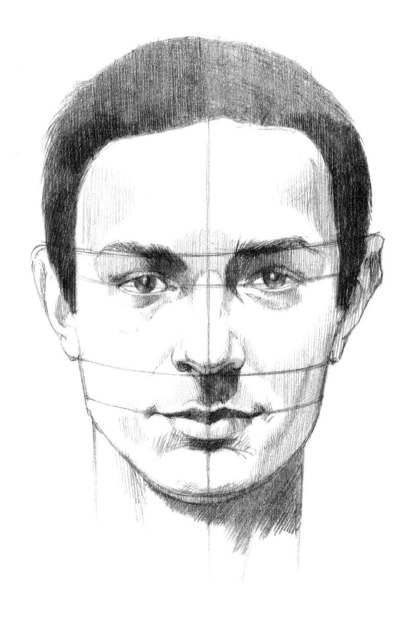

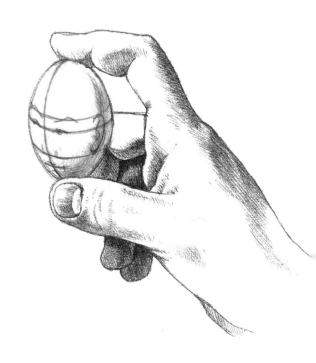

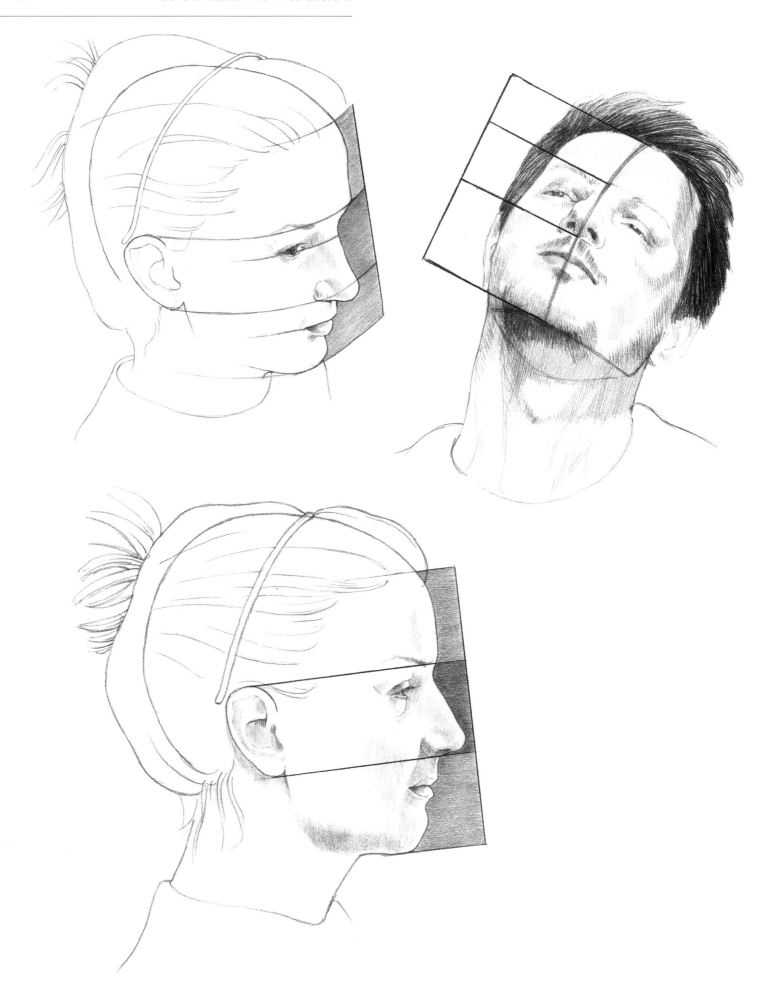

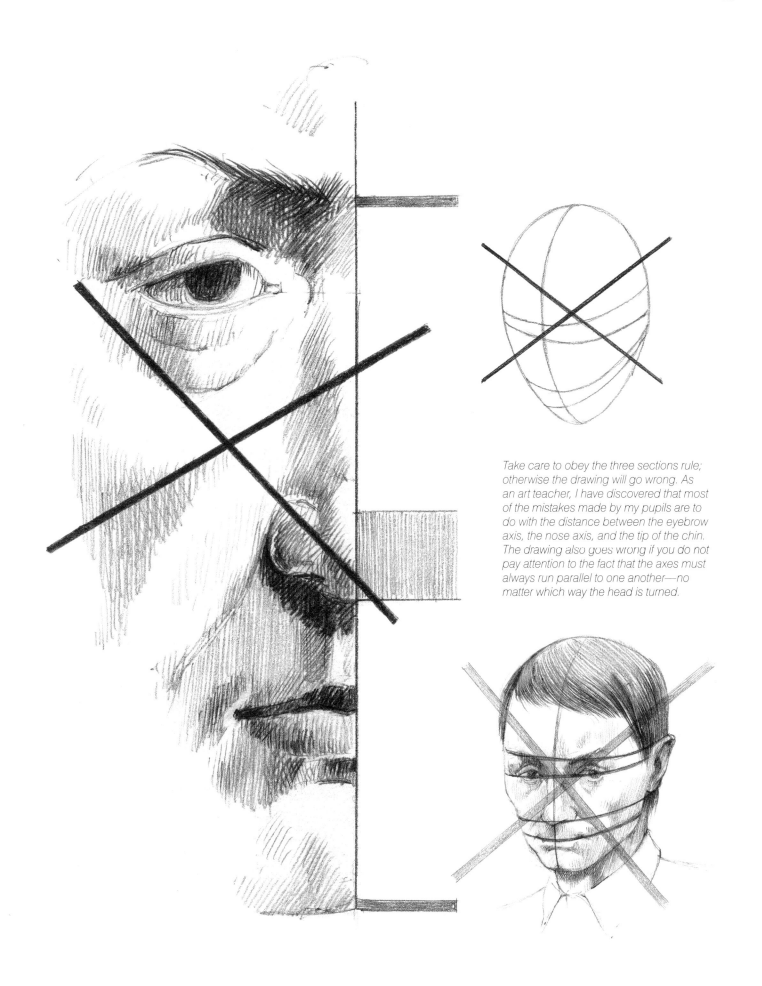

Take care to obey the three sections rule; otherwise the drawing will go wrong. As an art teacher, I have discovered that most of the mistakes made by my pupils are to do with the distance between the eyebrow axis, the nose axis, and the tip of the chin. The drawing also goes wrong if you do not pay attention to the fact that the axes must always run parallel to one another—no matter which way the head is turned.

If you divide the distance between the eyebrow axis and the nose axis into three equal parts, the eye axis will be the dividing line for the first part.

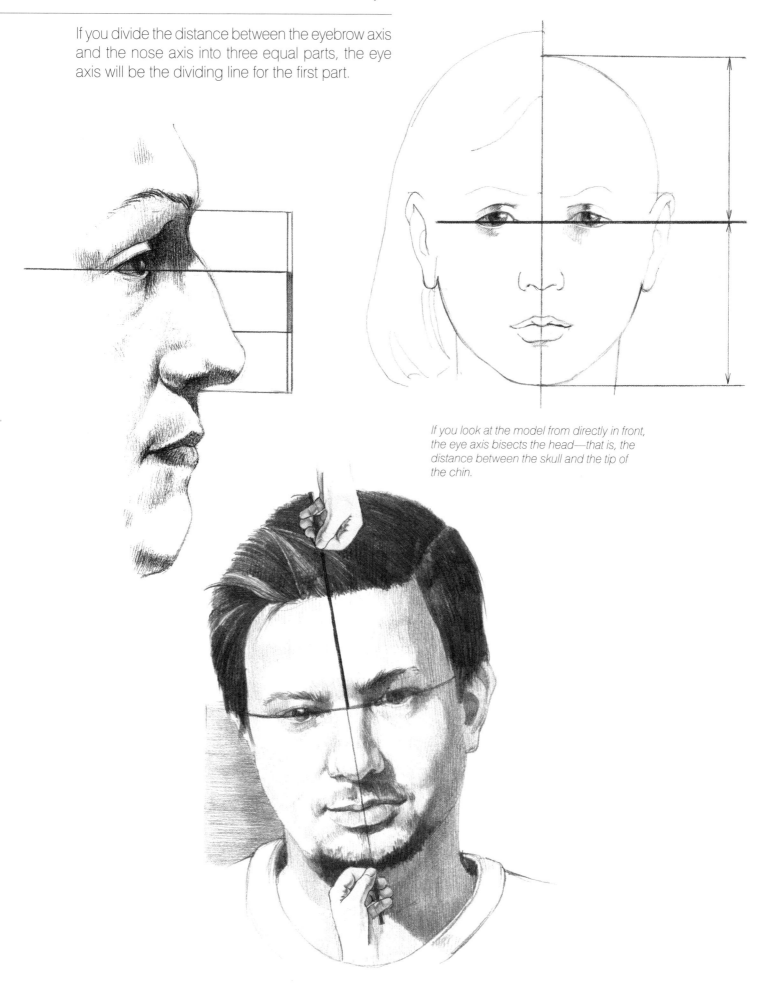

If you look at the model from directly in front, the eye axis bisects the head—that is, the distance between the skull and the tip of the chin.

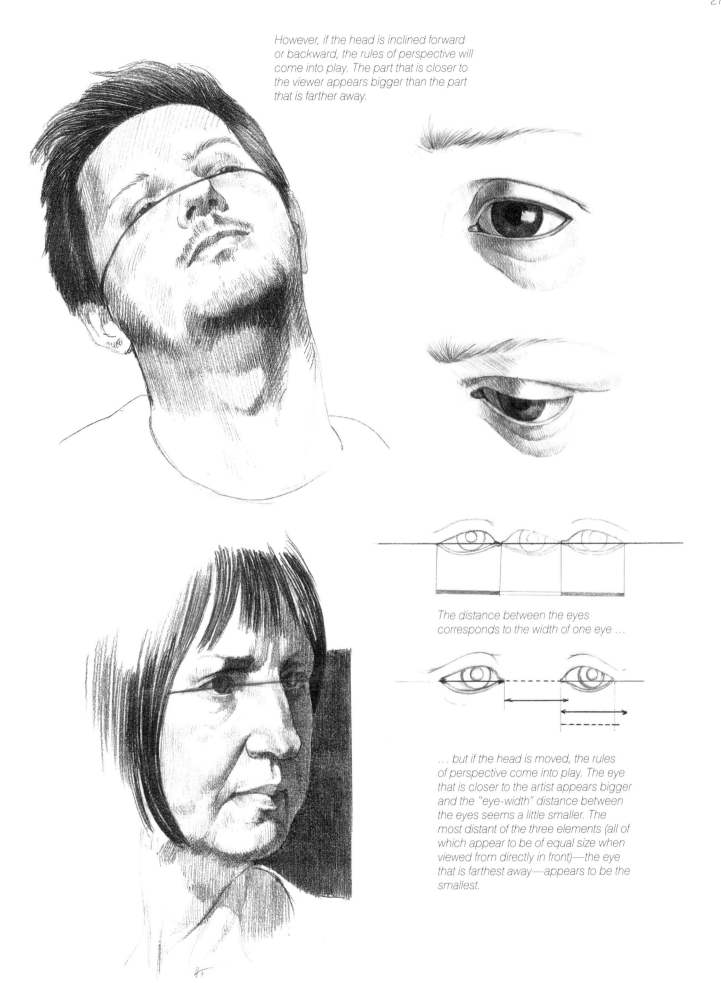

However, if the head is inclined forward or backward, the rules of perspective will come into play. The part that is closer to the viewer appears bigger than the part that is farther away.

The distance between the eyes corresponds to the width of one eye …

… but if the head is moved, the rules of perspective come into play. The eye that is closer to the artist appears bigger and the "eye-width" distance between the eyes seems a little smaller. The most distant of the three elements (all of which appear to be of equal size when viewed from directly in front)—the eye that is farthest away—appears to be the smallest.

In order to determine the **position of the nose**, you need to know that the main axis bisects it lengthwise. When the head is turned, the part of the nose that is closer to the viewer appears bigger. In people of the European type, the distance between the outer edges of the nose is small, corresponding to the width of an eye—the same as the distance between the eyes—so two lines running through the inner corner of the eye and parallel to the main axis determine the width of the nose. Of course, there are many ethnicities, for example in Africa, Asia, and Australia, for whom this rule does not apply because the distance between the outer edges of the nose is bigger in their case.

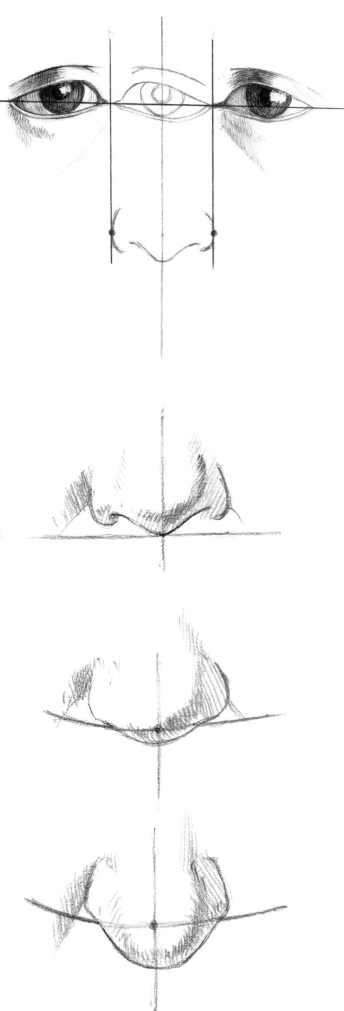

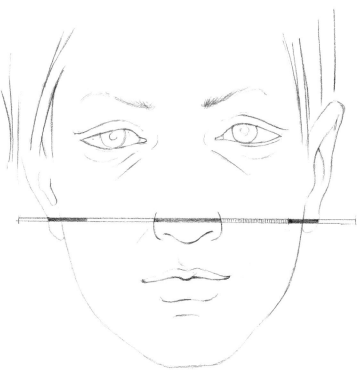

When drawing the nose, it is very important to check the measurements. For example, you must pay attention to how many times the width of the nose fits into the overall width of the face.

The point below the nose is lower than the bottom of the outer edges of the nose, as can be demonstrated by an imaginary horizontal line through the point below the nose. The tip of the nose of a model with a bowed head is often drawn on the axis that runs through the point beneath the nose. As a result, the nose is shortened and the face looks wrong. In a correct representation, the tip of the nose hides this point.

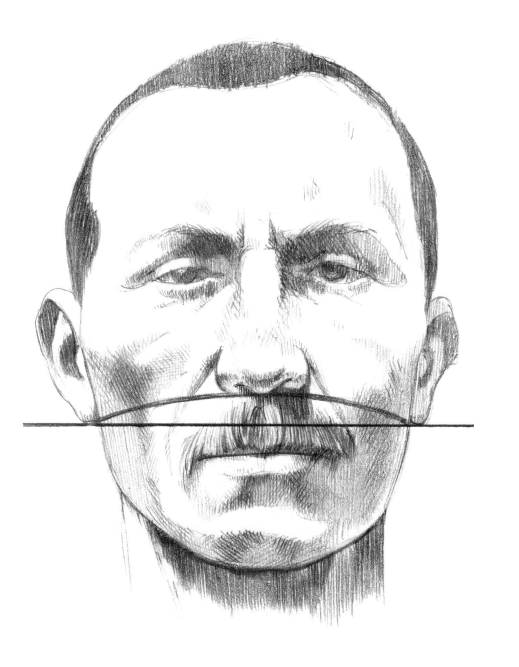

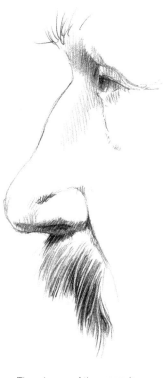

The shape of the nose is most easily seen in profile.

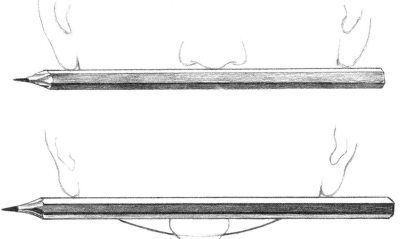

If you hold a pencil along the imaginary line between the tips of the earlobes, you can immediately see whether the area below the nose lies above or below this line. If it is above, you are looking at the head from below and you must draw an upward elliptical curve. If it is below, you are looking upward at the model and must draw a downward curve. All the other transverse axes run parallel to this curve. The one exception is when the three points (the tips of the earlobes and the point below the nose) are in line. In that case, the axis will be a straight line, and the other axes will be straight lines running parallel to it.

The ears lie between the axes of the nose and the eyebrows. In a face viewed from directly in front, the axes are straight lines.

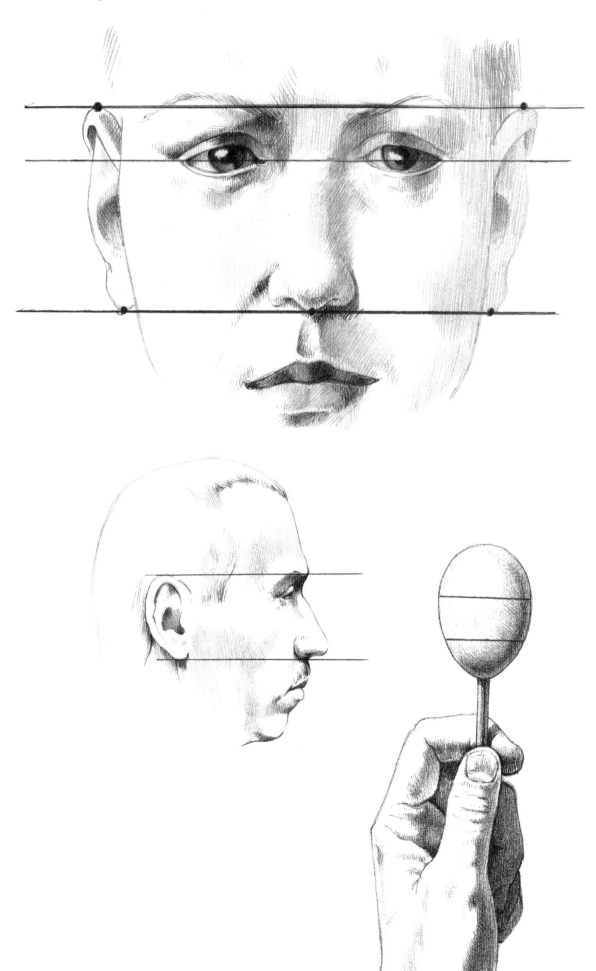

However, if the head is bent forward or back, these axes become elliptical. Determining the curve is made easier by the fact that, in this case too, the ears will lie between the two axes. Join the tips of the earlobes with an imaginary straight line and check which part of the face this crosses.

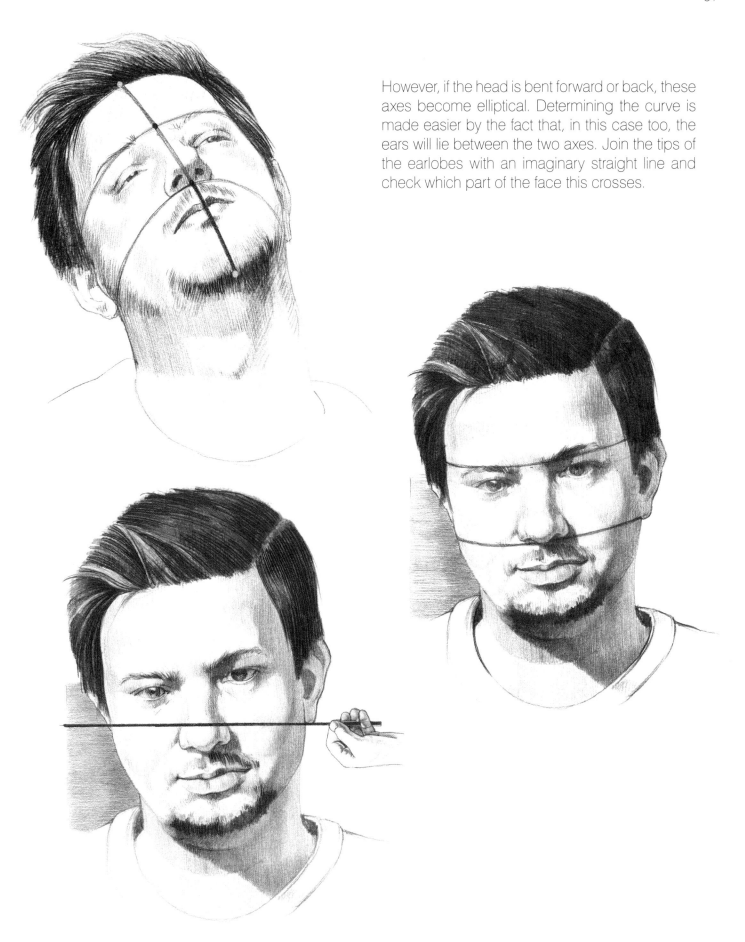

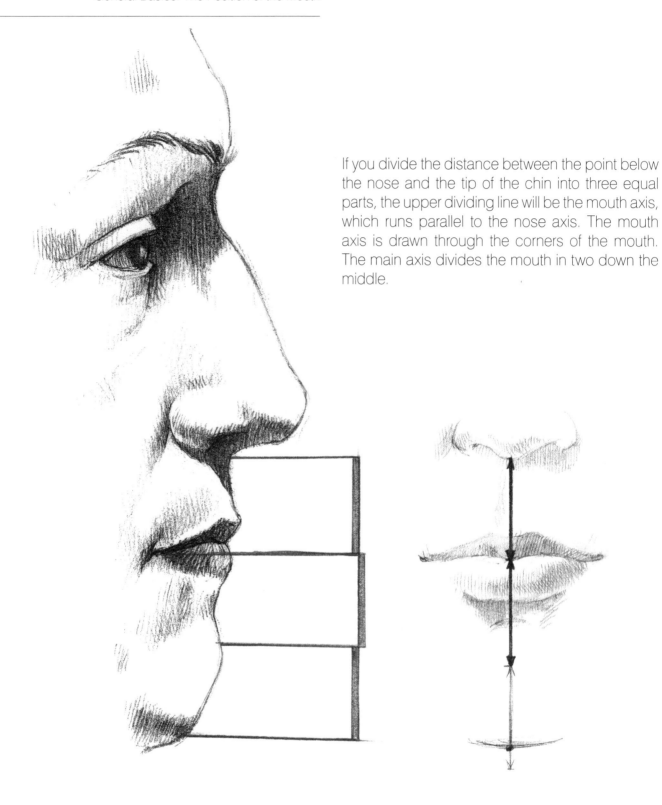

If you divide the distance between the point below the nose and the tip of the chin into three equal parts, the upper dividing line will be the mouth axis, which runs parallel to the nose axis. The mouth axis is drawn through the corners of the mouth. The main axis divides the mouth in two down the middle.

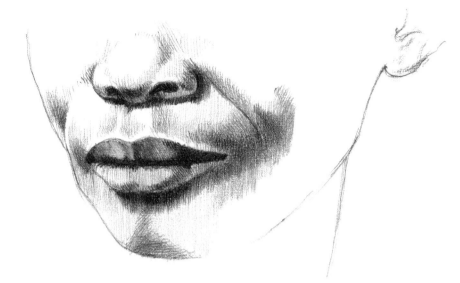

The philtrum (the groove above the upper lip) runs from the point below the nose down to the upper lip.

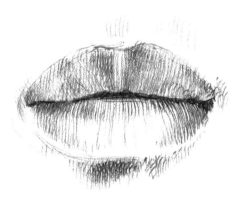

The lower lip is fuller than the upper lip. When drawing the lips, note that in people of the European type the lips are slightly darker than the rest of the skin.

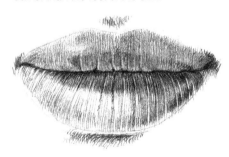

The width of the mouth must be checked by measuring. You must also bear in mind that, when the head is turned, the width of the mouth on the side that is farther away from the viewer will become reduced in accordance with the rules of perspective. The distance of the mouth from the nose and chin must also be checked by measuring, as it is often drawn too close to either the nose or the chin.

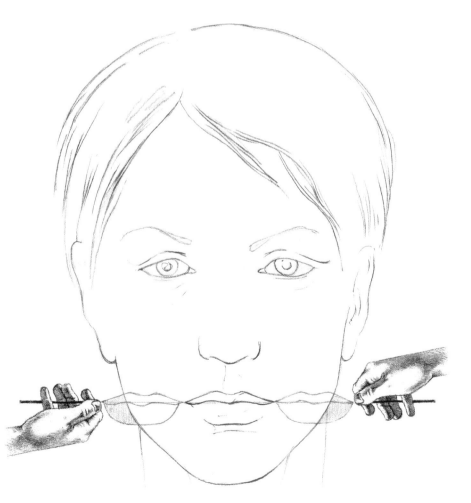

As previously mentioned, the main axis bisects the head—that is, it divides the head into two symmetrical halves. If you hold a mirror on the axis of symmetry—the main axis—the mirror image will create a complete face. However, you must be aware that the image obtained in this way does not entirely correspond to reality. The human head is indeed symmetrical—the features at each side of the head, the ears, eyes, earlobes, corners of the mouth, and so on, are drawn at the same distance from the line of bisection—but in reality there are small differences between the two halves of the face, which add character to the features.

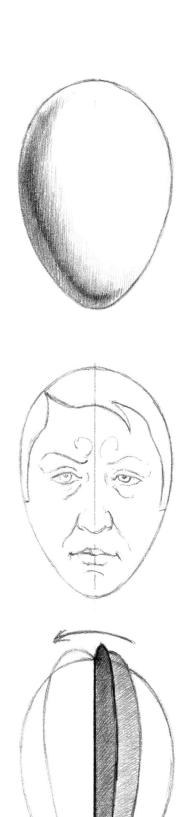

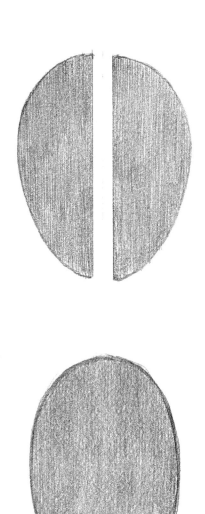

In order to study the symmetry of the face, use the egg to help you again. If you look at the face from directly in front, the axis of symmetry is a straight line, which is either vertical or slanted to the right

or left. If the head is turned, the axis of symmetry follows the shape of the head and becomes a curve, as you can see on the egg.

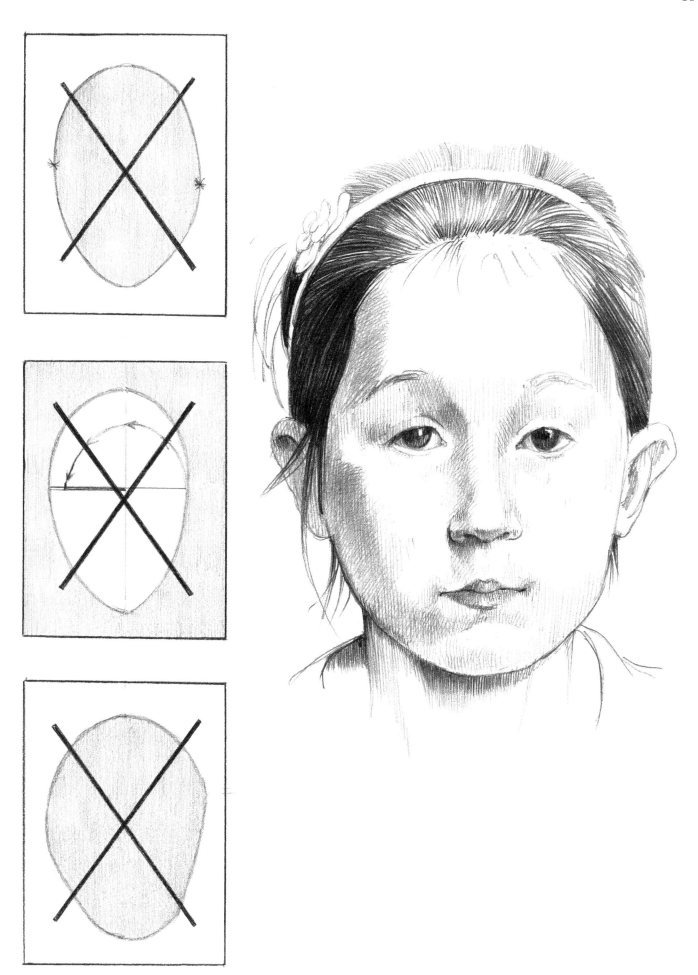

The key to a successful drawing of a human face is capturing the character. To help you with this, you need to determine the facial angle, which is different for everyone and is therefore a very good means of checking the accuracy of the drawing. The facial angle is the angle between two straight lines crossing the profile. The size of the angle varies from a right angle to an acute angle. One straight line connects the most prominent part of the forehead and the most prominent part of the upper jaw (the area below the nose). This intersects with the other straight line, which connects the outer edge of the auditory canal with the area just beneath the nose.

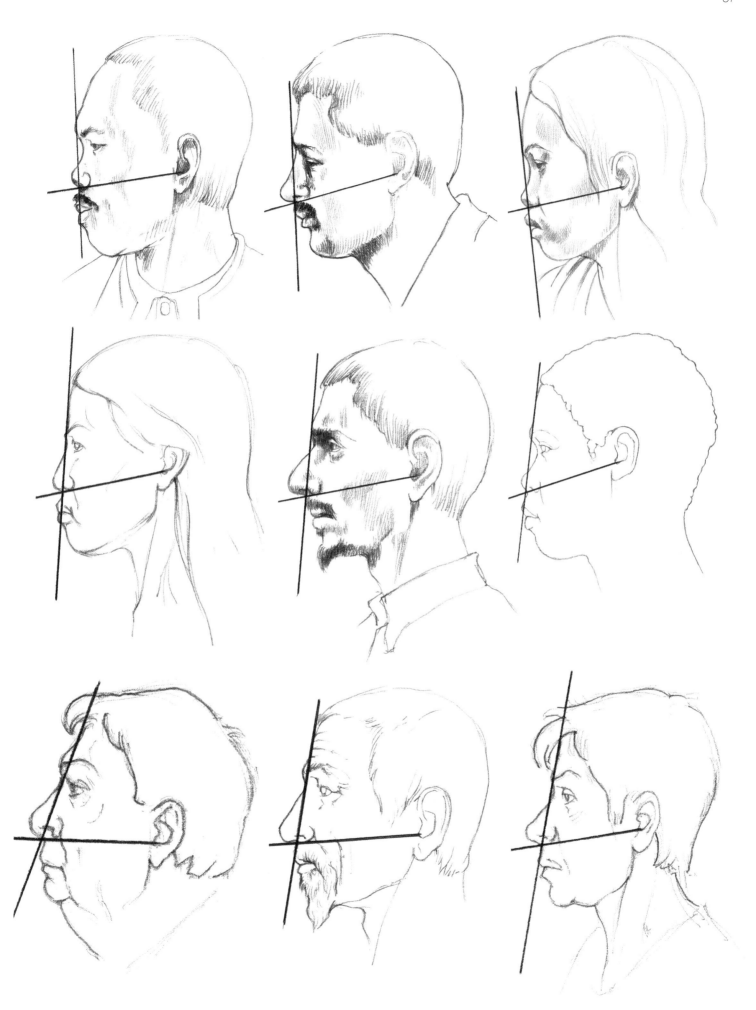

I come from a family of four generations of artists. My first drawing teacher was my grandfather, who studied at the Academy of Fine Arts in Budapest in the early 1900s, where he learned the classical forms of drawing and painting. I learned a lot from him and when I became a teacher, I passed this knowledge on to my pupils. I was inspired as a young man when I discovered everything my grandfather had taught me in Albrecht Dürer's book on human anatomy. Later, I also found the advice on drawing the human head in the writings of Leonardo da Vinci and other books from the 17th and 18th centuries. On the next few pages I will present the theoretical work of these artists with the help of their drawings, which I have reproduced here.

I will start with Piero della Francesca (c.1420–92) because he drew up the classical rules for drawing heads and bequeathed them to the world. He used perspective when depicting the details of faces in various attitudes. In the centuries that followed, these drawings became something of a yardstick and reappear in the studies of many masters.

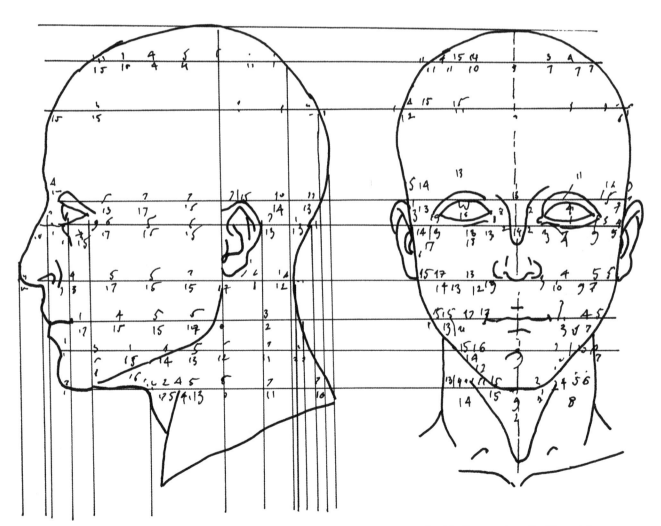

András Szunyoghy, after Piero della Francesca

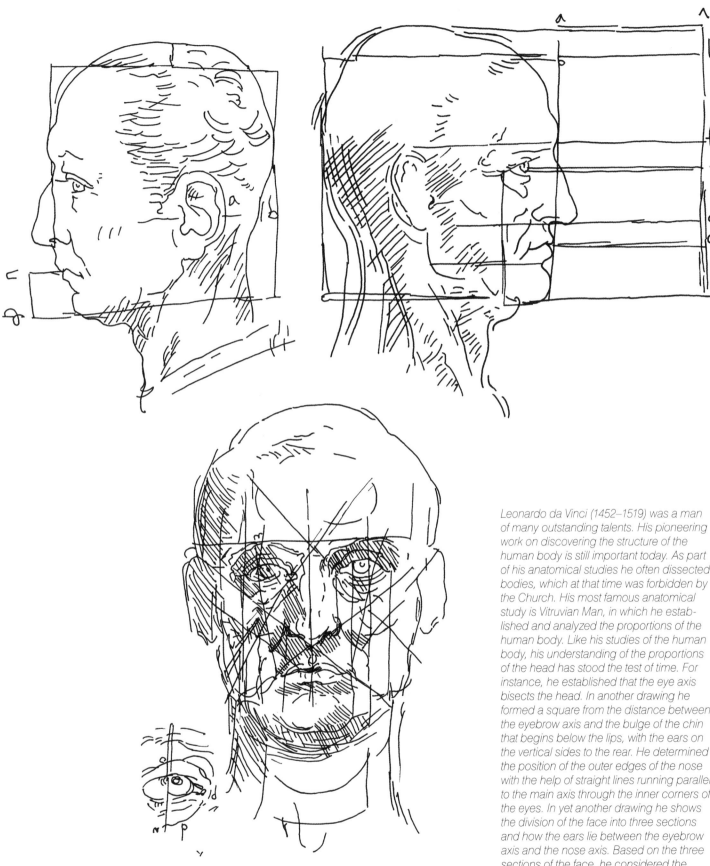

*András Szunyoghy, after Leonardo
da Vinci*

Leonardo da Vinci (1452–1519) was a man of many outstanding talents. His pioneering work on discovering the structure of the human body is still important today. As part of his anatomical studies he often dissected bodies, which at that time was forbidden by the Church. His most famous anatomical study is Vitruvian Man, in which he established and analyzed the proportions of the human body. Like his studies of the human body, his understanding of the proportions of the head has stood the test of time. For instance, he established that the eye axis bisects the head. In another drawing he formed a square from the distance between the eyebrow axis and the bulge of the chin that begins below the lips, with the ears on the vertical sides to the rear. He determined the position of the outer edges of the nose with the help of straight lines running parallel to the main axis through the inner corners of the eyes. In yet another drawing he shows the division of the face into three sections and how the ears lie between the eyebrow axis and the nose axis. Based on the three sections of the face, he considered the distance between the hairline and the tip of the chin as one side of a square, with the most prominent parts of the skull lying on the other vertical side.

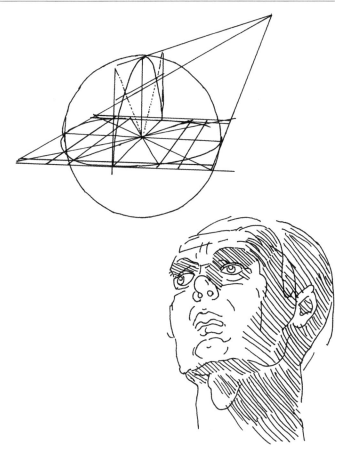

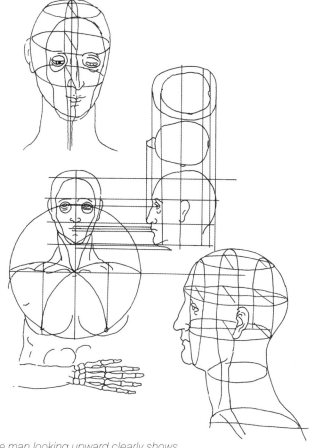

Albrecht Dürer (1471–1528) was acquainted with Piero della Francesca's establishment of the "classical" proportions of the head, which were based on the rules of perspective. His anatomical drawings prove that he had studied the rules of perspective in detail and was well versed in them. His drawings demonstrate the changes in the elliptical curves of the axes. The study of the man looking upward clearly shows that the eye axis is curved and that a curve through the point below the nose and the tips of the earlobes is also required. In another study he shows the course of the ellipses for the three sections of the head, and the ellipses of the bowed head also show that, in this face, the tip of the nose covers the nose axis.

Dürer must also have been an outstanding teacher, as this study shows how he tried to depict the three-dimensional relationships leading to the changes in shading as flat surfaces. With the help of these surfaces, he explained that planes with the same orientation have similar tonal values and from that observation developed the resulting logic of shading.

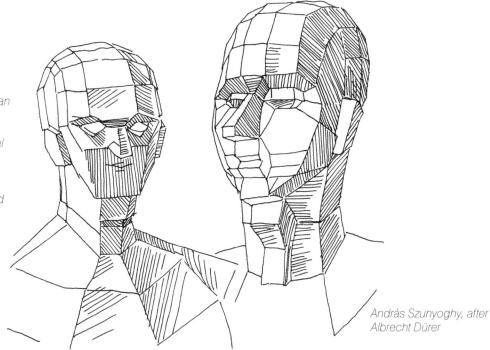

András Szunyoghy, after Albrecht Dürer

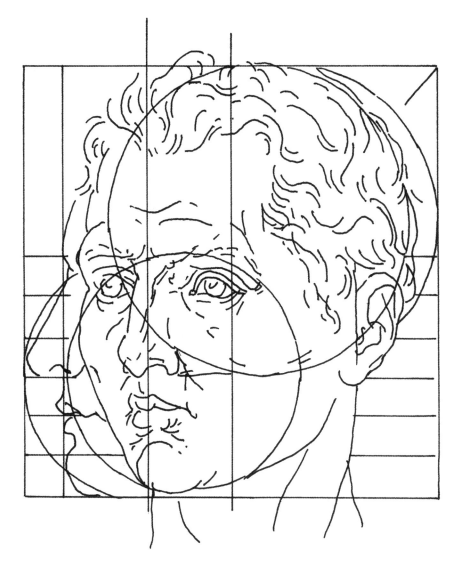

Professor Otto Geyer (1843–1914) published his textbook on drawing people in 1890. The illustrations in it are rather idiosyncratic, but nevertheless very detailed and accurate. On the face depicted from the front and in profile it is easy to recognize the rules concerning the axes— for example, the fact that the eye axis bisects the head. It is interesting that the position of the outer edges of the nose is determined by a straight line drawn from the outer edge of the corner of the eye parallel to the main axis and the corners of the mouth with a straight line from the inner edge of the corner of the eye. However, it is not absolutely necessary to follow these last two rules. Instead, I would recommend measuring the width of the mouth, and comparing it with another part of the face, as it can vary greatly from individual to individual.

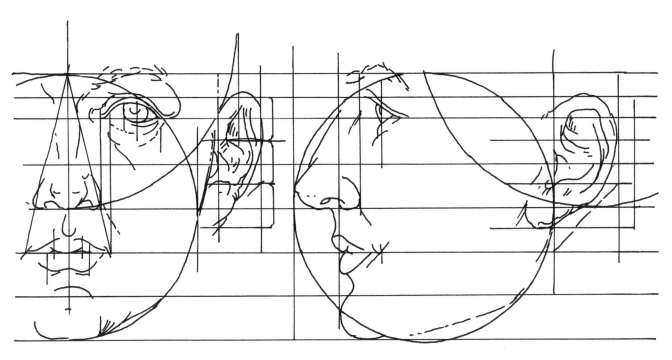

András Szunyoghy, after
Otto Geyer

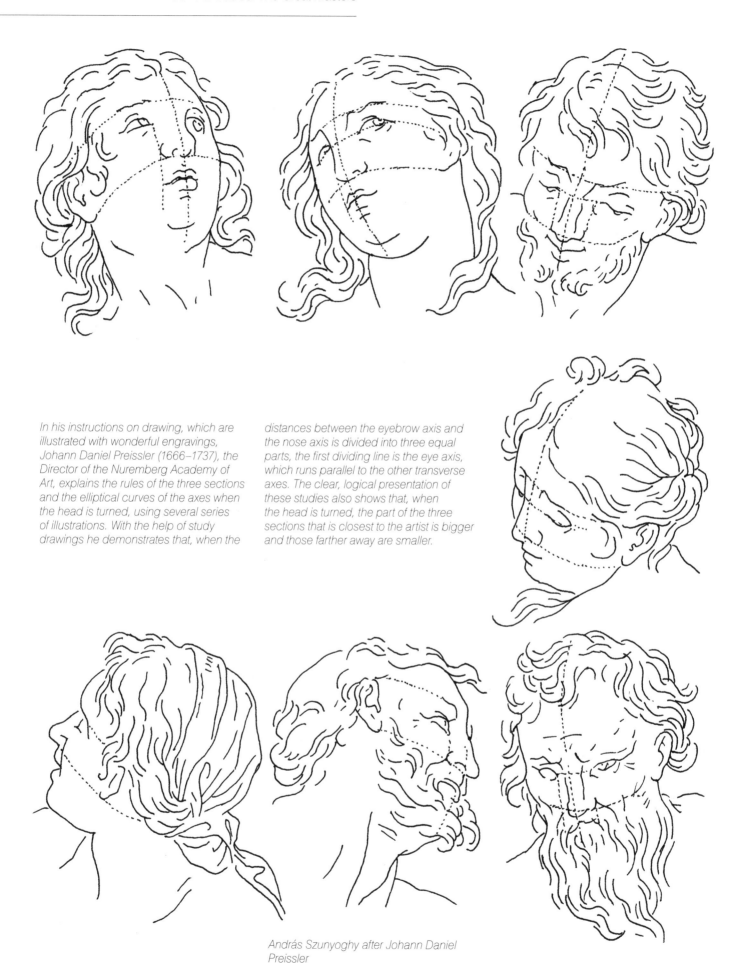

In his instructions on drawing, which are illustrated with wonderful engravings, Johann Daniel Preissler (1666–1737), the Director of the Nuremberg Academy of Art, explains the rules of the three sections and the elliptical curves of the axes when the head is turned, using several series of illustrations. With the help of study drawings he demonstrates that, when the distances between the eyebrow axis and the nose axis is divided into three equal parts, the first dividing line is the eye axis, which runs parallel to the other transverse axes. The clear, logical presentation of these studies also shows that, when the head is turned, the part of the three sections that is closest to the artist is bigger and those farther away are smaller.

András Szunyoghy after Johann Daniel Preissler

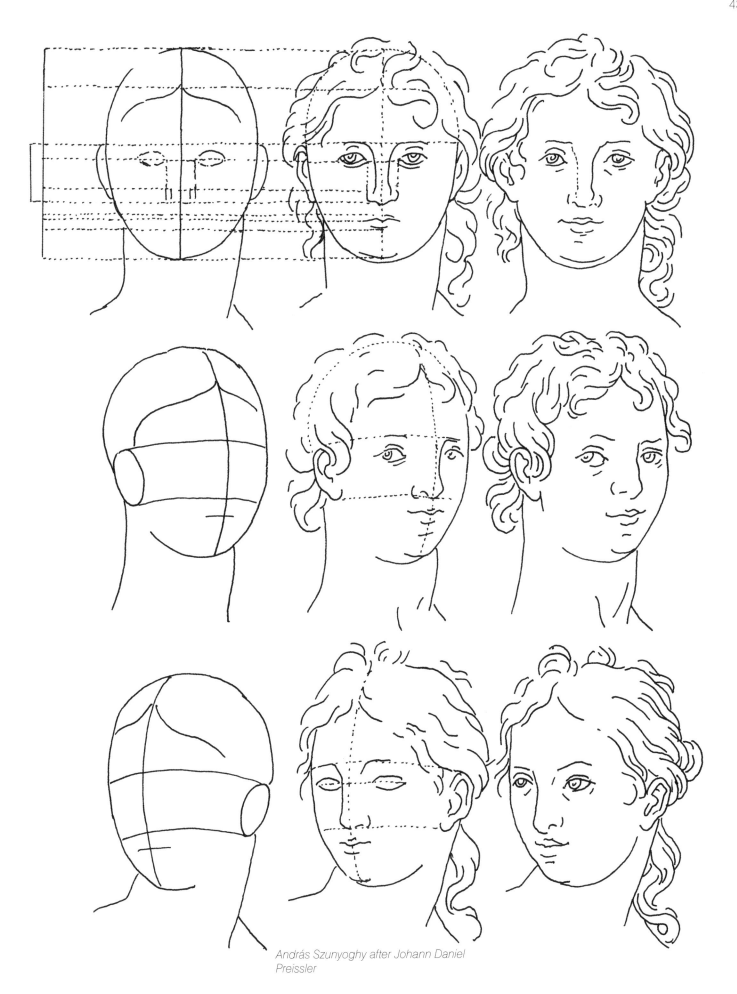

András Szunyoghy after Johann Daniel Preissler

A certain amount of basic anatomical knowledge is essential for drawing the head. This knowledge can be divided into two areas: bones (osteology) and muscles (myology). The skull consists of 22 bones, of which 8 form the cranium and 14 are facial bones. The only moving part of the skull is the lower jaw. As for muscles, we usually concern ourselves with those on the surface (which determine the contours of the face) but not with the deeper layers.

1 Frontal bone
2 Parietal bone
3 Nasal bone
4 Cheekbone
5 Upper jaw
6 Lower jaw

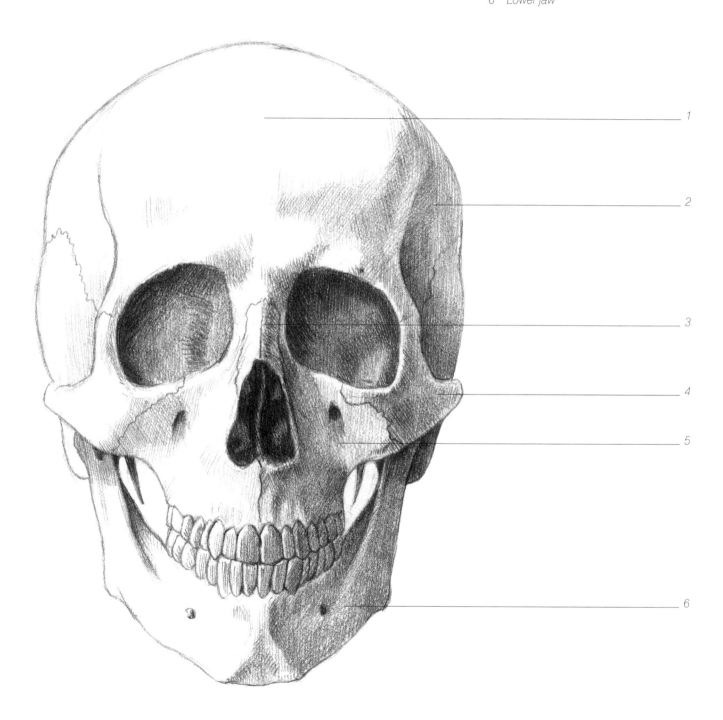

1 Frontal bone
2 Parietal bone
3 Sphenoid bone
4 Temporal bone
5 Nasal bone
6 Cheekbone
7 Occipital bone
8 Upper jaw
9 Lower jaw

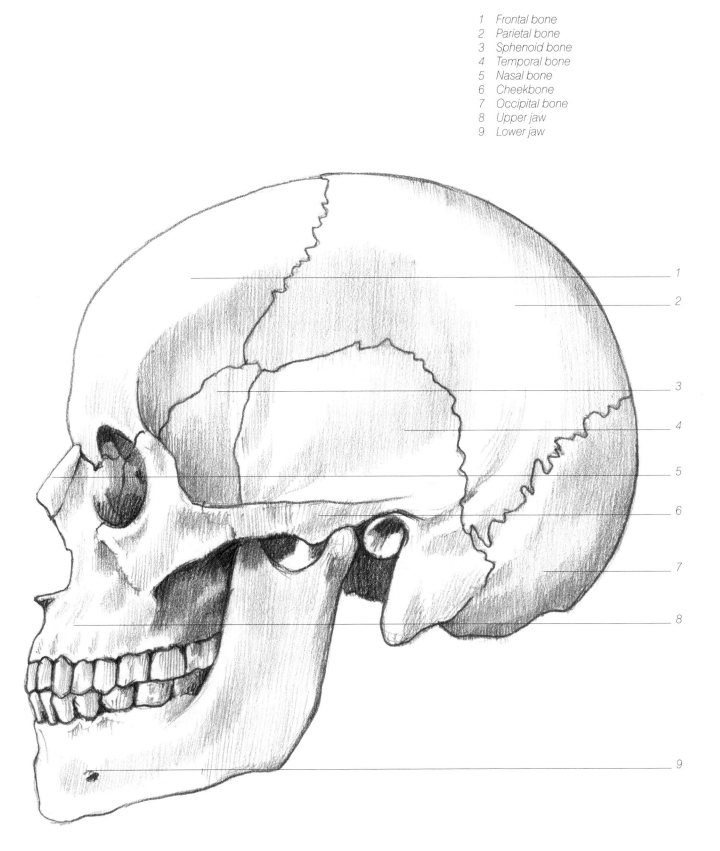

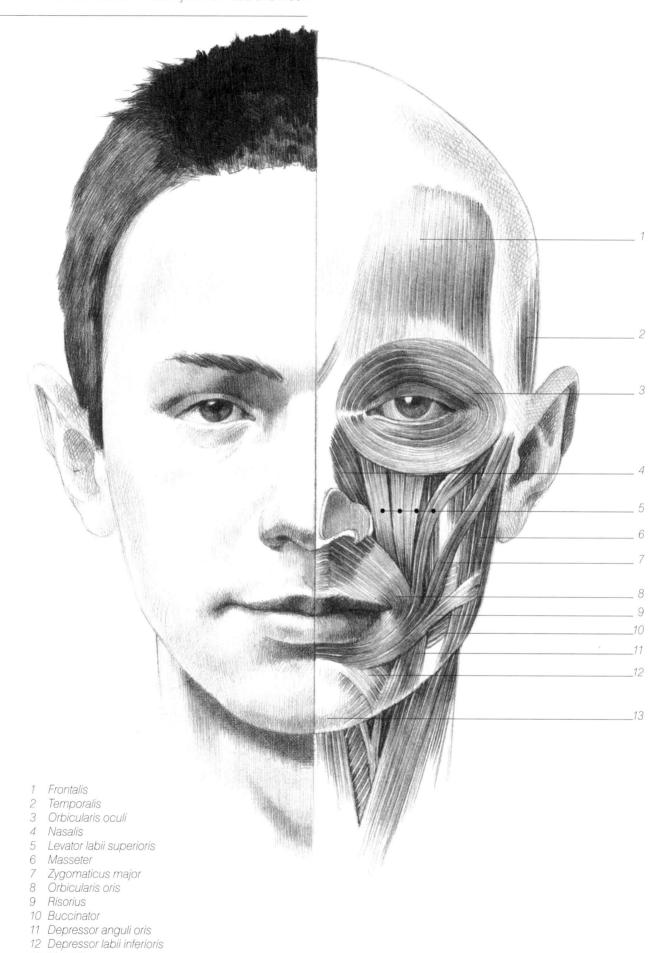

1 Frontalis
2 Temporalis
3 Orbicularis oculi
4 Nasalis
5 Levator labii superioris
6 Masseter
7 Zygomaticus major
8 Orbicularis oris
9 Risorius
10 Buccinator
11 Depressor anguli oris
12 Depressor labii inferioris
13 Mentalis

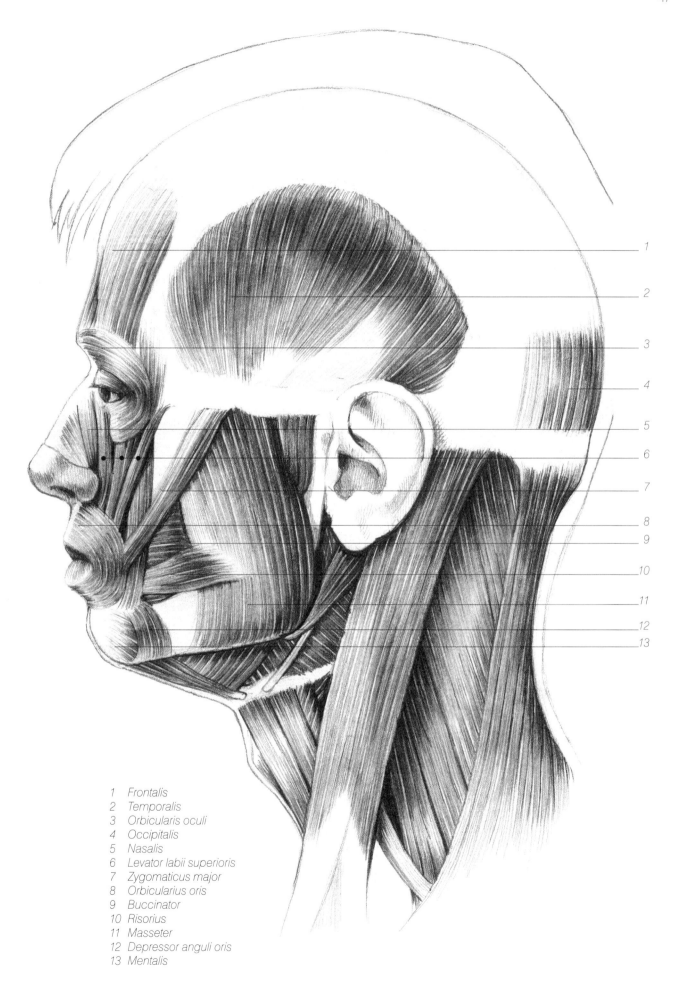

1 Frontalis
2 Temporalis
3 Orbicularis oculi
4 Occipitalis
5 Nasalis
6 Levator labii superioris
7 Zygomaticus major
8 Orbicularius oris
9 Buccinator
10 Risorius
11 Masseter
12 Depressor anguli oris
13 Mentalis

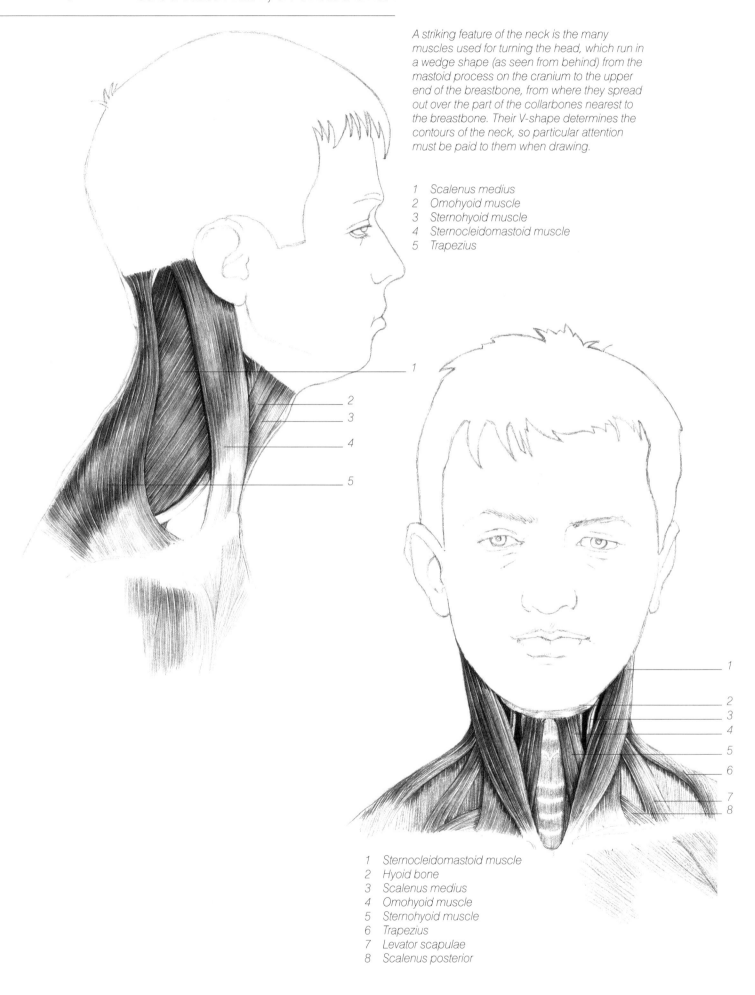

A striking feature of the neck is the many muscles used for turning the head, which run in a wedge shape (as seen from behind) from the mastoid process on the cranium to the upper end of the breastbone, from where they spread out over the part of the collarbones nearest to the breastbone. Their V-shape determines the contours of the neck, so particular attention must be paid to them when drawing.

1 Scalenus medius
2 Omohyoid muscle
3 Sternohyoid muscle
4 Sternocleidomastoid muscle
5 Trapezius

1 Sternocleidomastoid muscle
2 Hyoid bone
3 Scalenus medius
4 Omohyoid muscle
5 Sternohyoid muscle
6 Trapezius
7 Levator scapulae
8 Scalenus posterior

The shape of the back of the neck is determined by two muscles, the trapezius and the sternocleidomastoid muscle.

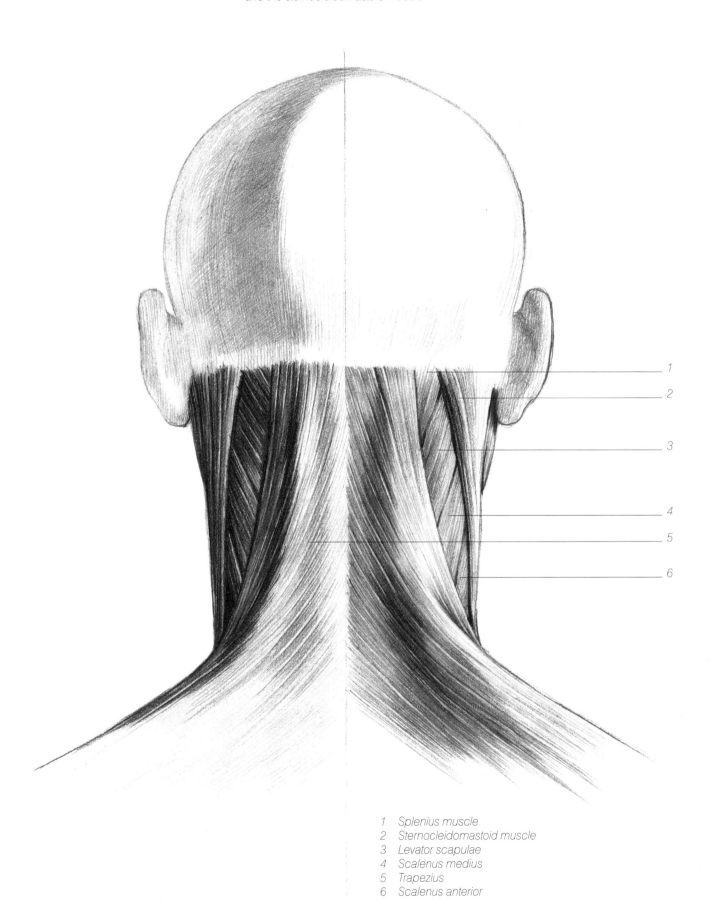

1
2
3
4
5
6

1 *Splenius muscle*
2 *Sternocleidomastoid muscle*
3 *Levator scapulae*
4 *Scalenus medius*
5 *Trapezius*
6 *Scalenus anterior*

To begin with, if depicting specific parts of the head is still causing difficulties, you can study the problematic parts in detail by copying plaster models. Such models have the added advantage that they never get tired, so you will have all the time in the world to draw them!

There is a wealth of drawing aids, many of which can be found in most studios. Interestingly, the same plaster models of facial features and the musculature of the head are used almost all over the world for learning drawing.

The large plaster ears, eyes, and mouths are details from Michelangelo's world-famous statue of David. With the help of these parts of the sculpture, which have been copied countless times over the centuries, you will find it easier to familiarize yourself with the structure, three-dimensionality, and spatial relationships of the individual parts of the face.

By looking at plaster copies of the eyes of the statue of David—one shows only one eye, the others both—you can study the shape and structure of the eyes, the thickness of the eyelids, and the foreshortening of the head. On the enlarged copy, you can more easily see that the eyebrows lie above the edge of the eye sockets rather than on them, that there are muscles that move the eyebrows located beneath the small mounds above the eyebrows, and how the latter change the three-dimensionality of the forehead.

The cast, on which you can also see the statue's nose, reveals the three-dimensionality of the nose and the position of the nostrils. In the enlargement, you can also better see the distance between the lachrymal sac and the fold beside the nose. This is the reason for many spoiled drawings, as the area below the nose is often drawn too far away from the eyebrow axis—probably because people mainly concentrate on the two characteristic areas of the face: the eyes and the nose.

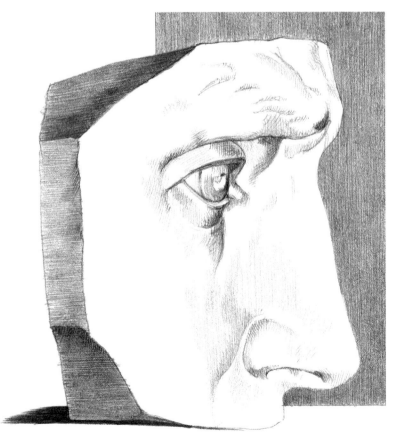

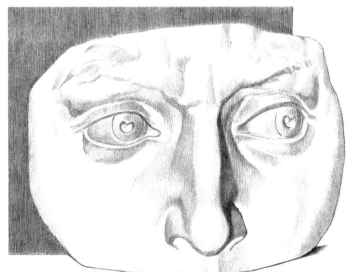

The plaster model of the ear is also a great help, as the fine detail of the outer ear is much harder to make out in life size than in the enlargement. On the copy of the statue's mouth you can observe that the main axis (the axis of symmetry) divides the upper and lower lips into two adjacent equal parts. The upper lip is always slightly narrower than the lower lip. By rotating the copy you can study exactly how the mouth appears in the different positions.

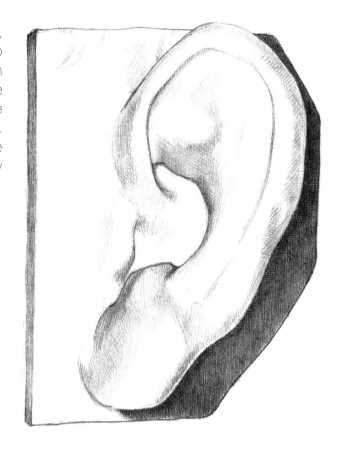

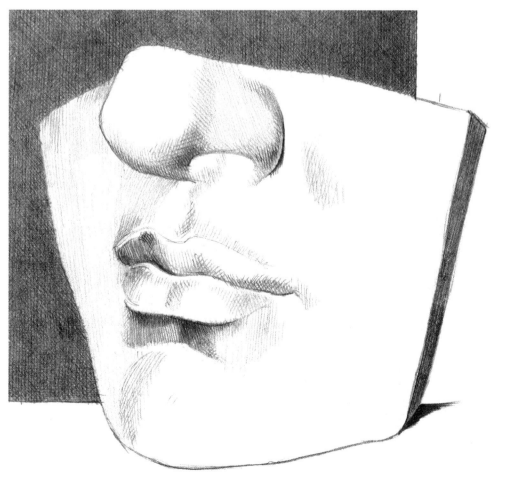

There are also aids made of plastic or plaster that can help you to familiarize yourself with the muscles close to the surface of the head and neck. This is essential because these muscles determine the character and expression of the face.

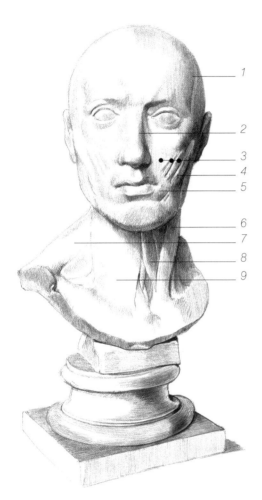

From in front
1 Temporalis
2 Nasalis
3 Levator labii superioris
4 Zygomaticus major
5 Orbicularis oris
6 Sternocleidomastoid muscle
7 Trapezius
8 Sternohyoid muscle
9 Platysma

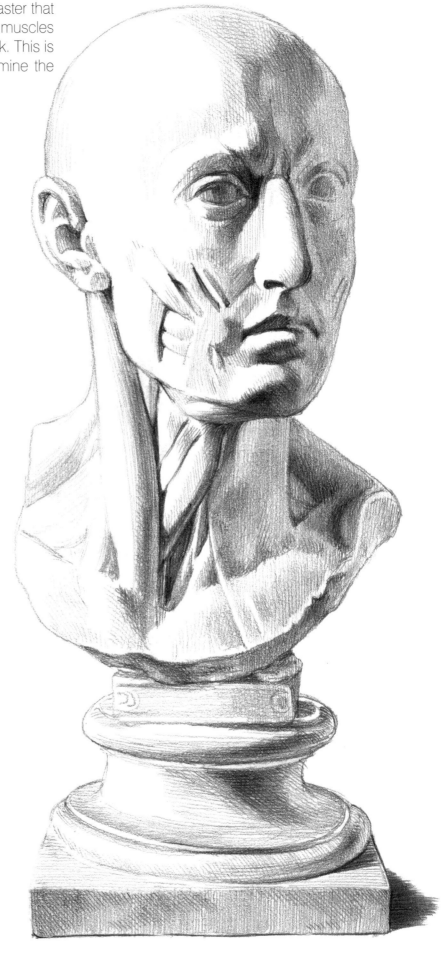

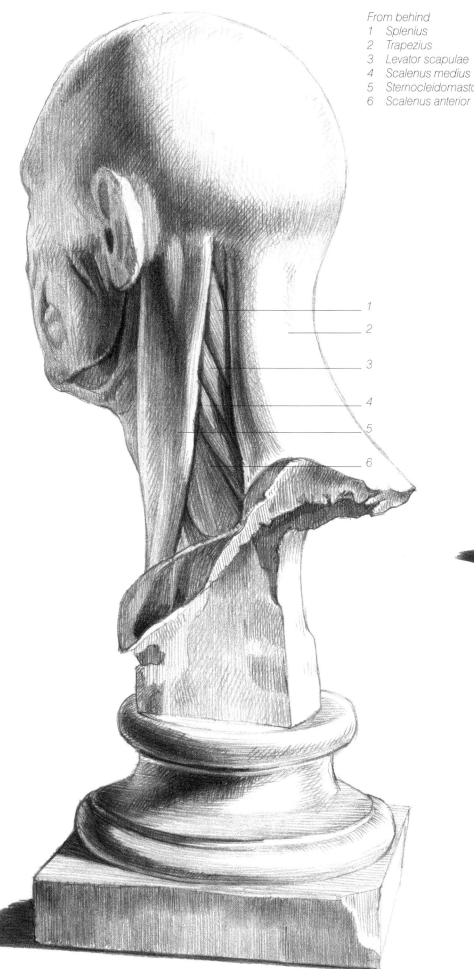

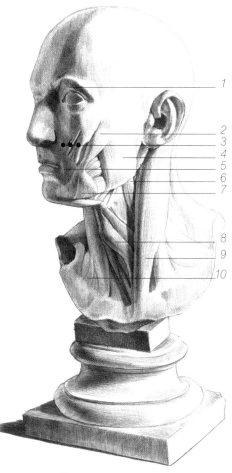

From behind
1 Splenius
2 Trapezius
3 Levator scapulae
4 Scalenus medius
5 Sternocleidomastoid muscle
6 Scalenus anterior

From the side
1 Orbicularis oculi
2 Zygomaticus major
3 Levator labii superioris
4 Masseter
5 Orbicularius oris
6 Sternohyoid muscle
7 Depressor anguli oris
8 Omohyoid muscle
9 Sternocleidomastoid muscle
10 Platysma

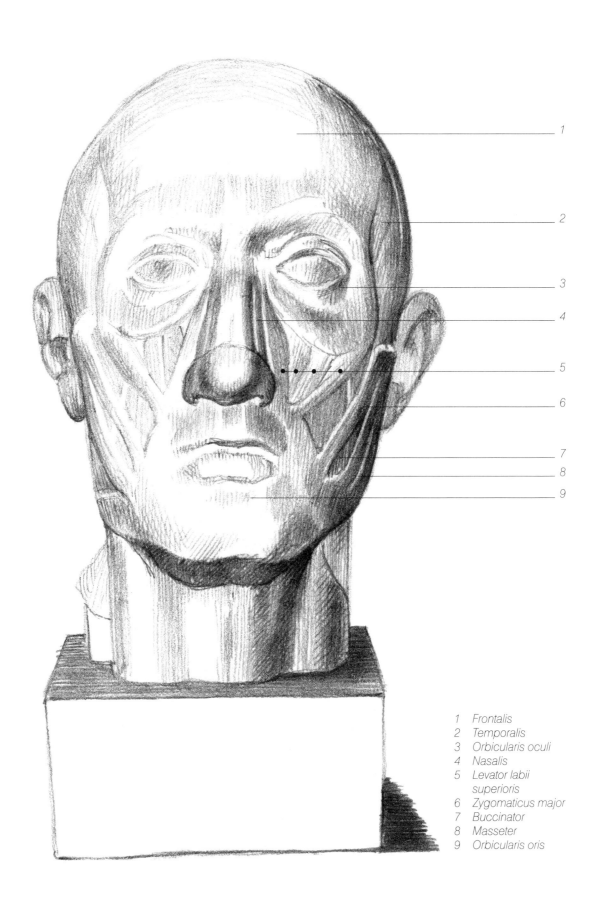

1 Frontalis
2 Temporalis
3 Orbicularis oculi
4 Nasalis
5 Levator labii
 superioris
6 Zygomaticus major
7 Buccinator
8 Masseter
9 Orbicularis oris

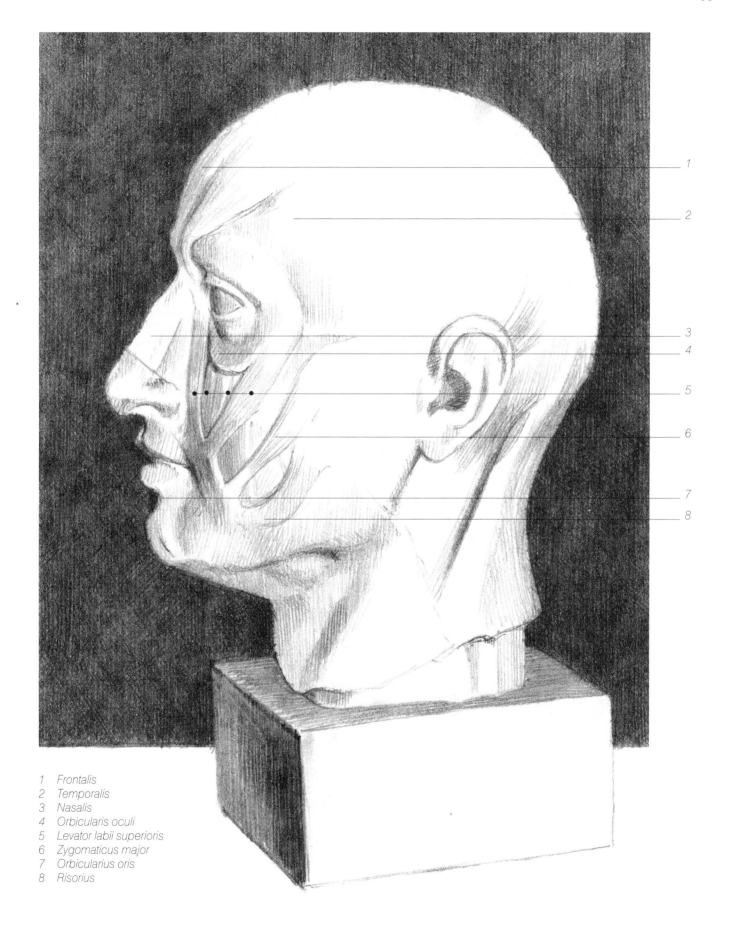

1 Frontalis
2 Temporalis
3 Nasalis
4 Orbicularis oculi
5 Levator labii superioris
6 Zygomaticus major
7 Orbicularius oris
8 Risorius

On the plastic heads the muscles are colored red, making them very realistic. On these models you can distinguish the surface muscles and the layer below and thus gain a better understanding of how they function. These plastic casts are of excellent quality and therefore better than plaster models, which are less exact because they have been copied so often that certain details can be hard to make out.

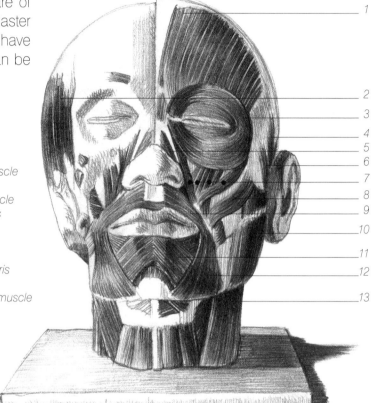

1 Frontalis
2 Temporalis
3 Orbicularis oculi
4 Superior auricular muscle
5 Nasalis
6 Anterior auricular muscle
7 Levator labii superioris
8 Zygomaticus major
9 Orbicularis oris
10 Masseter
11 Depressor labii inferioris
12 Depressor anguli oris
13 Sternocleidomastoid muscle

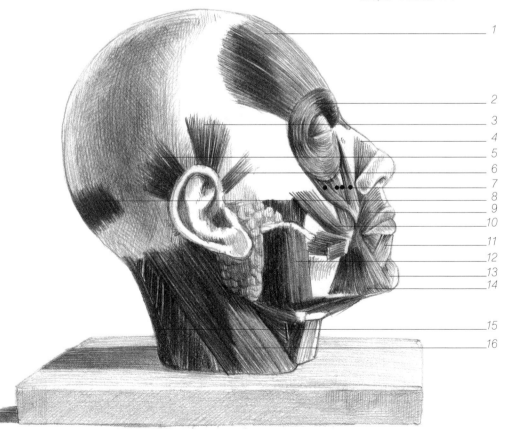

1 Frontalis
2 Orbicularis oculi
3 Superior auricular muscle
4 Compressor naris
5 Posterior auricular muscle
6 Anterior auricular muscle
7 Levator labii superioris
8 Occipitalis
9 Orbicularis oris
10 Zygomaticus major
11 Depressor labii inferioris
12 Masseter
13 Mentalis
14 Depressor anguli oris
15 Trapezius
16 Sternocleidomastoid muscle

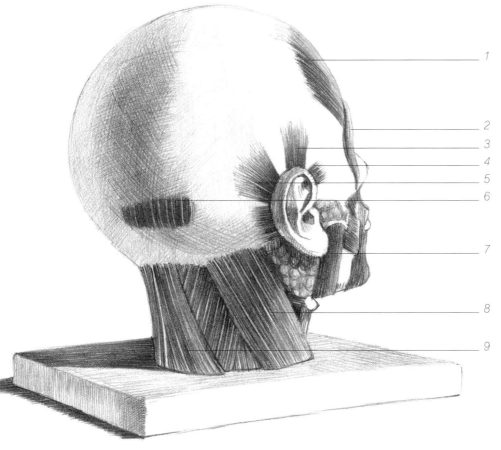

1 Frontalis
2 Orbicularis oculi
3 Superior auricular muscle
4 Anterior auricular muscle
5 Posterior auricular muscle
6 Occipitalis
7 Masseter
8 Sternocleidomastoid muscle
9 Trapezius

1 Frontalis
2 Temporalis
3 Nasalis
4 Depressor labii inferioris
5 Orbicularis oris
6 Risorius
7 Digastric muscle
8 Depressor anguli oris
9 Sternocleidomastoid muscle
10 Splenius
11 Omohyoid muscle

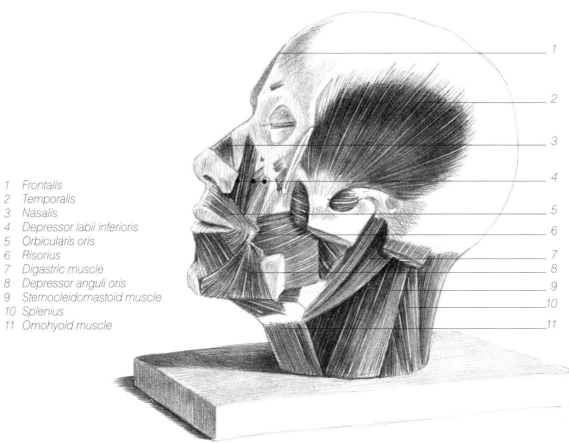

Tricks of Drawing

Chapter 2

In this chapter on the tricks of drawing I will first discuss what you need to know for all drawing, irrespective of the model and the subject. The prerequisite for a really successful piece of work is the composition, which—like a precise drawing—you can only get right if you are able to use the Dürer Grid, grayscale, and the techniques of measurement. The finished drawing must then be fixed and framed so you can enjoy it for a long time. Drawing is a complex procedure, the result of the interaction of eye, brain, and hand. You will make many mistakes at the start, but with plenty of practice you will develop a feeling for proportion. Once you can judge proportions accurately with the naked eye, you will no longer need to measure. But, until that time comes, I would recommend repeating the measurements and also checking the drawings.

There are hard-and-fast rules for measuring that must be obeyed; otherwise mistakes can easily creep in, and it is often only after racking your brains for a while that you realize that the measurements are the cause. Measuring is done with an aid called a measuring stick. This can be a pencil, a paintbrush, a wooden stick, or anything similar.

The measuring process is as follows: Hold the upper end of the measuring stick (pencil) at one end of the object to be measured and your thumbnail at the other end. Transfer the measurement to the clean sheet of paper by marking in a desired length and adding the other measurements in proportion.

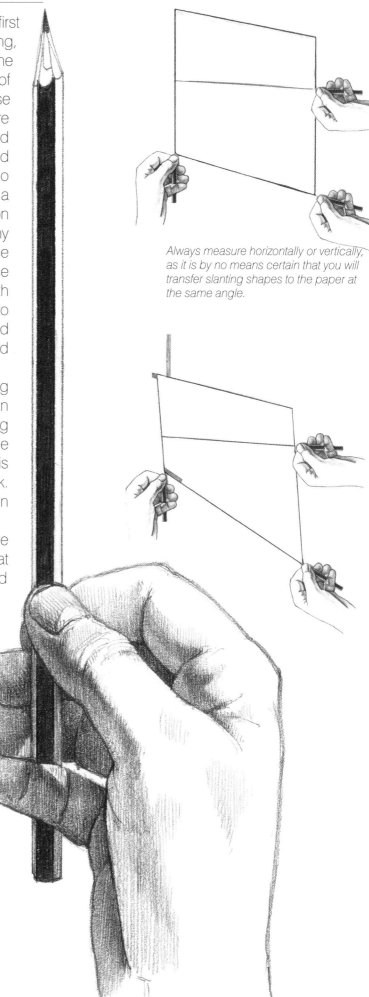

Always measure horizontally or vertically, as it is by no means certain that you will transfer slanting shapes to the paper at the same angle.

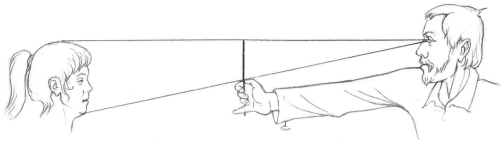

*The arm you are measuring with must be fully
extended, so that the measuring stick is always
at the same distance from your eyes.*

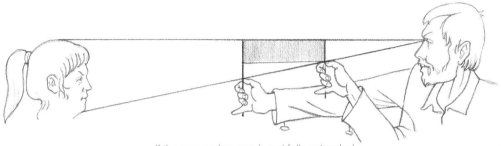

*If the measuring arm is not fully extended,
you will sometimes hold the measuring
stick closer to your eyes and sometimes
farther away, so you will get a different
measurement each time.*

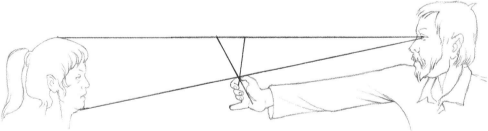

*Mistakes also occur if you do not hold the
measuring stick at a right angle to your arm,
because that will also give you incorrect
measurements.*

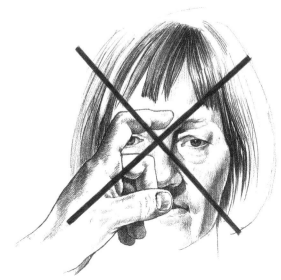

*Do not measure using your thumb
and forefinger!*

Artists have been using the Dürer Grid as an aid for a very long time. For example, Dürer's own works include wood engravings in which the artist is shown drawing a model seated behind a square grid on a sheet of paper that is also divided into squares. Our Dürer Grid (supplied with this book) is a postcard-sized sheet of film with a square grid. If you look at the model and the surrounding space, you can use the horizontal and vertical lines of the grid to help you determine the axes, edges, and contours of the details to be portrayed. Using the Dürer Grid, you can immediately gauge the angle of any deviation from the vertical or horizontal.

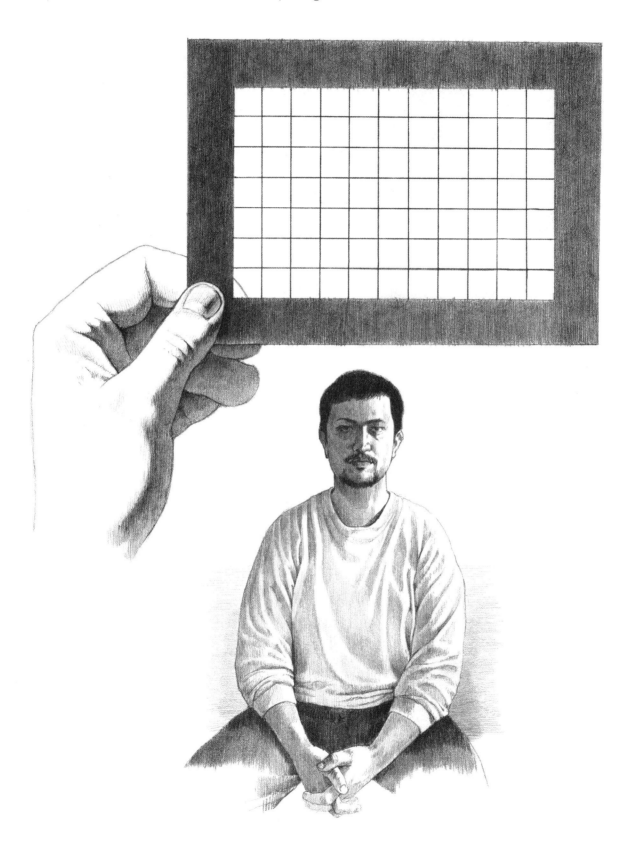

The Dürer Grid is also very helpful in determining the section—the parts of your subject—that you would like to use in your drawing. If you hold the Dürer Grid closer to your eyes, you enlarge the section; if you hold it farther away, you make it smaller. This makes it easier to select the best section of the subject.

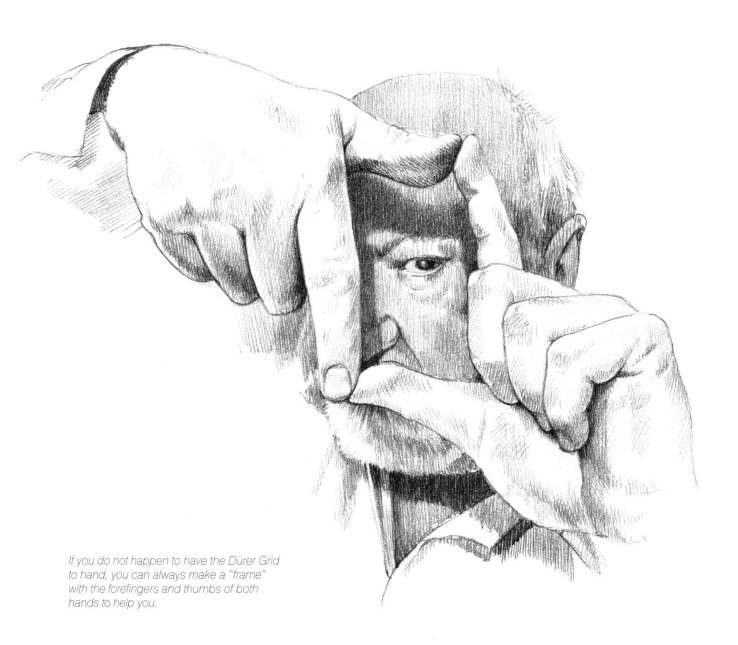

If you do not happen to have the Dürer Grid to hand, you can always make a "frame" with the forefingers and thumbs of both hands to help you.

There are hard-and-fast rules for the composition of the drawing and the positioning of the model on the paper. The Dürer Grid makes composition easier. If you equate the inner edge of the grid with the edges of the drawing paper, it is easier to define the space for the model you are intending to draw. When drawing portraits, the emphasis is, of course, on the face. The ideal size for the head is 8 to 9½ inches (20–24 cm)—assuming the drawing paper is big enough. Positioning the figure on the paper is no easy task. Ideally, the distance of the skull and ears from the edges of the paper will be the same. A distance below the chin of around four to five times as big as the distance above the head is just acceptable. In portrait drawings the whole of the upper body can often be seen and in this case the hands will also play an important part in the composition. In the first example showing poor composition, the head is positioned too far to the left, creating a large, unused space on the right; in the second, the head is not in the middle. It is equally unattractive if the face takes up a disproportionate amount of space and cause the skull to "bump into" the top. Choosing a horizontal format for a portrait poses a particular problem, as it is very

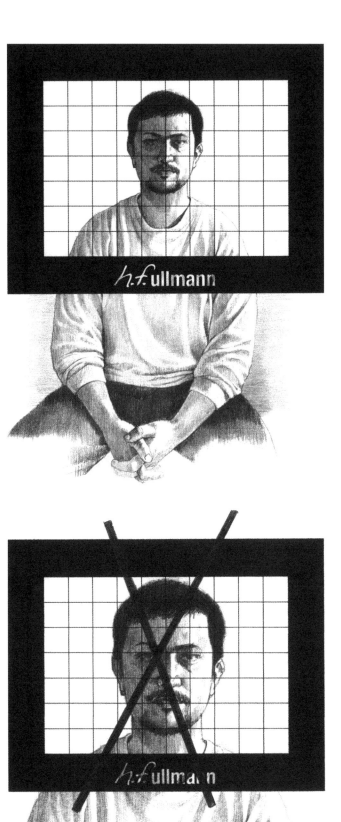

irritating to see big empty spaces beside the face. It gives the impression that nothing is happening there, while you feel there is something lacking in the face because you would like to see more of it. You should choose this format only if a balance can be attained by means of the "mass" of the shoulders.

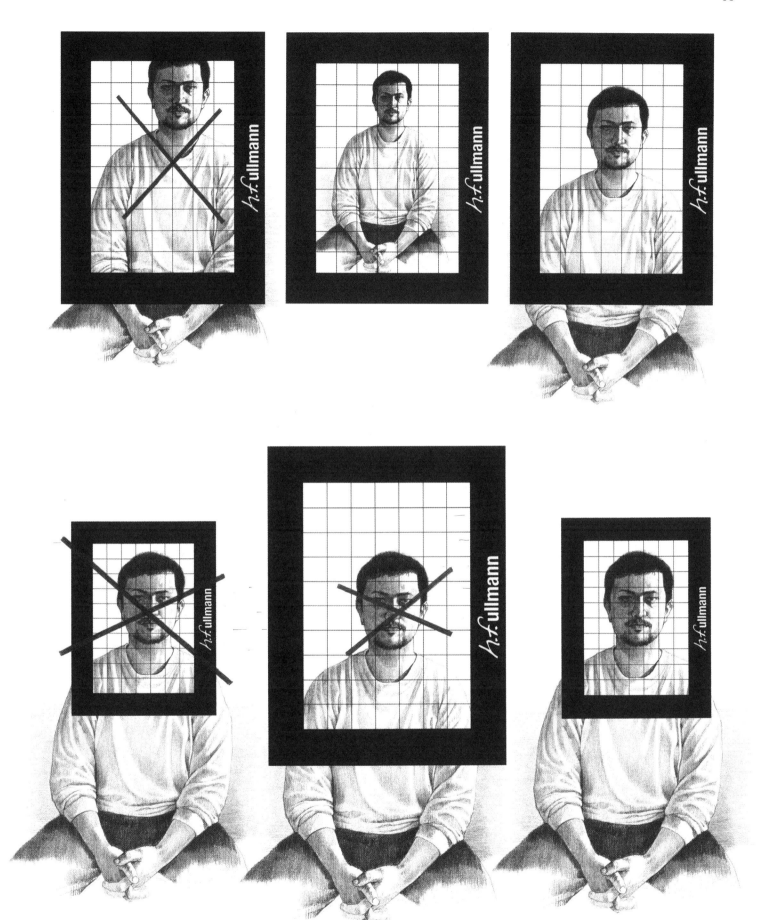

One important rule is that the figure in the drawing should be moved the opposite way from the direction in which the model is looking. In this way, you suggest that there is something that has caught the model's attention. Some correct and incorrect solutions are shown on these two pages.

If you are sitting directly opposite the model, the figure should be positioned right in the middle of the paper, with less empty space above the head and more beneath the chin.

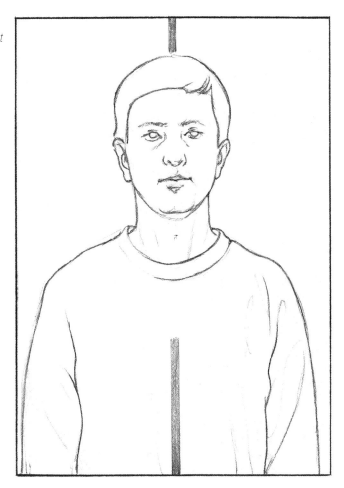

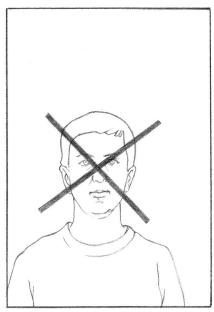

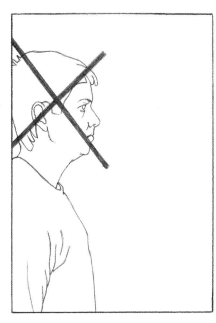

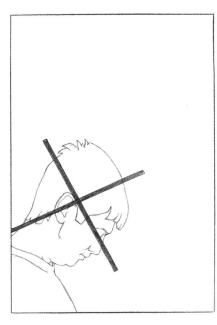

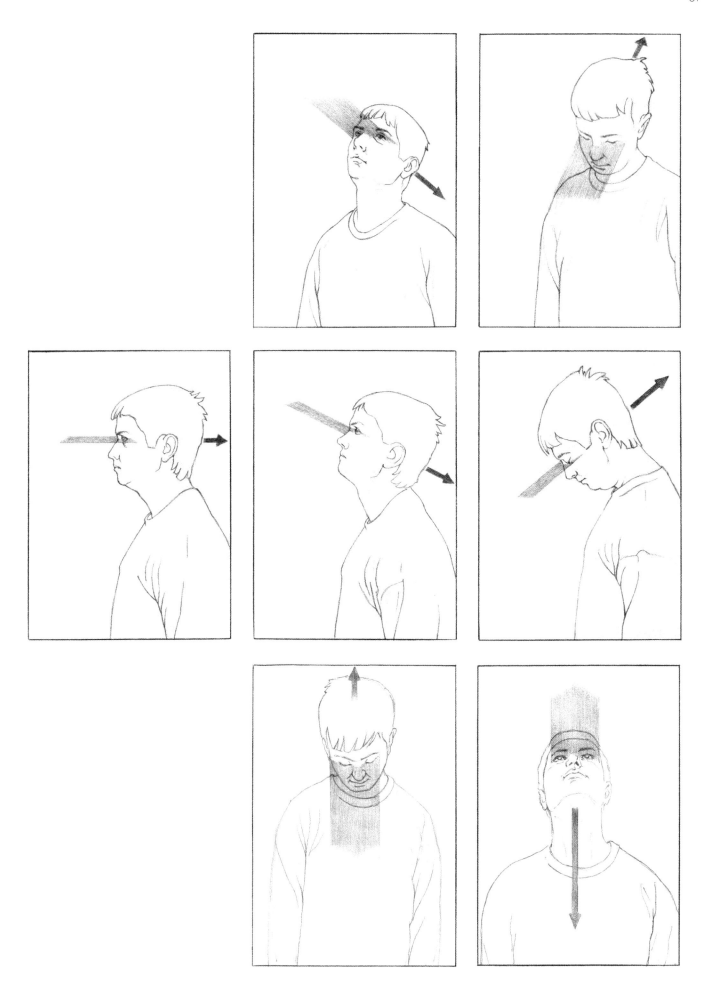

In drawing, lighter and darker tones are used to reproduce reality. When you have only just taken up drawing, it is not easy to distinguish differences in tonal values that are often very small. The way the drawing is shaded makes it "harmonious"— that is, the tonal values are graduated in relation to the darkest value. Everybody has the ability to do this, and in time you will be able to make out the differences in tonal values with increasing accuracy. However, differentiating the shades of gray is difficult to begin with, so I recommend my pupils to screw up their eyes when looking at the model. That compresses what you see and makes it easier to distinguish the different zones.

To practice identifying the tones, I recommend that you use the grayscale that comes with this book. Its 11 fields show the gradations of gray from white to black. The grayscale is simple to use. Hold it against the model, make a mental note of the tonal value of each area, and then check the value on the drawing.

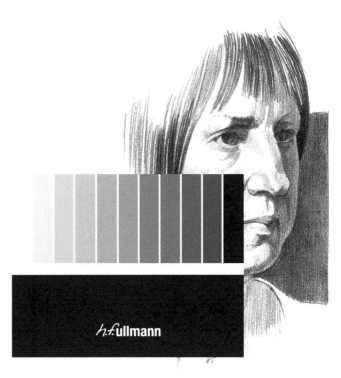

Identifying the dark tone of the hair

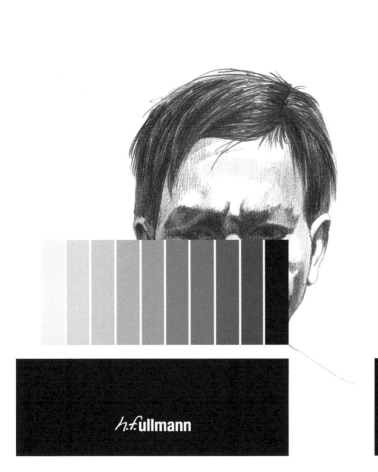

Determining the gray tone around the eyes. Screw up your eyes to pick out the correct tone.

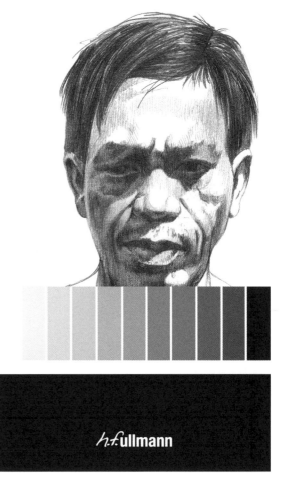

This is how you check the shading of the parts of the head that are in shadow.

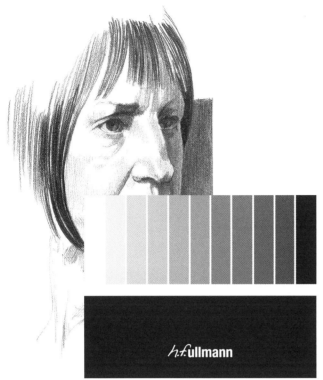

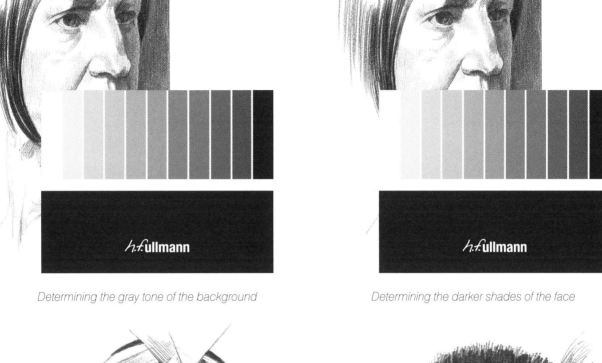

Determining the gray tone of the background

Determining the darker shades of the face

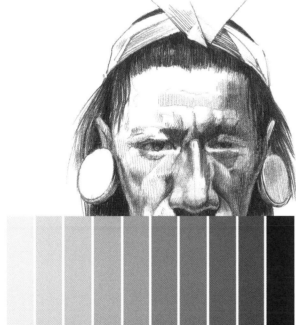

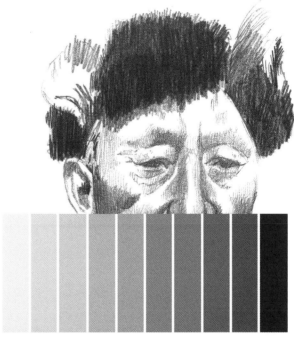

Here the gray tone of the cast shadow under the nose is to be determined.

Compare the different tones of the face.

The convex eyeballs are located to the right and left of the line bisecting the head. The white of the eye surrounds the colored part, or iris, and the round, black pupils, whose diameter varies depending on the light conditions.

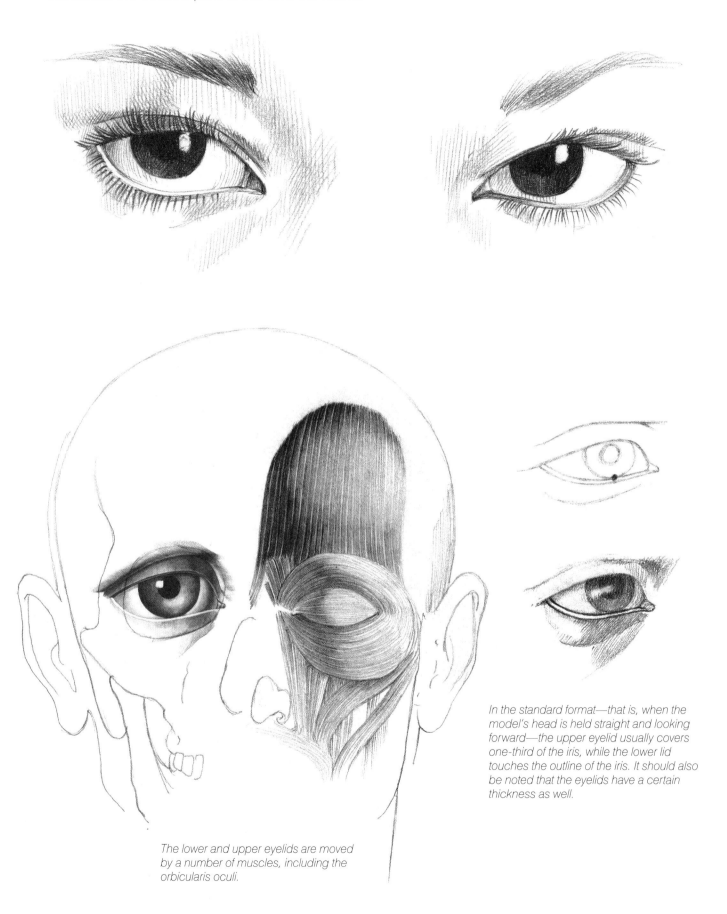

The lower and upper eyelids are moved by a number of muscles, including the orbicularis oculi.

In the standard format—that is, when the model's head is held straight and looking forward—the upper eyelid usually covers one-third of the iris, while the lower lid touches the outline of the iris. It should also be noted that the eyelids have a certain thickness as well.

I explained which measurements you should use to determine the position of the eyes in the drawing on pages 22 and 23, but there are a few more rules you should know before starting work.

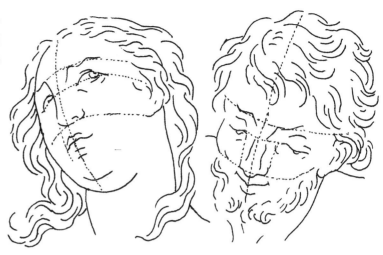

Back in the 17th century, Johann Daniel Preissler taught his pupils the following important rule: If you divide the distance between the eyebrow axis and the nose axis into three equal parts, the eye axis that determines the position of the eyes will be the dividing line for the first third. (András Szunyoghy after Johann Daniel Preissler)

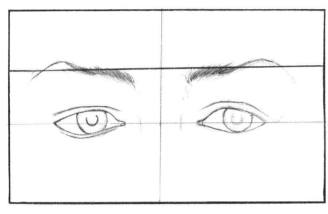

You always begin by determining the direction of the main axis, because the eye axis, which determines the position of the eyes, is always perpendicular to it.

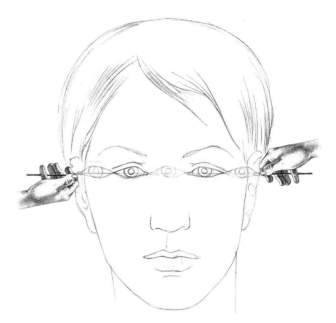

If you are drawing the model from directly in front, the general rule is that the width of one eye is about one-fifth of the width of the entire face and the distance between the eyes is about the size of one eye.

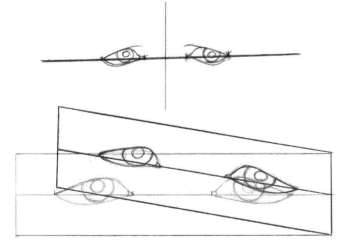

If the head is turned, the rules of perspective will apply. Of the three measurements (which in reality are of equal size), the eye that is closer to the artist will be the largest, the distance between the eyes slightly smaller, and the eye that is farthest away will be smallest. If you keep the three measurements the same, the drawing will go wrong!

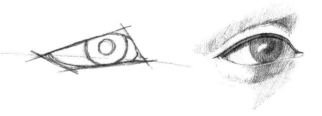

When you come across a new shape, it is helpful to compare it with a familiar geometrical shape. The outside of the eye is shaped like a rhombus. When drawing the upper eyelid, begin at the inner corner of the eye with a steep, upward line and then draw a line sloping gently downward. For the shallower curve of the lower lid, start from the outer corner of the eye with a steeply falling line, followed by a gently rising line.

Depicting the eyes is no easy task. Here are a
few typical common mistakes.

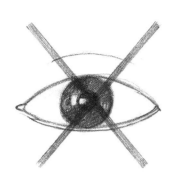

*My pupils often draw "plum-stone eyes,"
with the curves of the upper and lower eyelid
symmetrical.*

*Note that, in reality, the eyelids cover
different amounts of the iris and that the
whole of the iris is not visible.*

*The commonest problem with drawings in
profile is that the white of the eye is too big.
Imagine how disproportionately long this eye
would be if viewed from in front!*

*Pay attention to the distance between the
eyes and the eyebrows as well. These
features are often drawn too close together.*

*The position of the eyes is also wrong when
the distance between the lachrymal sac and
the side of the nose is too great. In addition,
the white of the eye should not remain white if
you are using dark shading.*

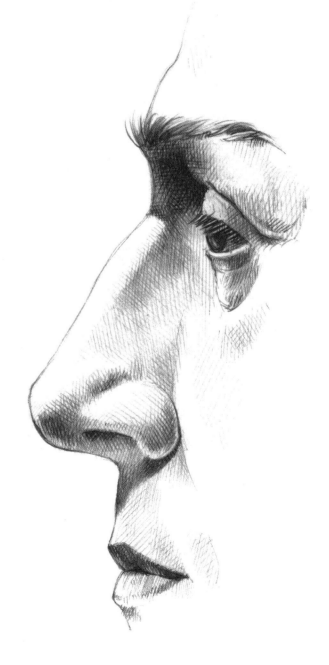

The eyes are among the most interesting parts of any face. They give away a lot of things about people: their gender, their age, often their ethnicity, and not least how they are feeling. In a good drawing you can reproduce an impressive variety of feelings: interest, boredom, joy and sorrow, anger, fear, despair, and many more.

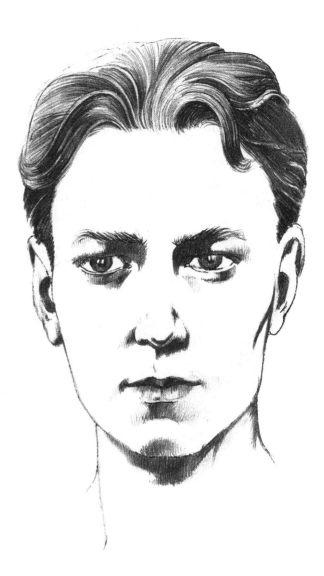

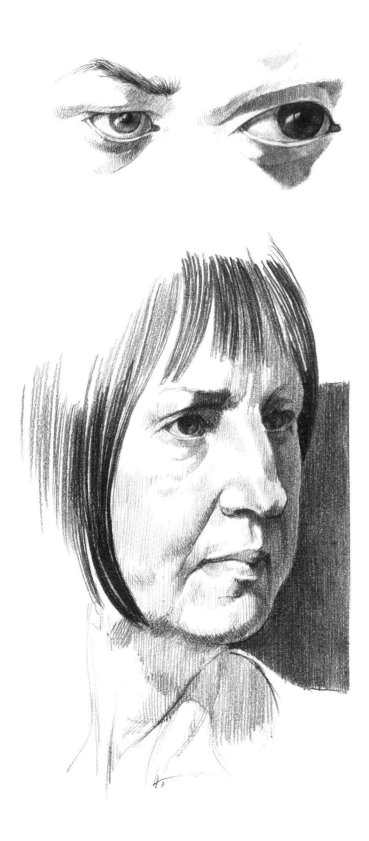

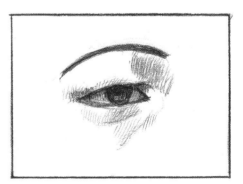

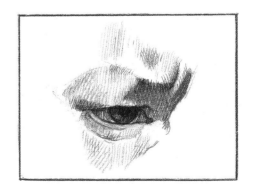

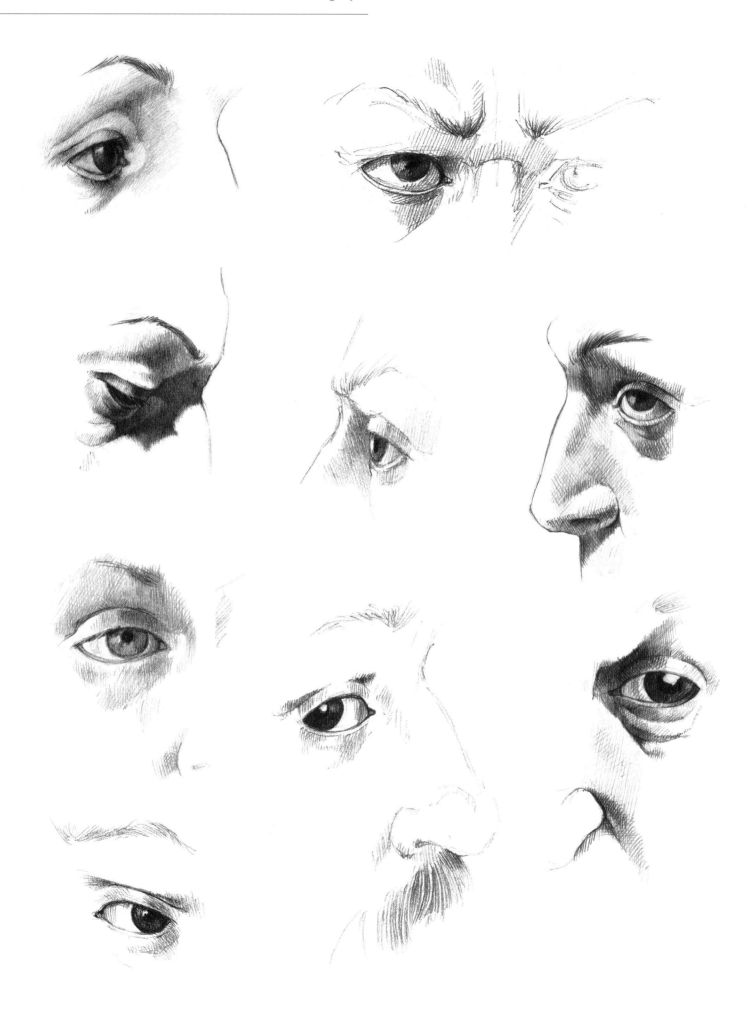

The lifelike depiction of the eyelids also requires a certain amount of practice and a lot of attention. For example, the closed eyes of the sleeper are quite different from eyes that are screwed up (against light, for example). When shading, you must consider the fact that the eyelids cover a spherical eyeball, which must be shown in the drawing—as must the thickness of the eyelids. Notice how the curve of the eyelids changes with different attitudes of the head.

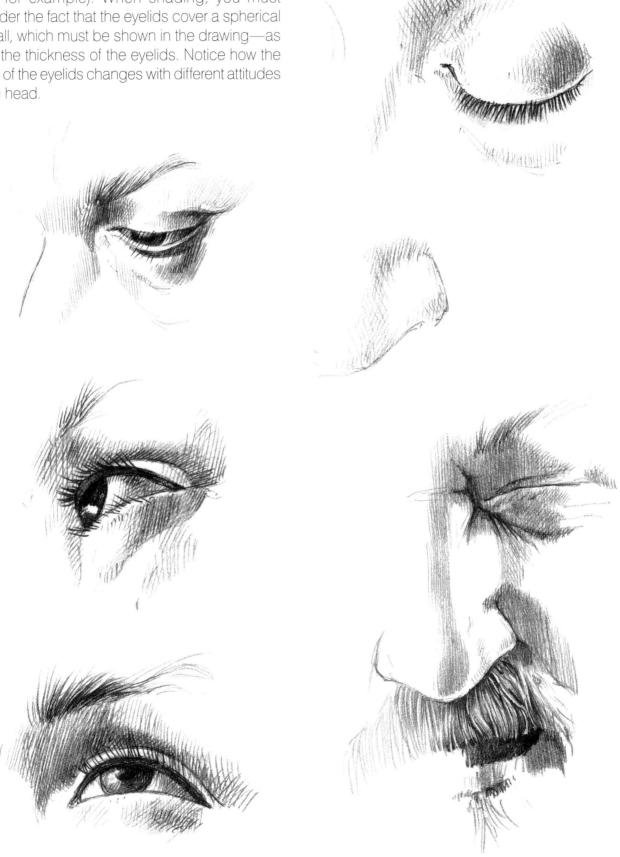

As previously mentioned, certain parts of the face show the ethnic type to which a person belongs. The eyes express this particularly powerfully in Central and Eastern Asians. Apart from the flat face, straight black hair, and sparse facial hair, one of the characteristic features is the epicanthic fold above the eyes, covering the upper eyelid and the inner corner of the eye.

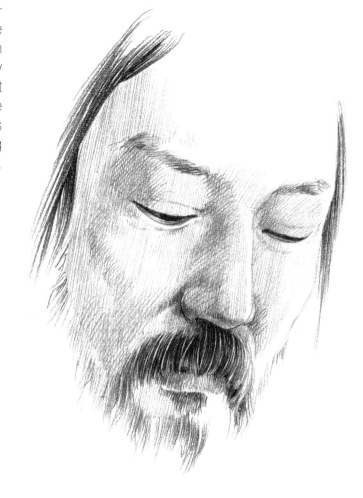

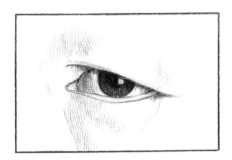

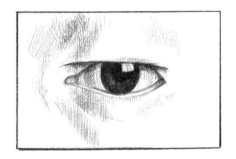

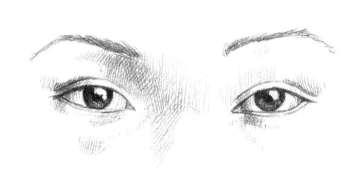

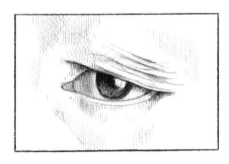

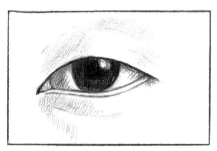

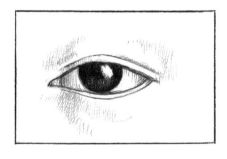

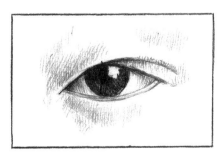

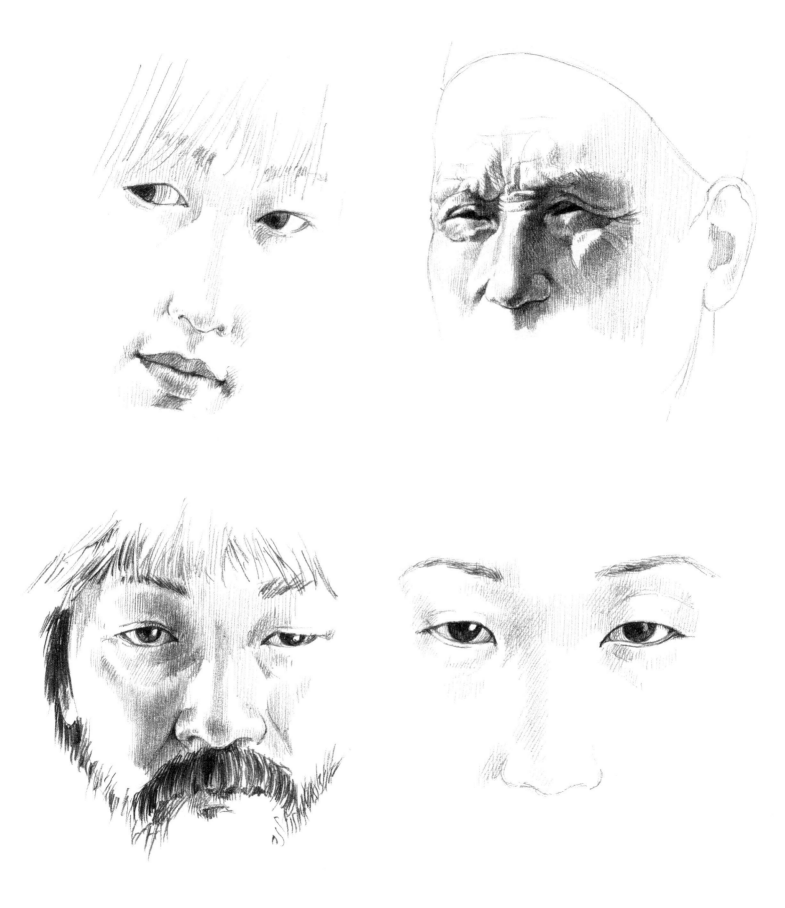

The eyebrow axis is an important element of the three sections of the face. Because it is absolutely necessary to know the rules concerning the eyebrow axis in order to draw the eyes, nose, and ears, you should quickly revise them now. You should also note that the eyebrows are not located on the rim of the eye socket but above it.

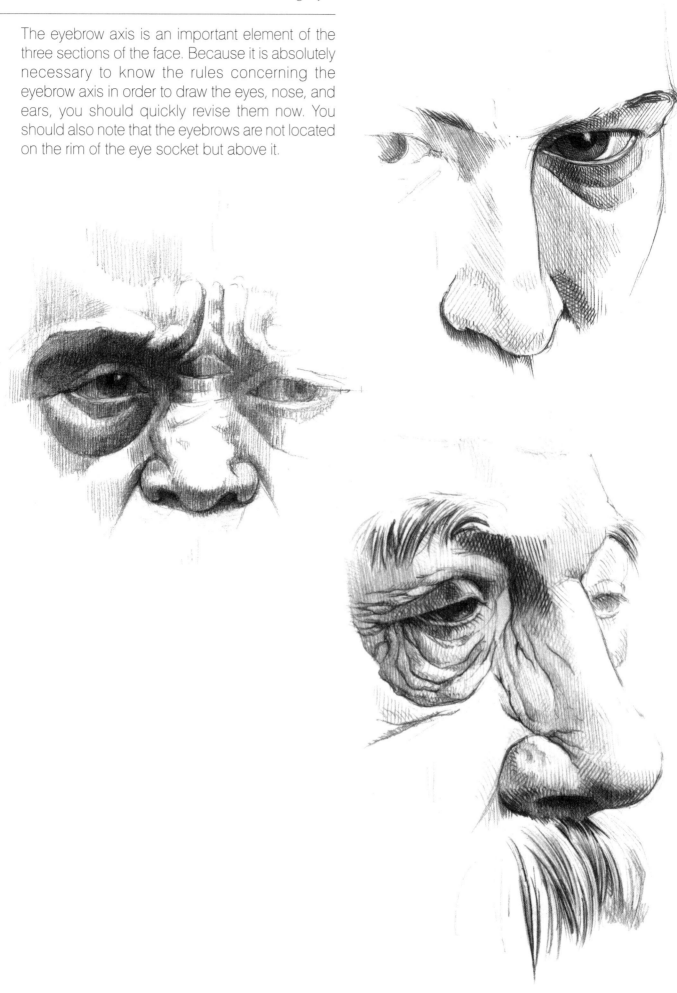

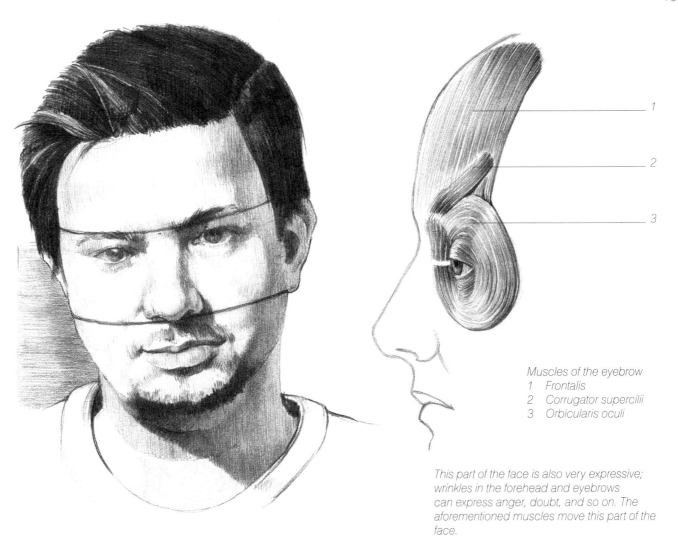

Muscles of the eyebrow
1 Frontalis
2 Corrugator supercilii
3 Orbicularis oculi

This part of the face is also very expressive; wrinkles in the forehead and eyebrows can express anger, doubt, and so on. The aforementioned muscles move this part of the face.

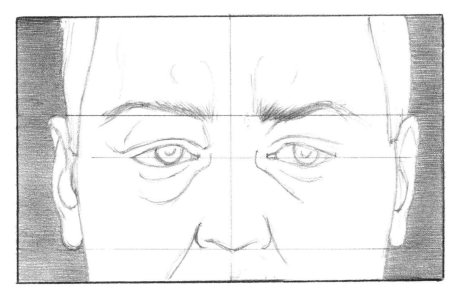

The eyebrow axis runs perpendicular to the main axis and parallel to the transverse axes.

The nose is the most protuberant part of the face and crucial for its character. It is located in the middle of the face and is bisected by the main axis (see page 28–29). It consists largely of cartilage, which gives it its shape.

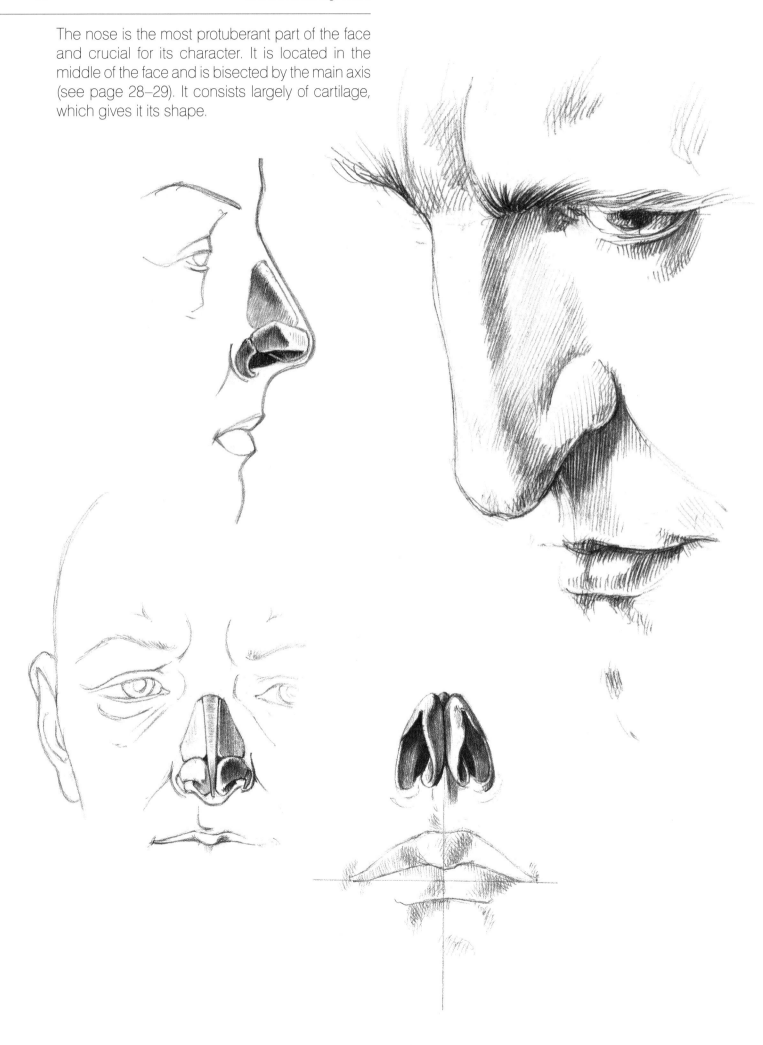

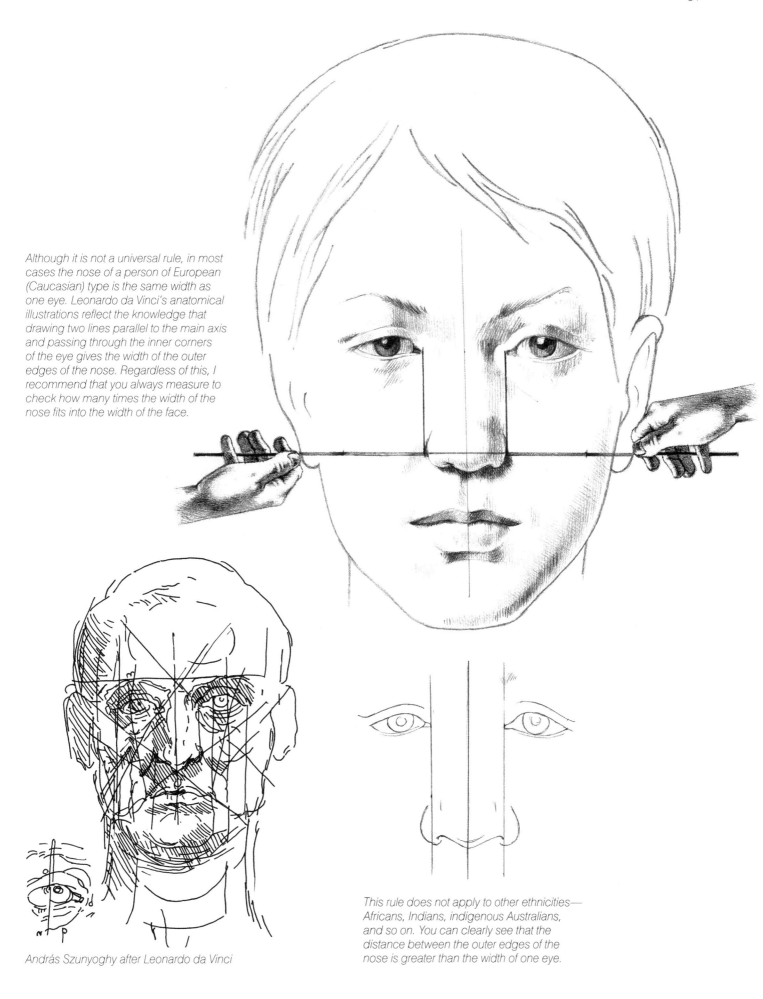

Although it is not a universal rule, in most cases the nose of a person of European (Caucasian) type is the same width as one eye. Leonardo da Vinci's anatomical illustrations reflect the knowledge that drawing two lines parallel to the main axis and passing through the inner corners of the eye gives the width of the outer edges of the nose. Regardless of this, I recommend that you always measure to check how many times the width of the nose fits into the width of the face.

András Szunyoghy after Leonardo da Vinci

This rule does not apply to other ethnicities— Africans, Indians, indigenous Australians, and so on. You can clearly see that the distance between the outer edges of the nose is greater than the width of one eye.

There are also typical mistakes that most beginners make when drawing noses.

The shape of the nose is very individual; it must be studied carefully if you wish to draw it successfully. You can expect to produce a number of drawings that you are not satisfied with. All I can say is, do not give up and keep trying to reproduce the characteristic features. Representing the nose as just two nostrils, as children do, is not an option! Do not be satisfied with this; practice, and you will get it right!

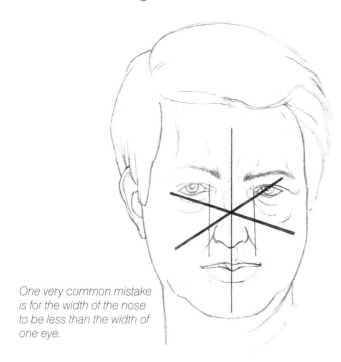

One very common mistake is for the width of the nose to be less than the width of one eye.

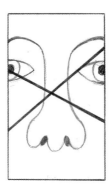

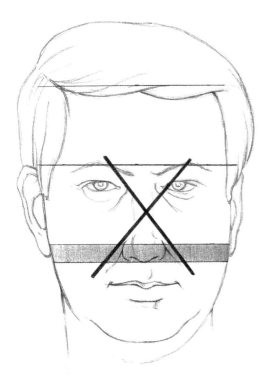

In my pupils' drawings I also often have to correct the relationship between the three sections, because the middle section has ended up bigger, although it should be exactly the same size as the other two. This is probably the result of concentrating particularly on this area when drawing, because it contains important elements such as the eyes and nose. It is best to mark in the sections when you first start work.

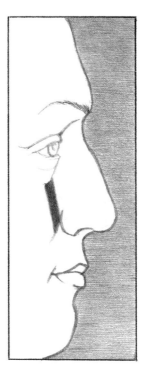

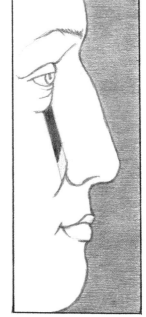

The distance between the lower edge of the lachrymal sac and the furrow beside the nose often becomes greater than it really is. You should always check this by measuring.

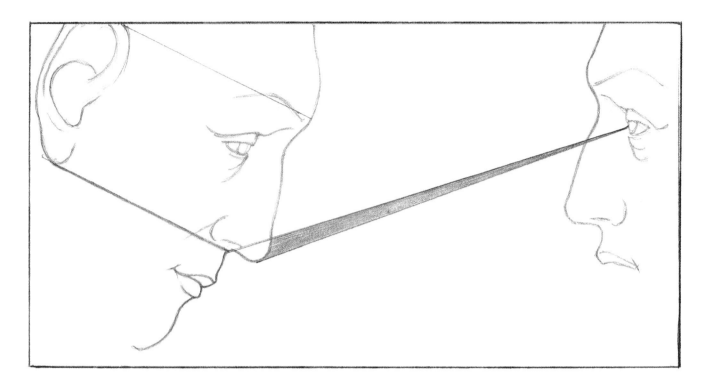

If the model's head is inclined forward, the tip of the nose covers the nose axis. People often make the mistake of aligning the tip of the nose with the nose axis. As a result, the nose becomes too short and the distance between the lachrymal sac and the furrow beside the nose becomes too small.

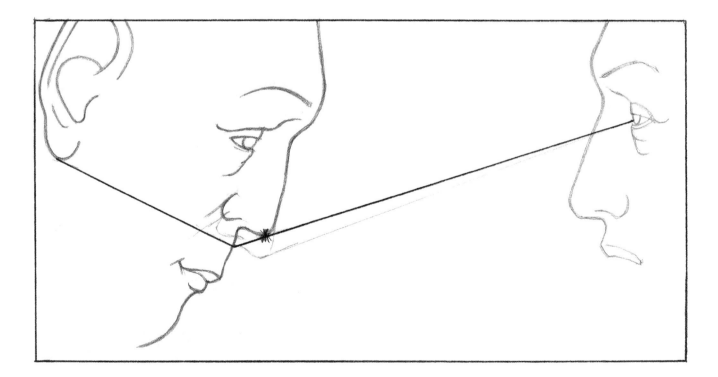

Studies of noses

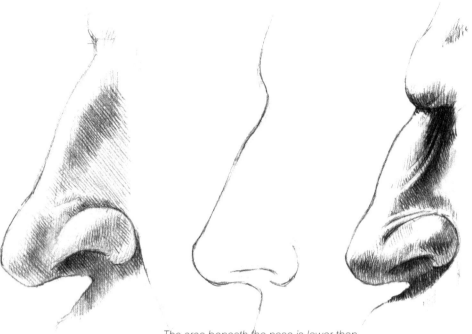

The area beneath the nose is lower than the lowest part of the outer edges of the nose.

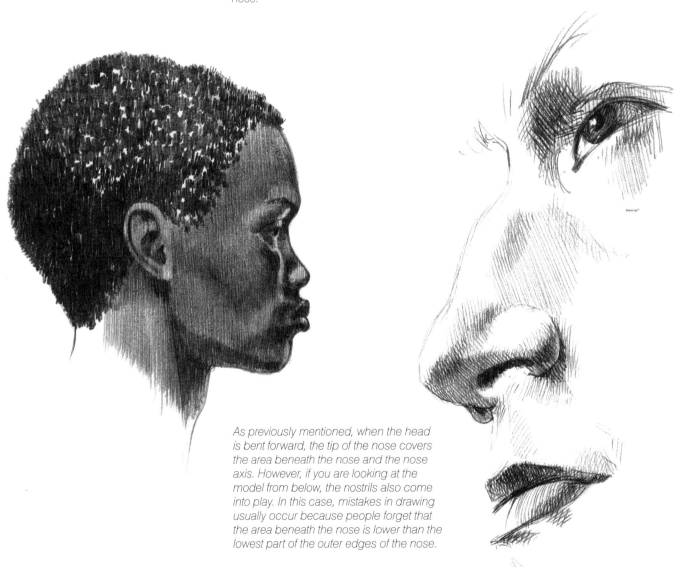

As previously mentioned, when the head is bent forward, the tip of the nose covers the area beneath the nose and the nose axis. However, if you are looking at the model from below, the nostrils also come into play. In this case, mistakes in drawing usually occur because people forget that the area beneath the nose is lower than the lowest part of the outer edges of the nose.

The human nose can vary widely in shape, and the shape can often help you to recognize which ethnic type the person belongs to. Whatever the case, when shading you must note that the planes of the bridge of the nose must be emphasized and distinguished from the surfaces of the sides by gradations of shading. The curved surfaces of the fleshy outer edges of the nose are also represented by different tonal values. Apart from a few unusual faces, or in certain lighting conditions, the lowest part of the nose will be darker because of the form shadow, and the same will also be true of the nostrils.

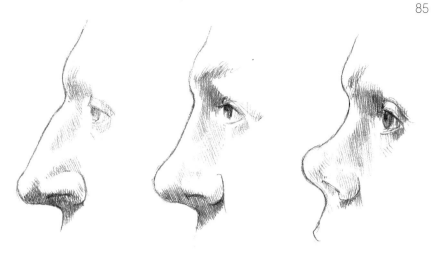

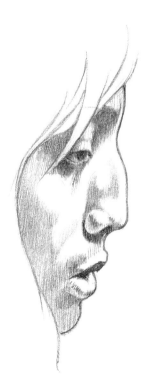
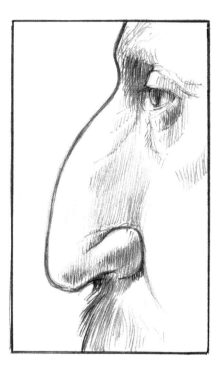
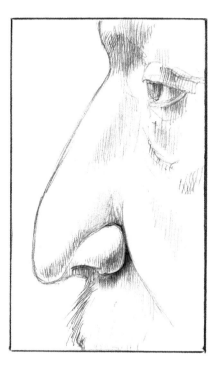
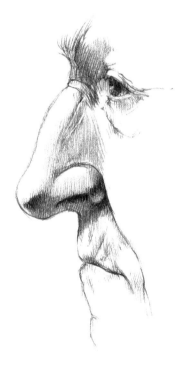

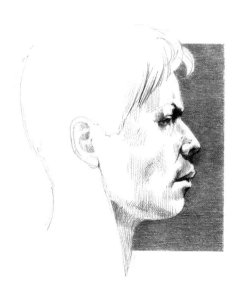
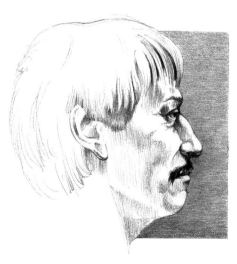
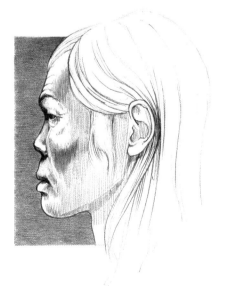

The nose is in the middle of the face, and that is probably why some traditional peoples wear nose ornaments—a kind of badge by which they can be identified. Such ornaments are made from a wide variety of materials: metal plates, feathers, animal teeth, bones, or simply a thin stick.

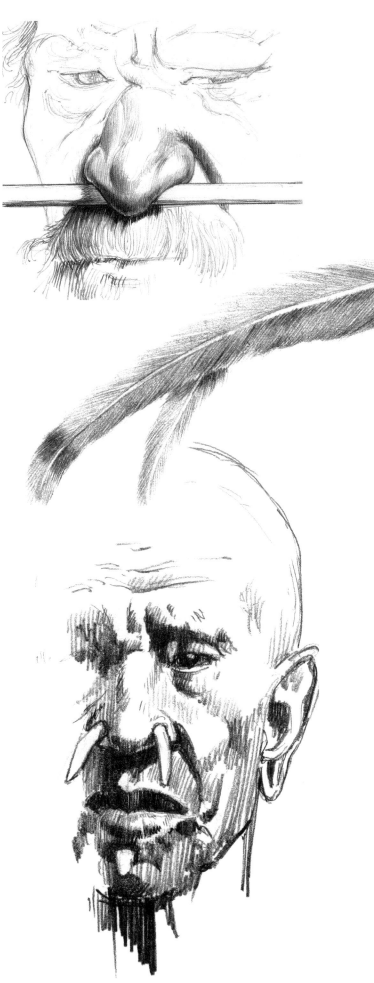

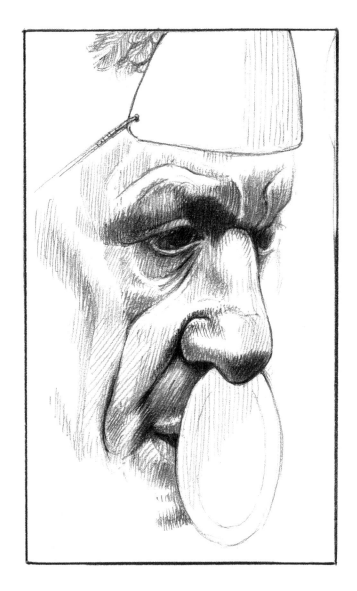

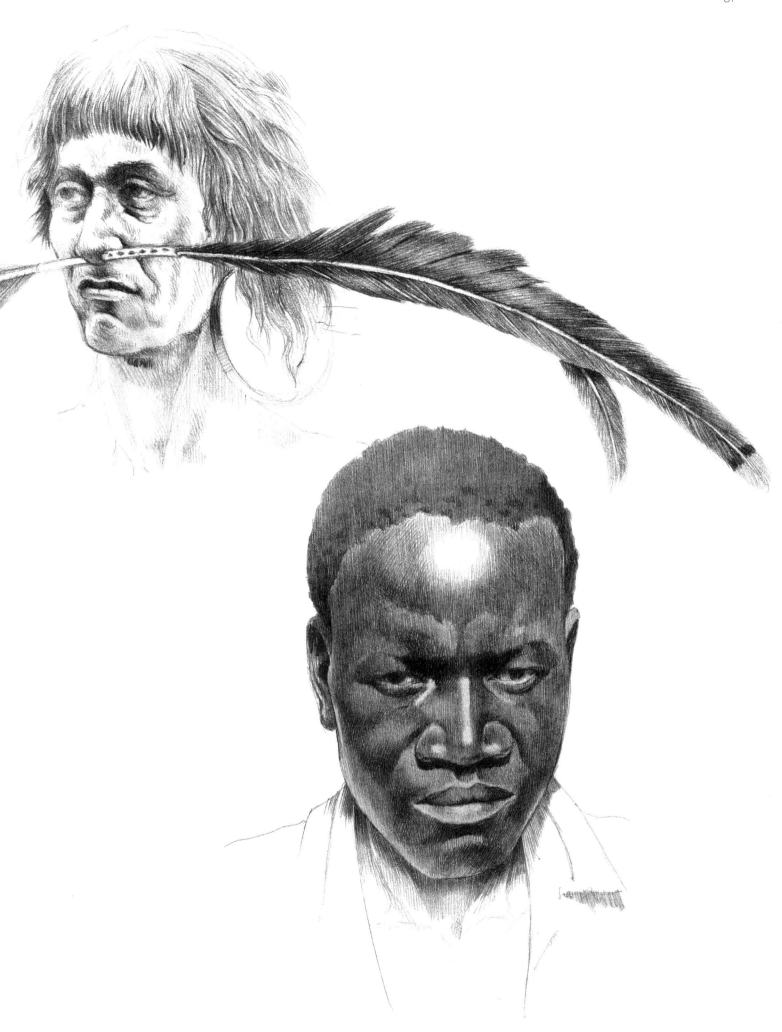

The ear is the organ of hearing and balance. Its
external part is the pinna, and the shape of this is
determined by the cartilage of which it is formed. It
collects the sound waves and conducts them into
the tympanic cavity. It is attached to the skull and
the external part of the auditory canal by ligaments
and muscles.

1 Helix
2 Darwin's tubercle
3 Fossa triangularis
4 Conchal cavity
5 Crus helicis
6 Antihelix
7 Tragus
8 Antitragus
9 Intertragic notch
10 Auditory canal
11 Earlobe

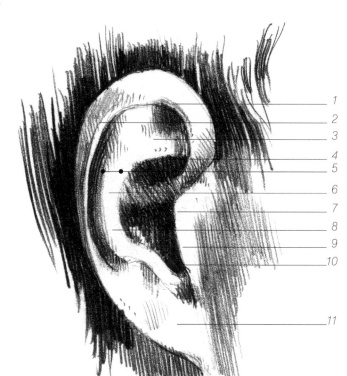

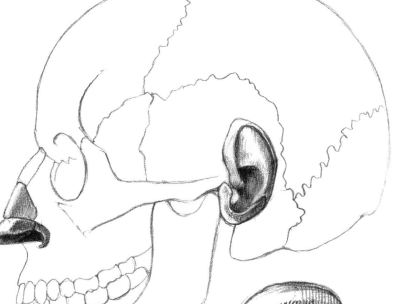

1 Helix
2 Crus helicis
3 Fossa triangularis
4 Antihelix
5 Spina helicis
6 Conchal cavity
7 Cartilage of the external
 auditory canal
8 Crus helicis

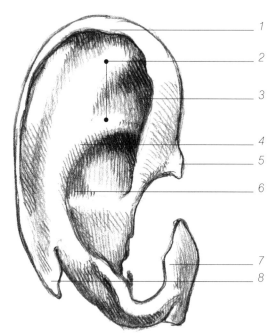

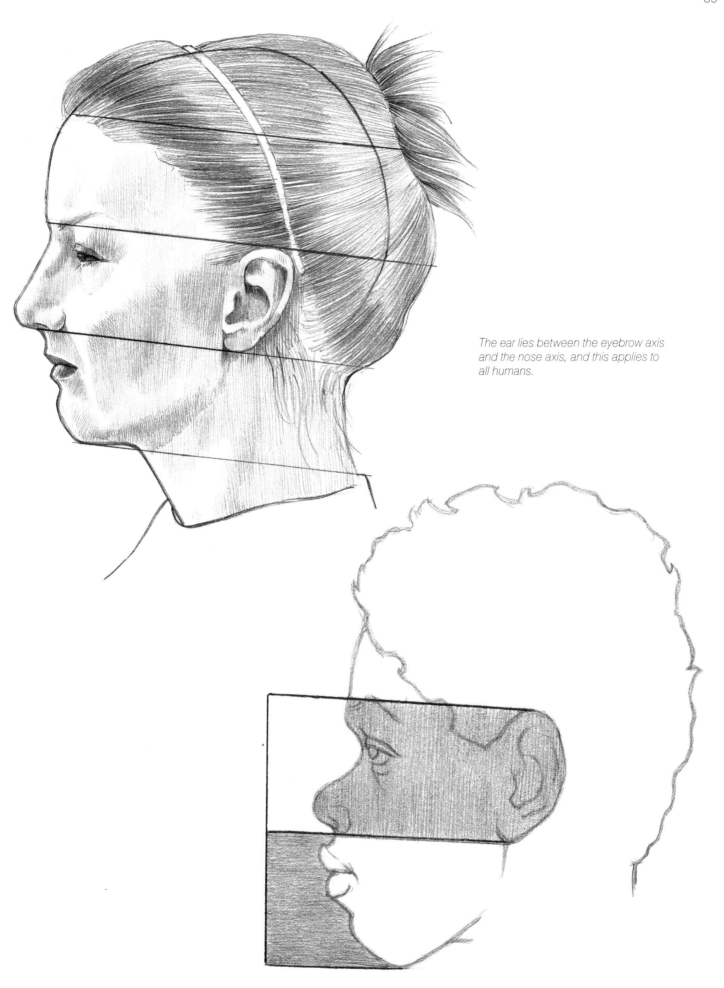

The ear lies between the eyebrow axis and the nose axis, and this applies to all humans.

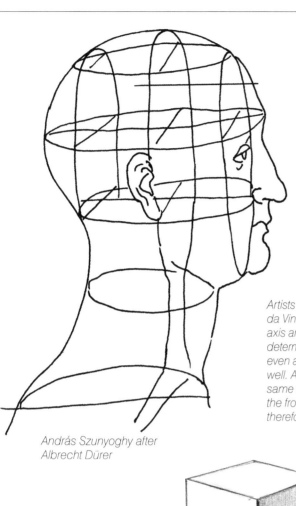

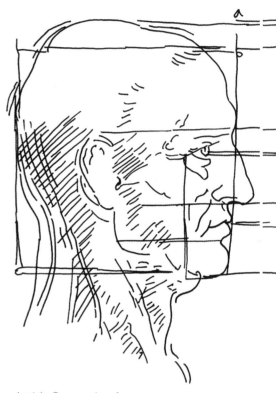

Artists as long ago as Dürer and Leonardo
da Vinci were already using the nose
axis and the eyebrow axis to help them
determine the position of the ears. Dürer
even applied the rules of perspective as
well. Although the ears and nose are the
same size, if you look at the model from
the front, the ears are farther away and
therefore appear smaller.

*András Szunyoghy after
Leonardo da Vinci*

*András Szunyoghy after
Albrecht Dürer*

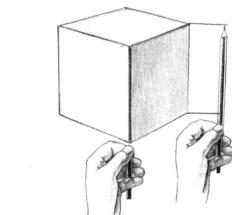

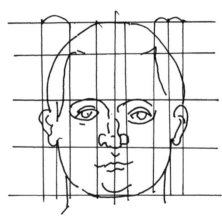

*András Szunyoghy after
Albrecht Dürer*

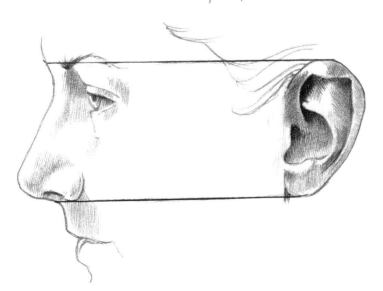

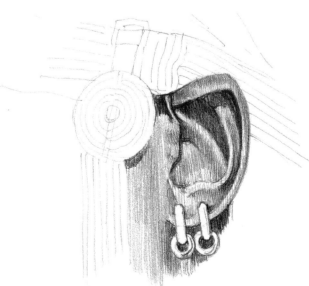

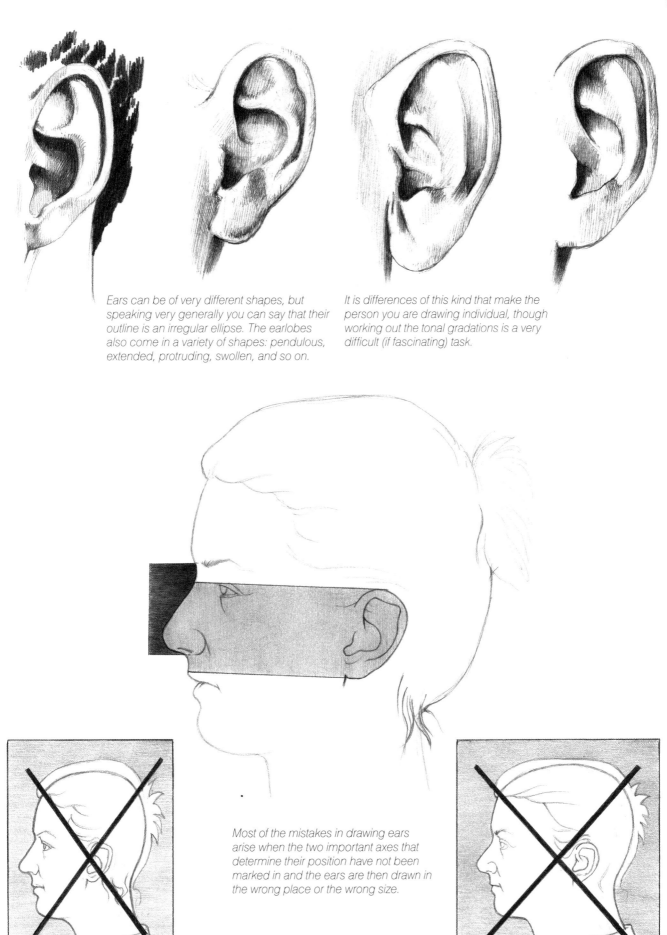

Ears can be of very different shapes, but speaking very generally you can say that their outline is an irregular ellipse. The earlobes also come in a variety of shapes: pendulous, extended, protruding, swollen, and so on.

It is differences of this kind that make the person you are drawing individual, though working out the tonal gradations is a very difficult (if fascinating) task.

Most of the mistakes in drawing ears arise when the two important axes that determine their position have not been marked in and the ears are then drawn in the wrong place or the wrong size.

Just as with the nose, many ethnic groups wear
ornaments in their ears.

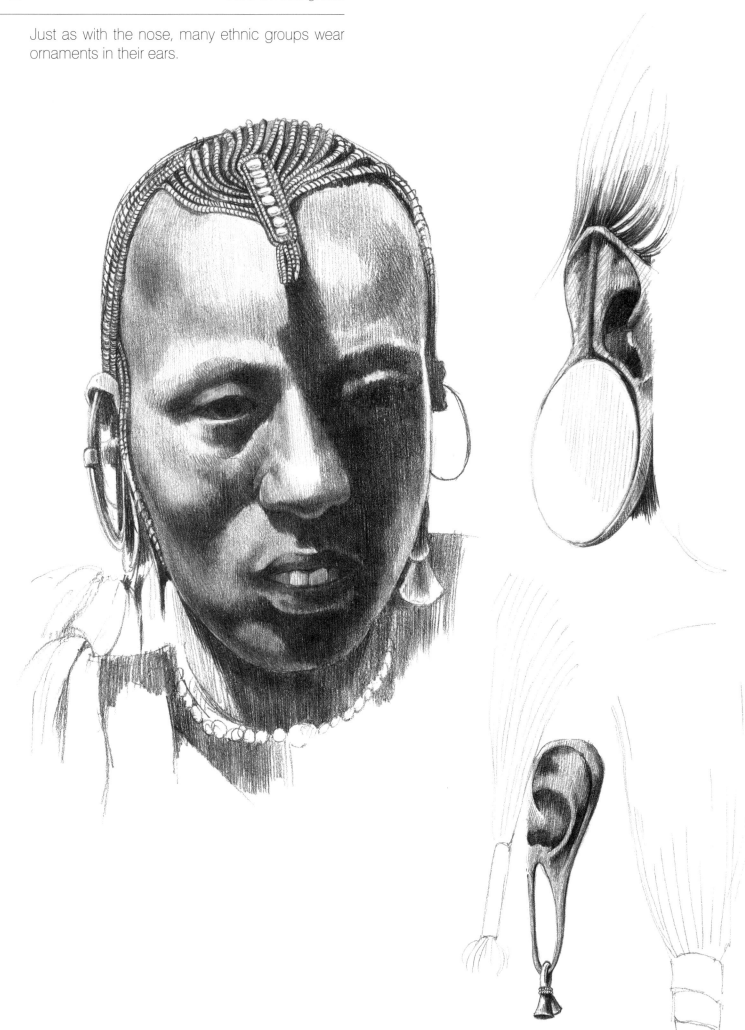

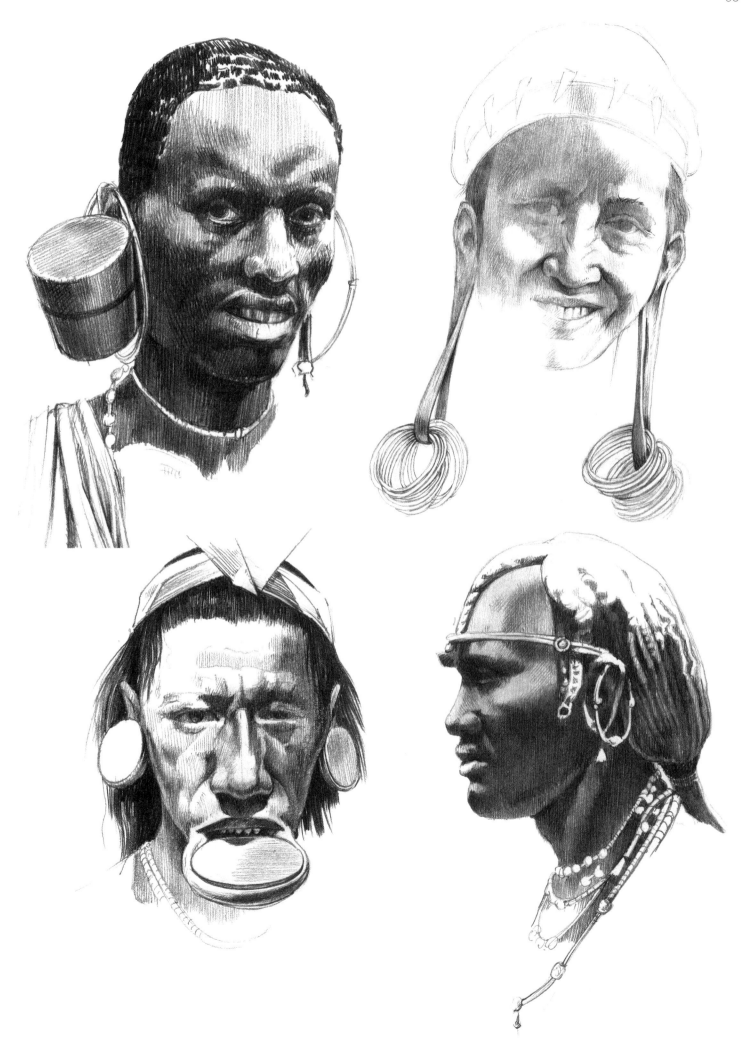

The mouth is used for taking in food and for speech. The ring of muscle around it is mainly responsible for its movements. There is a characteristic little groove running between the septum and the mouth.

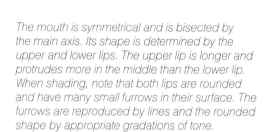

The mouth is symmetrical and is bisected by the main axis. Its shape is determined by the upper and lower lips. The upper lip is longer and protrudes more in the middle than the lower lip. When shading, note that both lips are rounded and have many small furrows in their surface. The furrows are reproduced by lines and the rounded shape by appropriate gradations of tone.

Piero della Francesca (c.1420–1492) was the first artist to determine the position of the mouth. On his schematic drawing you can see that, if you divide the distance between the tip of the chin and the tip of the nose into three equal parts, the axis nearest to the nose axis runs through the mouth. This measurement rule applies to all ethnic groups and is still used in drawing today.

András Szunyoghy after Piero della Francesca

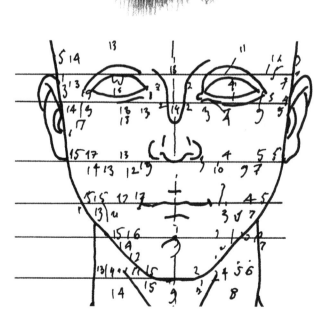

The size and thickness of the mouth varies enormously. For example, the mouth of this man is particularly thick and wide in relation to the other parts of the face. As there are no general rules for this, you cannot do without measurements when drawing the mouth!

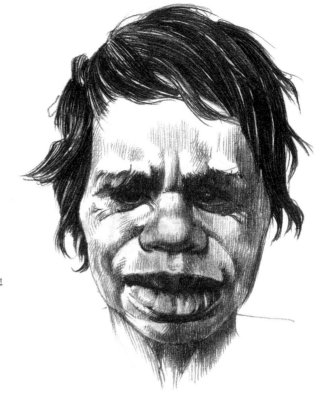

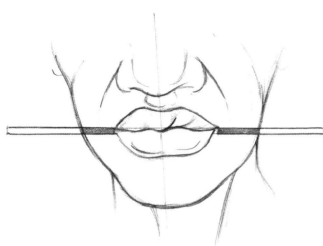

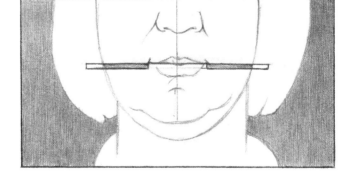

I would recommend that you always mark in the main axis first and then measure how many times the width of the mouth fits into the overall width of the face. In that way, you will avoid the most common mistakes: asymmetry and incorrect dimensions.

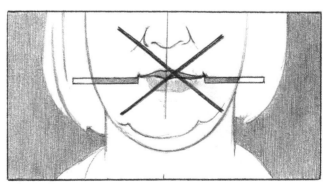

One common mistake is that the transverse axes are not parallel to one another, as a result of which the position of the mouth in the drawing does not correspond to the reality.

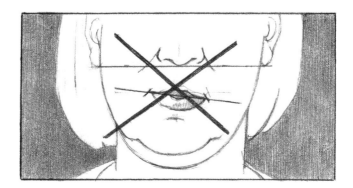

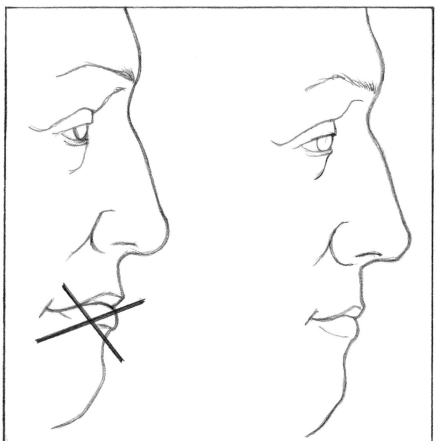

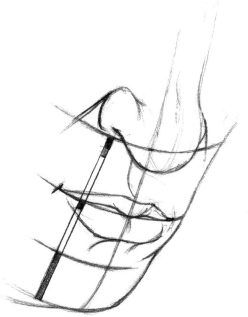

When drawing the profile you must take care that, as with the eyes, the mouth does not become too wide. Imagine how wide it would be if you were looking at the model from in front. Measuring to check will help here, too.

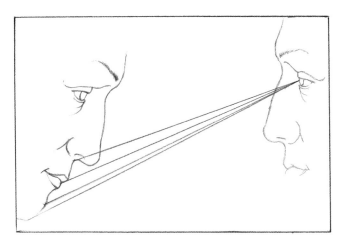

The rules of perspective must also be followed when drawing the mouth. The measurements of the aforementioned three sections between the nose axis and the tip of the chin will be different when you are not looking at the model from directly in front. If the head is bowed, the part between the axes of the nose and mouth is closest to the viewer and will therefore appear biggest, while the other two will become gradually smaller. If the model is looking up, it is the other way round: The chin will appear biggest. The main axis divides the mouth into two equal parts, but when the head is turned to the side, the half that is closer to the viewer will always appear bigger.

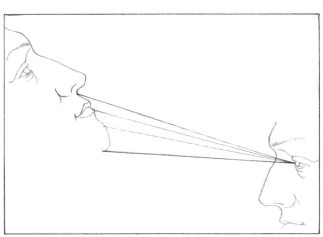

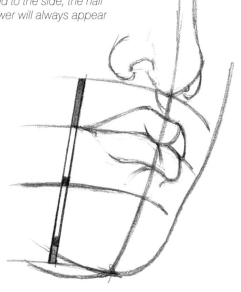

Thick lips are a particular feature of black people, whose lips are usually much fuller and broader than those of Caucasians. Viewed from in front, they usually dominate the face, but in profile the rule still applies that the mouth axis is the first axis below the nose, if you divide the distance between the nose axis and the tip of the chin into three sections.

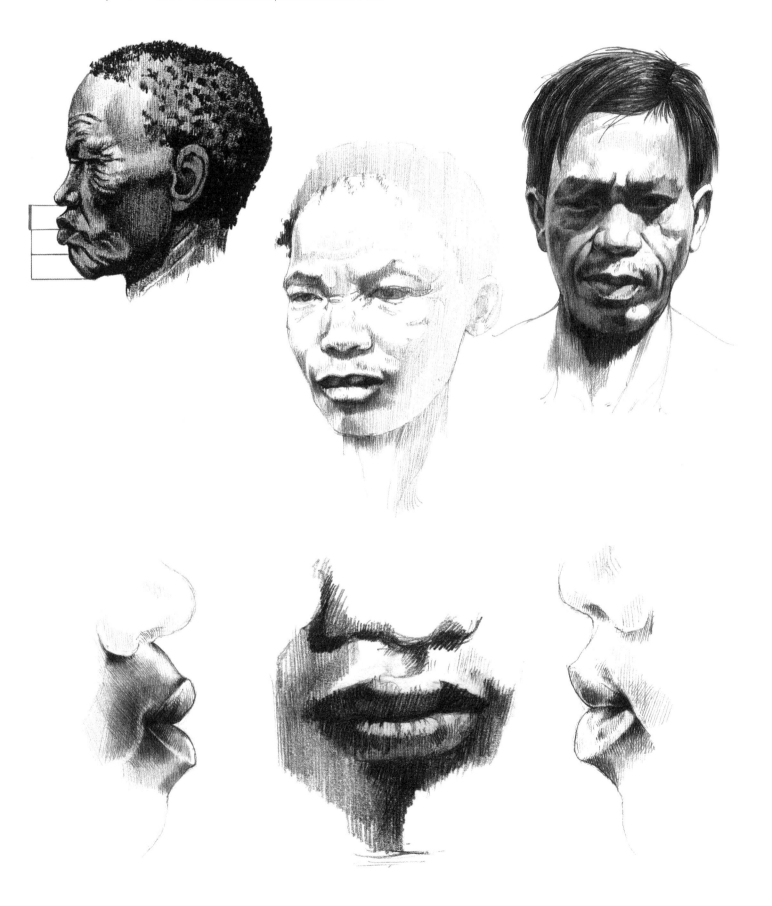

Studies of the mouth. Together, the eyes, nose, and mouth are, of course, indicative of the various ethnicities, but even by itself the mouth can give us an idea of which ethnic group the person belongs to. It also allows you to guess the age, mood (disgusted, joyous, etc.), or the activity (singing, eating, whistling, etc.).

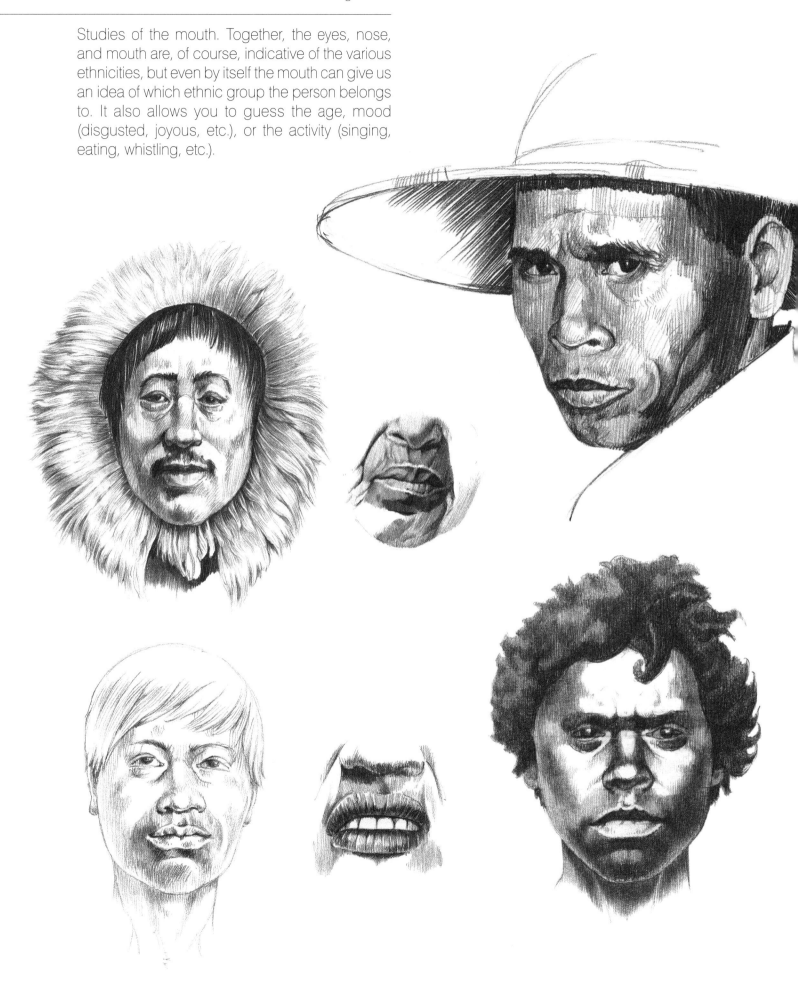

For many ethnic groups, characteristic lip ornaments are also part of their traditions.

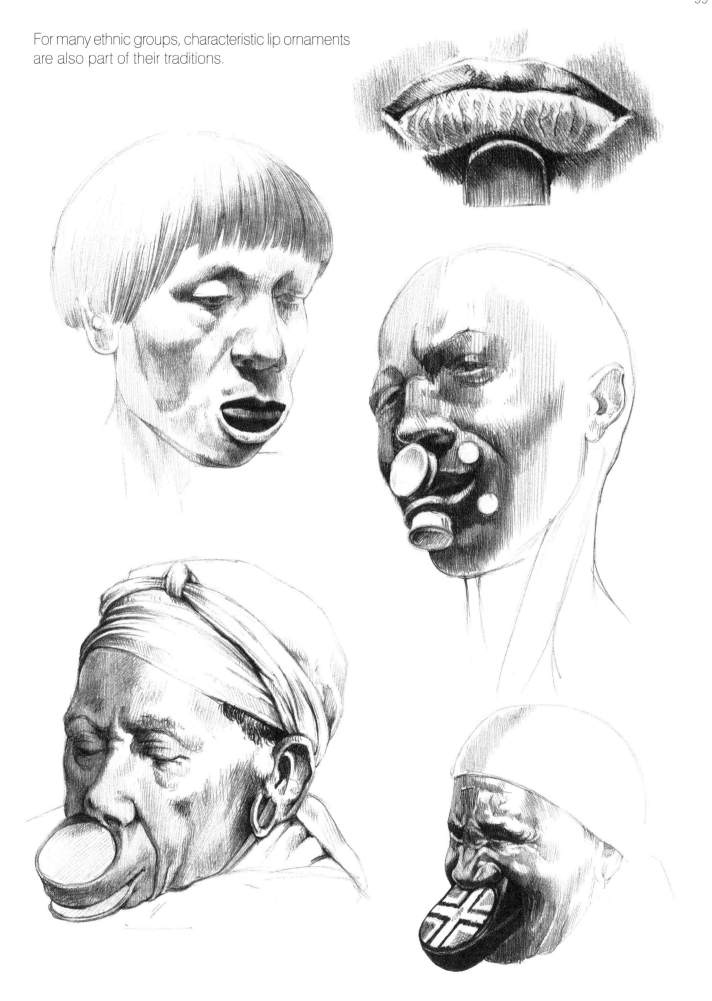

On the previous pages I have discussed the many
rules that are essential for drawing a good portrait.
Now I will show you how to put into practice the
knowledge you have already acquired.

*Always start the drawing by determining
the main axis. Using a pencil, it is easy to
ascertain how far—if at all—it deviates from
the vertical.*

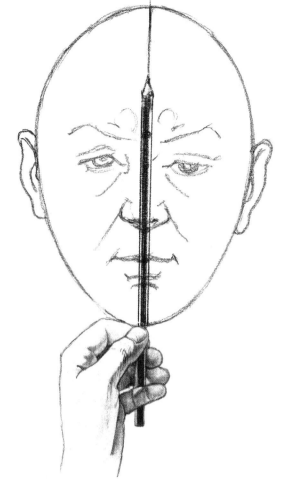

The more sections you subdivide the face into, the
more precisely you can determine the position of
the details. You already know that the face consists
of three sections of equal size (the distance
between the tip of the chin and the nose axis, the
distance between the nose axis and the eyebrow
axis, and the distance between the eyebrow axis
and the hairline). If you now divide the distance
between the eyebrow axis and the nose axis into
three equal parts, the first line below the eyebrow
axis will be the eye axis. If you divide the distance
between the nose axis and the tip of the chin into
three equal parts, you will find the mouth axis,
which is the first line below the nose axis. All this
also means that of the six equal-sized sections
between the eyebrow axis and the tip of the chin
below the eye axis there are five still remaining …

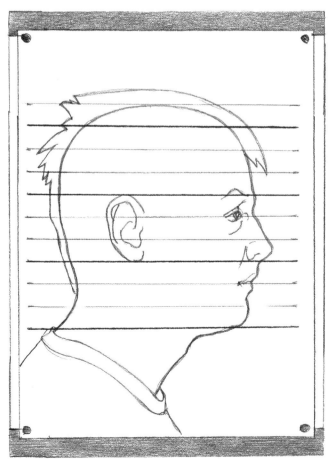

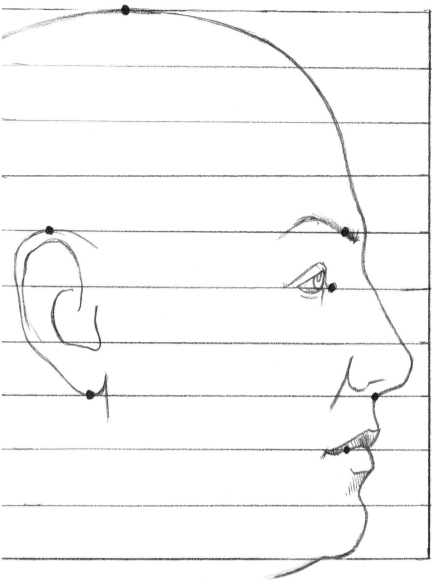

… and because the eye axis cuts the head in half, you can also divide the distance between that and the top of the skull into five equal parts. The highest point is the top of the skull, the fourth line below it is the eyebrow axis, and the fifth is the eye axis. The seventh line is the nose axis, on which the nose lies, and the eighth line is the mouth axis. The ears are located between the eyebrow axis and the nose axis.

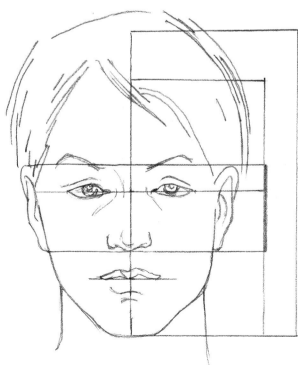

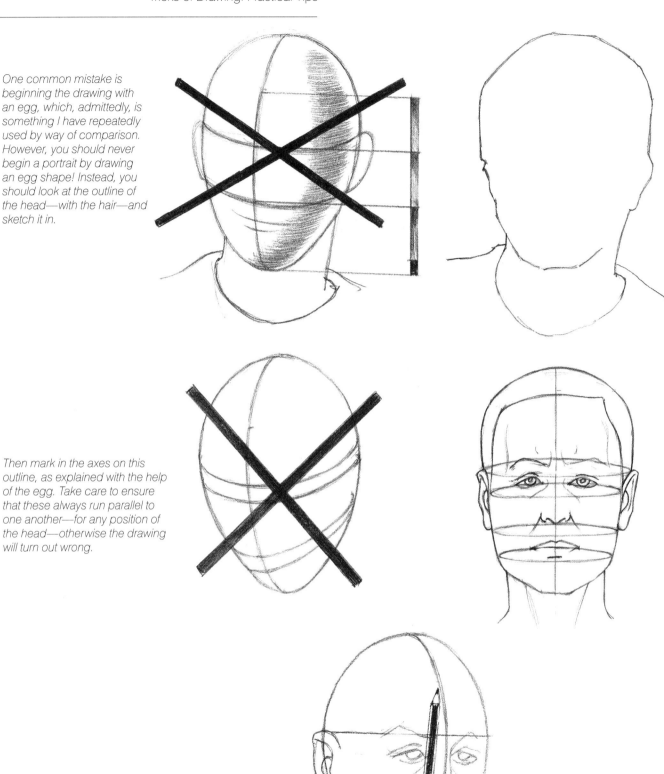

One common mistake is beginning the drawing with an egg, which, admittedly, is something I have repeatedly used by way of comparison. However, you should never begin a portrait by drawing an egg shape! Instead, you should look at the outline of the head—with the hair—and sketch it in.

Then mark in the axes on this outline, as explained with the help of the egg. Take care to ensure that these always run parallel to one another—for any position of the head—otherwise the drawing will turn out wrong.

In order to apply the rules of perspective, you must next ascertain which part of the head is closest to you. To do this, determine the precise direction of the main axis.

In particular circumstances it may not be quite so easy to determine the size of the head, which you need to know in order to mark in the axes. A beard or a "large amount of fabric" on the model's head make things more difficult for the artist, and so does piled-up, backcombed hair. But even here your recently acquired knowledge will come in useful. Look for a detail that you can measure accurately and make sure the other measurements are in line with it. Suitable examples of this are the distance between the eye axis and the tip of the chin, which is the same as the distance between the eye axis and the top of the skull, or any of the other ten sections of the face.

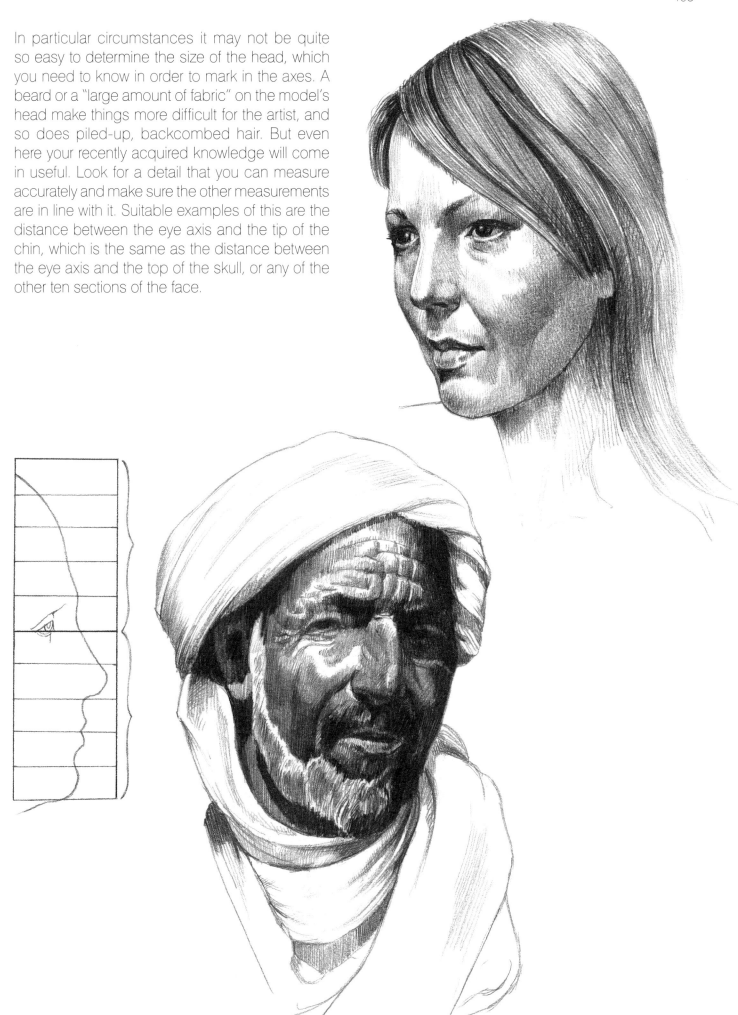

The human head is roundish. When shading in the portrait you might find it useful to imagine a ball, the surface of which is lightest where the light falls on it at a right angle and then gradually becomes darker. However, unlike the smooth surface of the ball, the human face consists of a number of plane surfaces running in different directions and with minor differences in tonal values. Dürer was the first artist whose study drawings include some that show an original method in which he reduced the three-dimensional features of the head to plane surfaces. He used this to explain the logic of the tonal values of the face to his pupils.

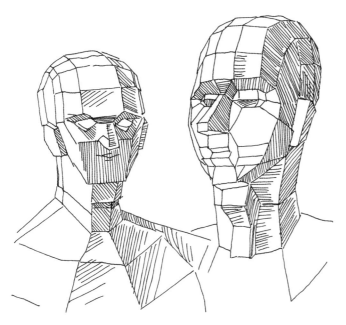
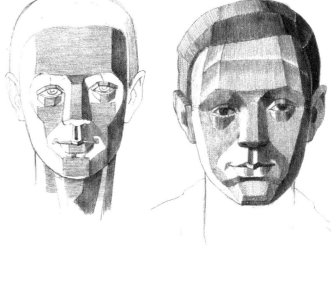

András Szunyoghy after Albrecht Dürer

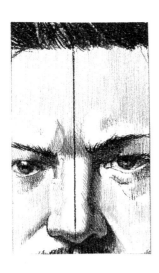
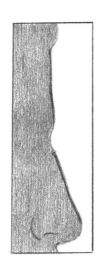

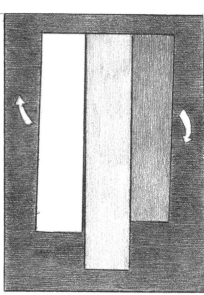

Practice depicting the various planes of the face. For instance, the difference between the tonal values of the forehead and the bridge of the nose is relatively large. Decide which plane is darker.

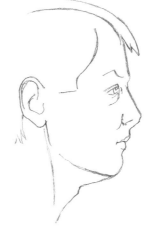

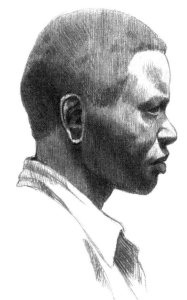

Several tonal values can also be distinguished on the forehead when viewed both from in front and in profile.

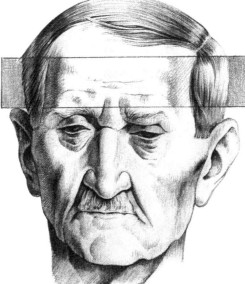

The part of the surface that is closest to the light source is brighter than the one that is farther away.

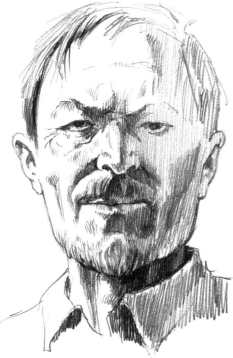

It is best to mark in the stronger shading at the sketch stage.

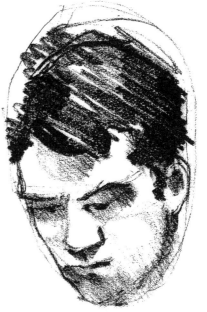

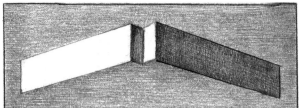

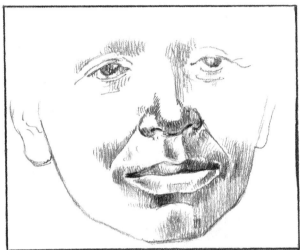

The differences in tonal values resulting from the groove in the upper lip between the nose and the mouth can be demonstrated using a folded strip of paper. The part of the groove closer to the light source but in shadow is darker than the part that is farther away.

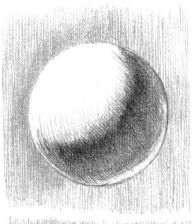

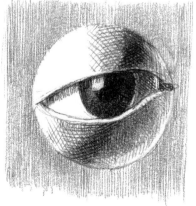

The fine, three-dimensional effect of the eyes and eyelids is reproduced by following the rules for the sphere. The brightest part of the sphere is easy to pick out, and the curved surface gets gradually darker from there. On the upper surface is an arc along which the light only just touches it. Behind that, the body is dark. This is the form shadow.

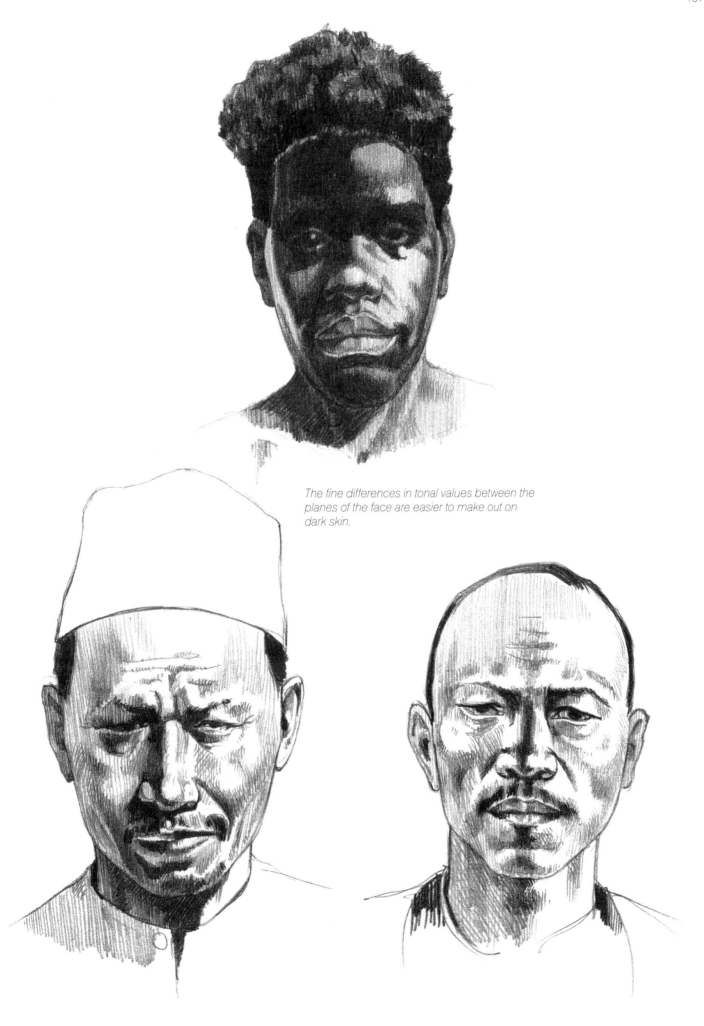

The fine differences in tonal values between the
planes of the face are easier to make out on
dark skin.

When drawing a model with the head inclined forward, you must take account of the spatial distortion resulting from the perspective. Pay attention to the changes in the curve of the axes. With the head in this position, the model's forehead is closest to the artist, so that the forehead will appear to be the biggest of the three sections of the face, which are the same size when viewed from directly in front (see page 20). The other two will each appear slightly smaller than the previous one. This rule (almost) always applies, no matter from which direction the head is viewed.

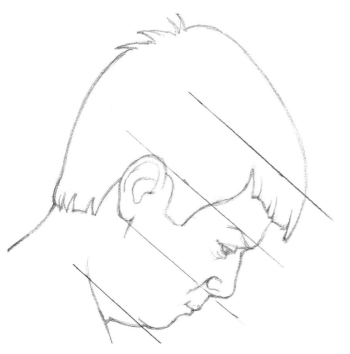

One exception to the rule on page 100 is the face in profile. In this case, no part of the face is closer to the viewer, so the distances between the hairline and the eyebrow axis, the eyebrow axis and the nose axis, and the nose axis and the tip of the chin, will remain the same, even if the model raises or lowers his or her head.

If the model has the head thrown back you can also observe the changes according to the rules of perspective. As it is now the area between the nose axis and the tip of the chin that is closest to the artist, this will be the biggest in the drawing. The other two sections become proportionately smaller, the farther away they are from the viewer. This also applies when looking at the model from in front or in three-quarter profile.

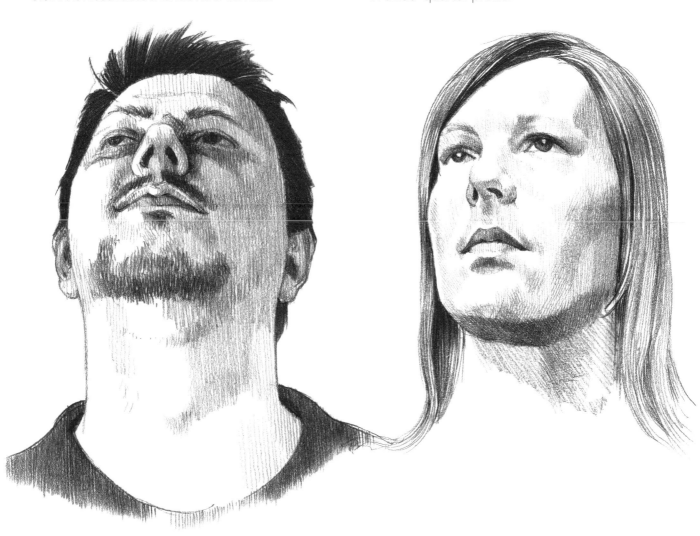

To draw a beautiful, lifelike portrait of a person whose head is thrown back, you must determine the curves of the main axis and the transverse axes. You can establish how far the main axis deviates from the vertical with the help of a pencil or a Dürer Grid. The transverse axes run at 90 degrees to the main axis. The easiest one to establish is the nose axis because it runs through points that can be precisely determined: the lowest tip of the earlobe and the point below the nose. After that, marking in the remaining axes is not too difficult because they run parallel to the nose axis.

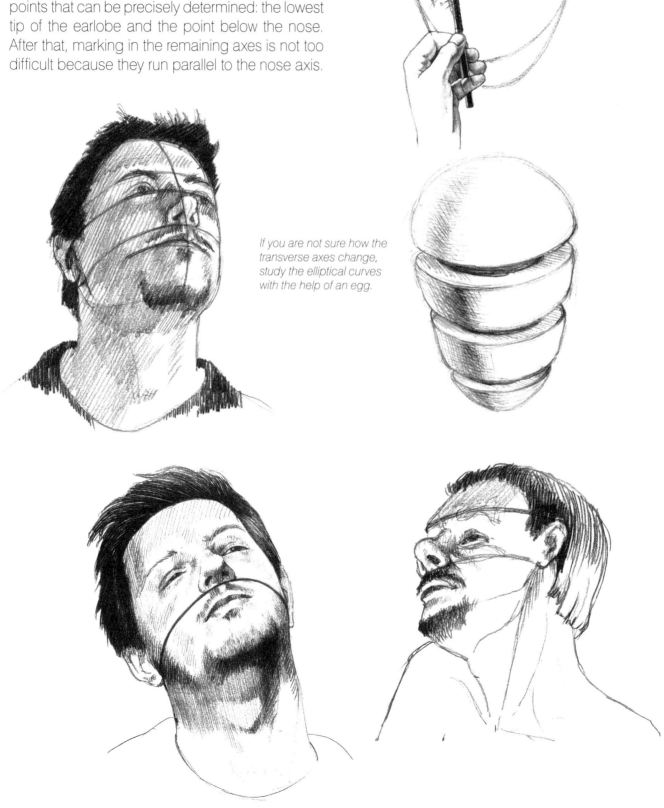

If you are not sure how the transverse axes change, study the elliptical curves with the help of an egg.

You should begin a profile drawing with a quick sketch. Pay attention to the characteristic shapes, the relative sizes of the individual details, and the most important tonal values. Only then should you start on the fine drawing, checking the measurements, coordinating the tonal values, and correcting any errors. It is not a serious problem if the sketch is not accurate. The main thing is that you have something that you can improve on.

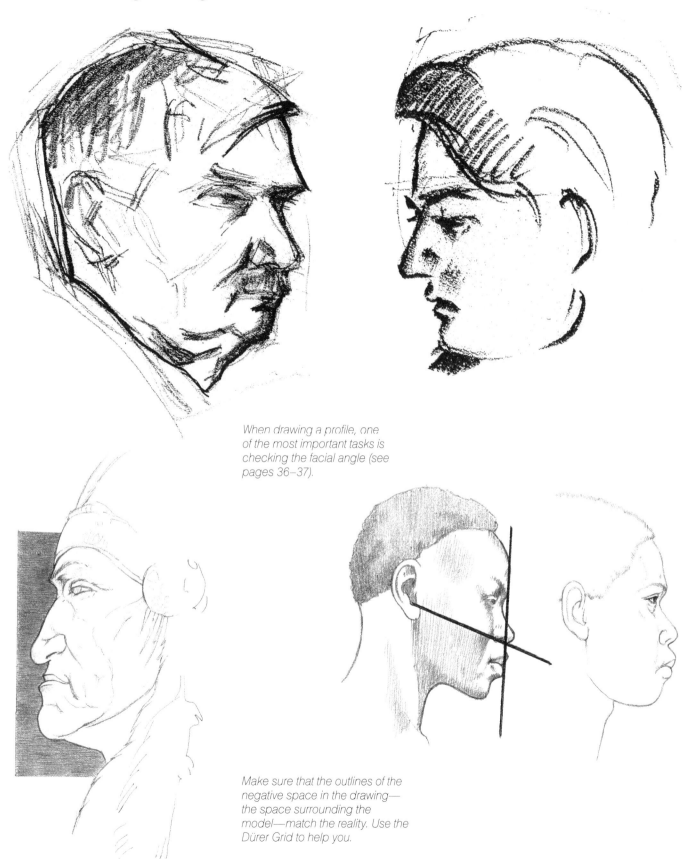

When drawing a profile, one of the most important tasks is checking the facial angle (see pages 36–37).

Make sure that the outlines of the negative space in the drawing— the space surrounding the model—match the reality. Use the Dürer Grid to help you.

The following drawings demonstrate the most common mistakes in profile drawing.

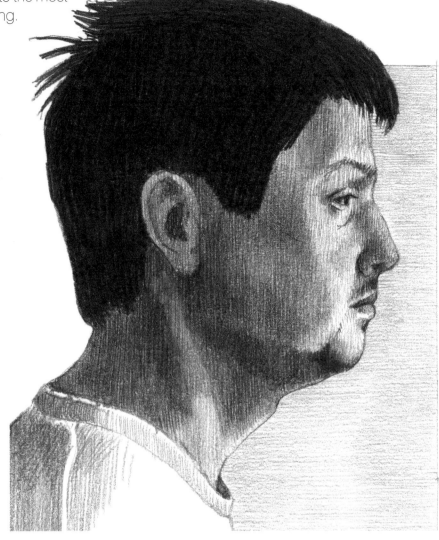

When drawing profiles you will also need to apply everything you know about transverse axes. One of the commonest mistakes—probably because the nose is the characteristic feature of the profile and people pay particular attention to it—is drawing the middle section of the three bigger than the other two, which makes the nose too long.

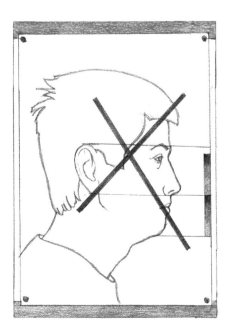

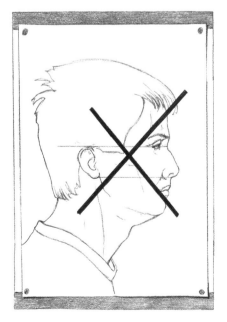

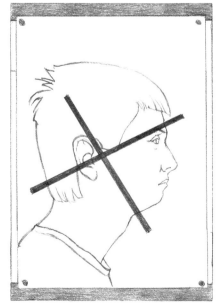

The ears should lie between the nose axis and the eyebrow axis, not between the nose axis and the eye axis!

It is also easy to get the shape and size of the chin wrong. Mistakes of this kind can best be corrected with the help of the Dürer Grid.

The outline of the hair—and the negative space—can also be used to check the drawing. Check whether the mass and outlines match the reality.

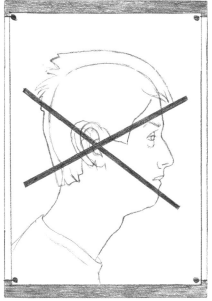 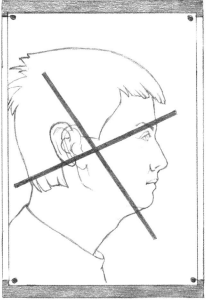

Use measurements to check whether the distance between the ears and the nose corresponds to the reality. It is all too easy for it to become too small or too large in the drawing.

With any position of the head, including the profile, it may happen that the hair, the beard, a cap, or any fabric worn on the head, make it difficult to determine the size of the head and consequently the position of the transverse axes. In this event, look for a detail that you can definitely measure accurately. For instance, if you can determine the distance between the eyebrow and nasal axes, you can use it to find the distance between the nose axis and the tip of the chin as well. As you also know that the main axis bisects the head, everything else becomes easy when you use what you have just found about the tip of the chin. The distance between the tip of the chin and the eye axis is exactly the same as the distance between the eye axis and the top of the skull. Accordingly, you can also apply the rules on pages 100–103.

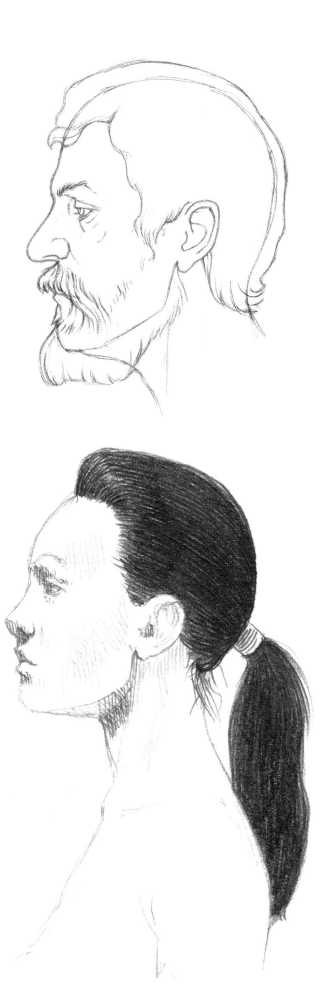

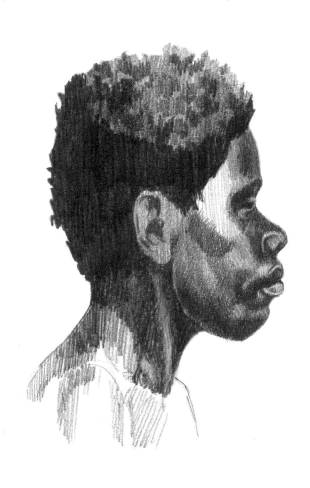

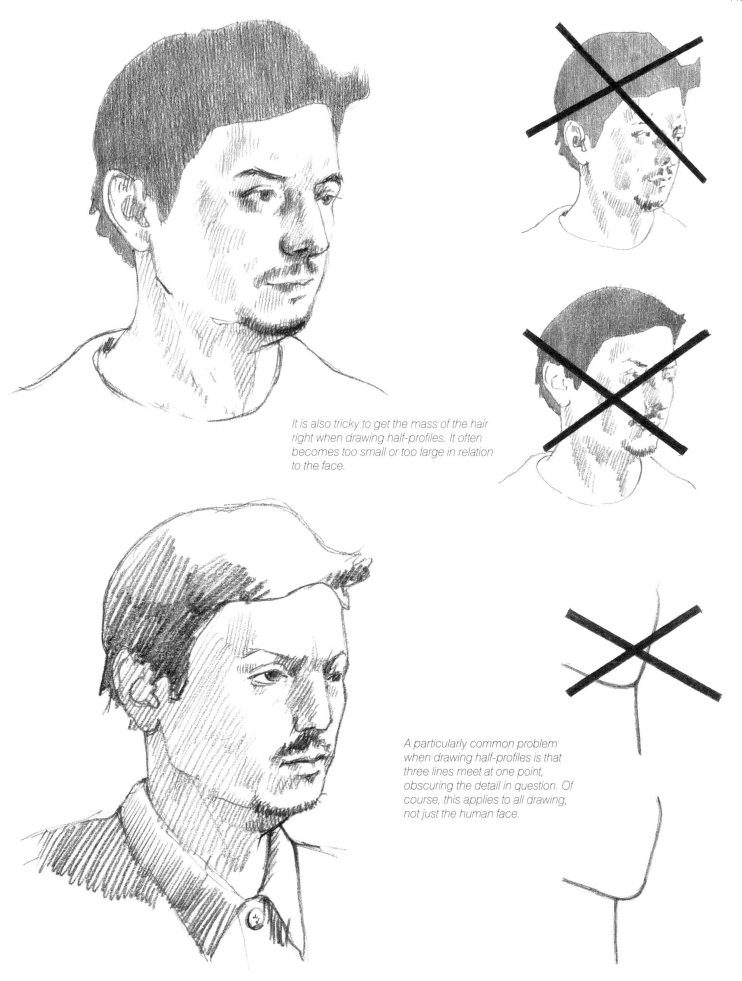

It is also tricky to get the mass of the hair right when drawing half-profiles. It often becomes too small or too large in relation to the face.

A particularly common problem when drawing half-profiles is that three lines meet at one point, obscuring the detail in question. Of course, this applies to all drawing, not just the human face.

Hair and beards adorn the head. The way they are worn is usually very individual and characteristic of the person concerned. As with clothing, the fashion of the times is also expressed in the hairstyle. Hair can be represented in many ways, from the sketchy to the meticulously detailed and accurate.

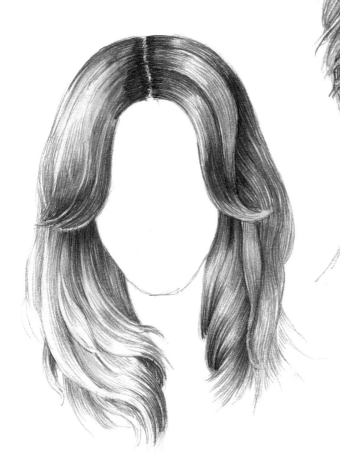

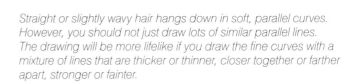

Straight or slightly wavy hair hangs down in soft, parallel curves. However, you should not just draw lots of similar parallel lines. The drawing will be more lifelike if you draw the fine curves with a mixture of lines that are thicker or thinner, closer together or farther apart, stronger or fainter.

When drawing the hair, always proceed from the simple to the more complex. First, sketch the outline and mark the simpler differences in tonal values— that is, the places that are lighter or darker. Gradually refine the transitions between the tones and draw in the waves. The combination of form and shading will produce an accurate representation. The tonal values are easier to determine if you screw up your eyes or use the grayscale.

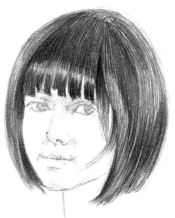

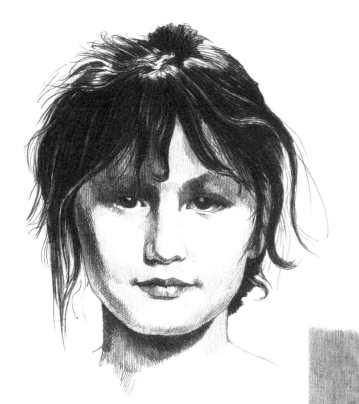

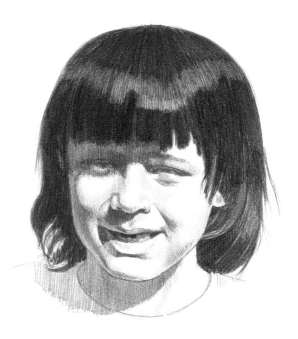

The easiest to draw is short, straight hair that follows the oval shape of the head. When you are reproducing the chiaroscuro you will use what you know about the sphere. Depending on the position of the light source, there will be a brightest point on which the rays of light fall vertically. The curved surface becomes gradually darker and you can pick out an arc along which the light rays touch the surface only tangentially. Behind this, the body is dark; this is the form shadow. However, when drawing the hair you must note that it does not have a smooth surface and the various planes will reflect the light differently.

Curls are reproduced with curving lines. At the same time, you can use the depiction of individual hairs to show whether or not the model is moving, whether a slight breeze is ruffling the hair or it has been caught by a gust of wind, or even if the model is standing in the rain or in the sun. In order to achieve this, you must plan the form of the strands.

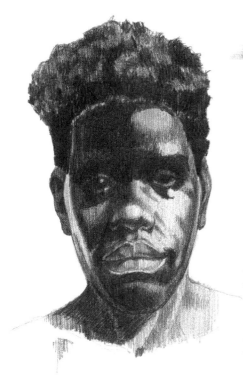

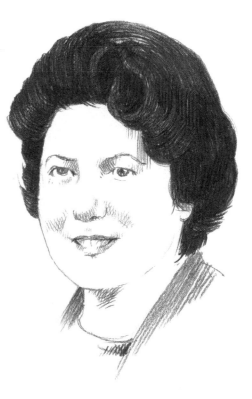

Drawing dark hair is not easy. I have shown the possible ways on two very different models. On the woman, I have depicted the neat hairstyle using parallel lines. I have separated the two adjacent, almost equally dark spots with a thicker line. I have portrayed the round shape of the head with thinner lines in the lighter area. On the young black man, I have shown the thickness and frizziness of the hair and the chiaroscuro by the use of a few dark spots. In order to reinforce the effect, I have depicted the outline of the hair with lines running in different directions.

Drawing beards seems difficult at first; however, there are a few tricks that can make this task easier to manage. As the face is known to be symmetrical, it is reasonable to suggest that your first thought should be to mark in the main axis bisecting the face, because the two halves to the right and left of this axis of symmetry will generally be mirror images of each other. Then you find the angle of the beard hairs, also in relation to the main axis. Long moustaches usually run in curves to the right and left, whereas short ones are often almost vertical. Of course, there are no rules that apply in all cases because beards have many individual distinctive features.

If the beard and moustache are gray, the face should be slightly darker in tone; with dark hair and beards, make the face paler.

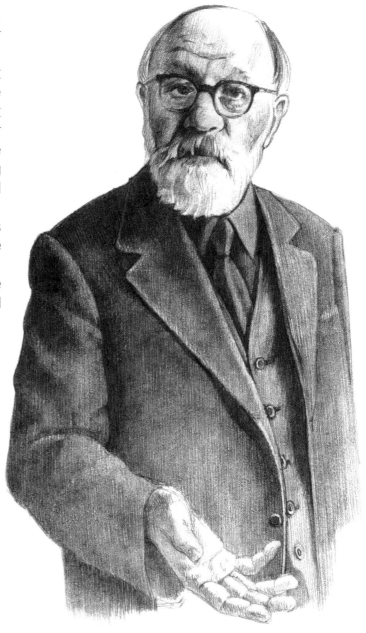

My former teacher, Jenő Barcsay

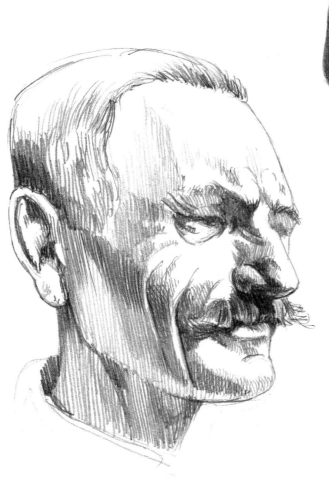

As with the hair, most of the problems with drawing beards arise because it is more difficult to determine the actual measurements of the head. Measuring helps here, too. Select a suitable section of the face as your starting point and relate all other measurements to this (see pages 110–111).

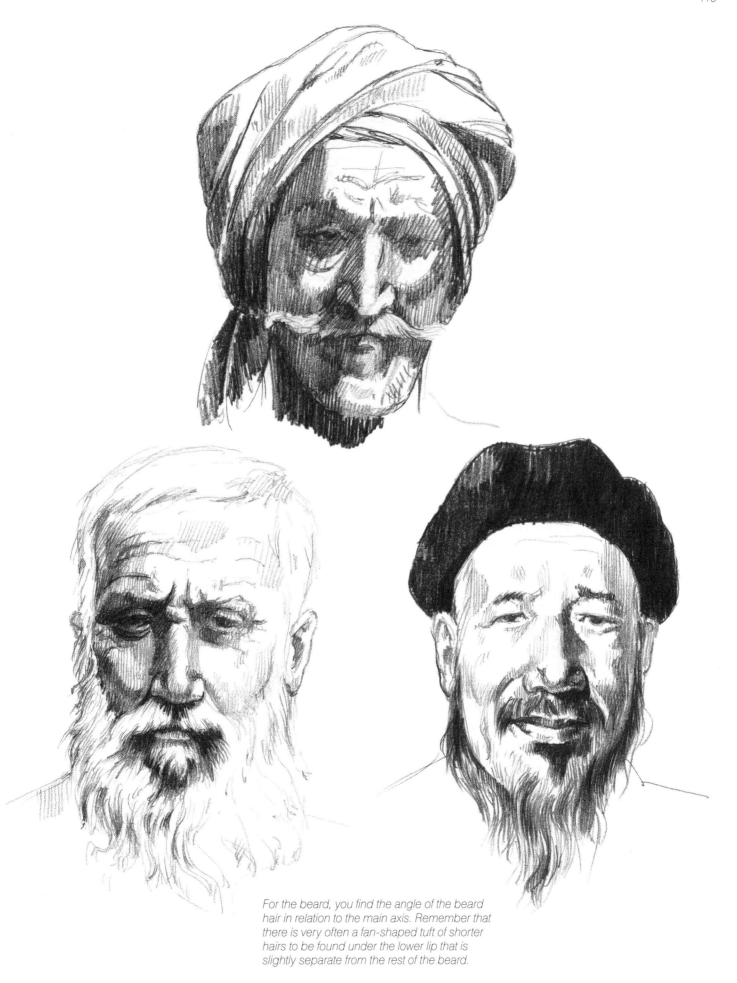

For the beard, you find the angle of the beard
hair in relation to the main axis. Remember that
there is very often a fan-shaped tuft of shorter
hairs to be found under the lower lip that is
slightly separate from the rest of the beard.

The style of hair and beard usually provides information on the times in which models live or lived as well as their age, gender, position in society, and ethnicity.

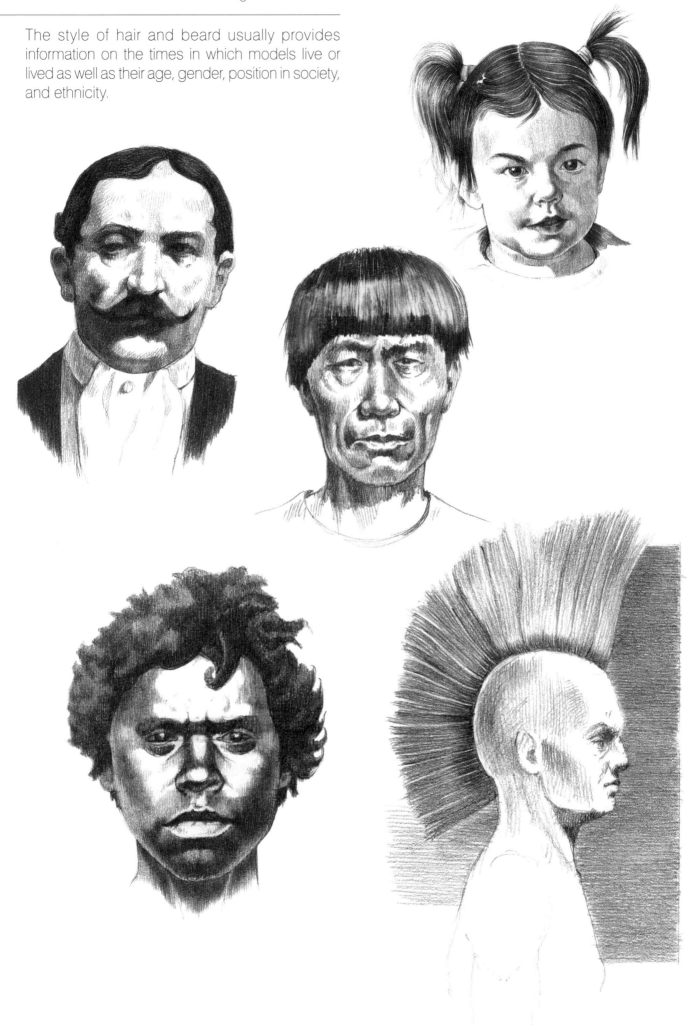

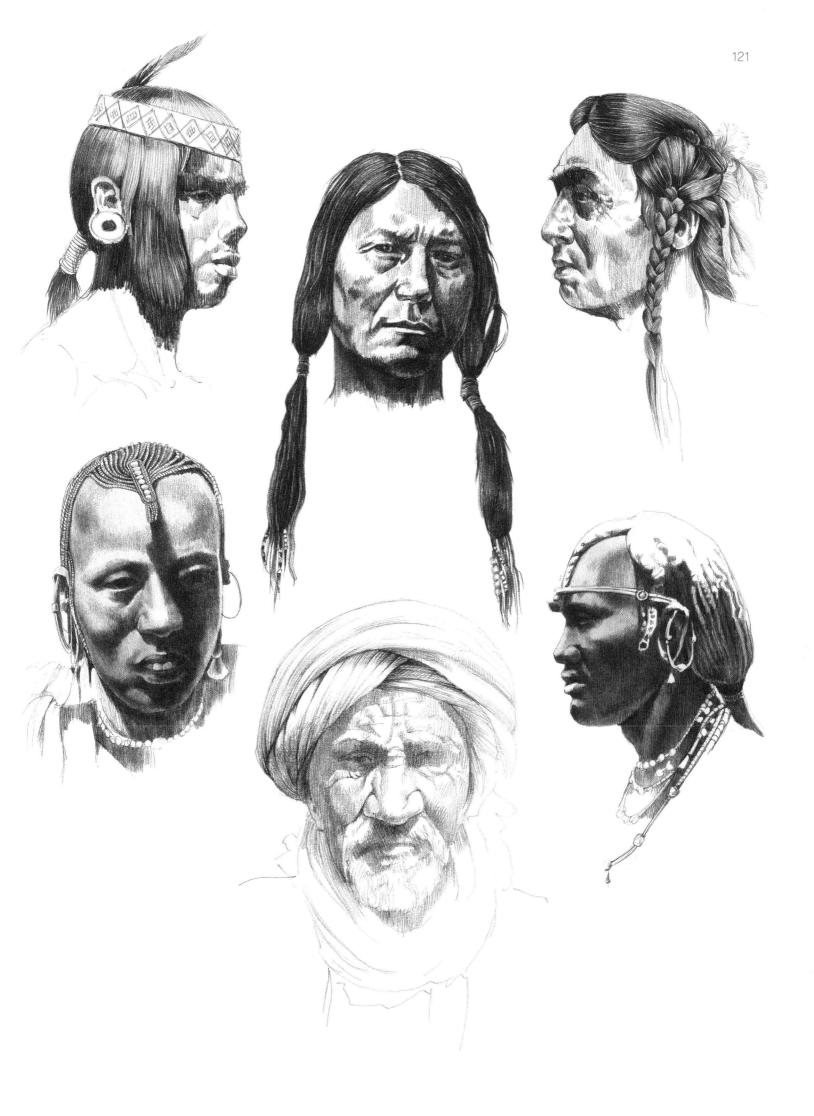

I consider myself fortunate that my anatomy teacher at the Budapest Academy of Fine Arts was Jenő Barcsay, whose anatomy book is known all over the world. He described the differences between the male and female face and body as follows: "The female body is more padded than the male, and the woman's head is somewhat larger than the man's." Generally speaking, it can be said that the face and chin of a woman are a little rounder and the features a little softer, although, of course, the exact opposite may be true in individual cases.

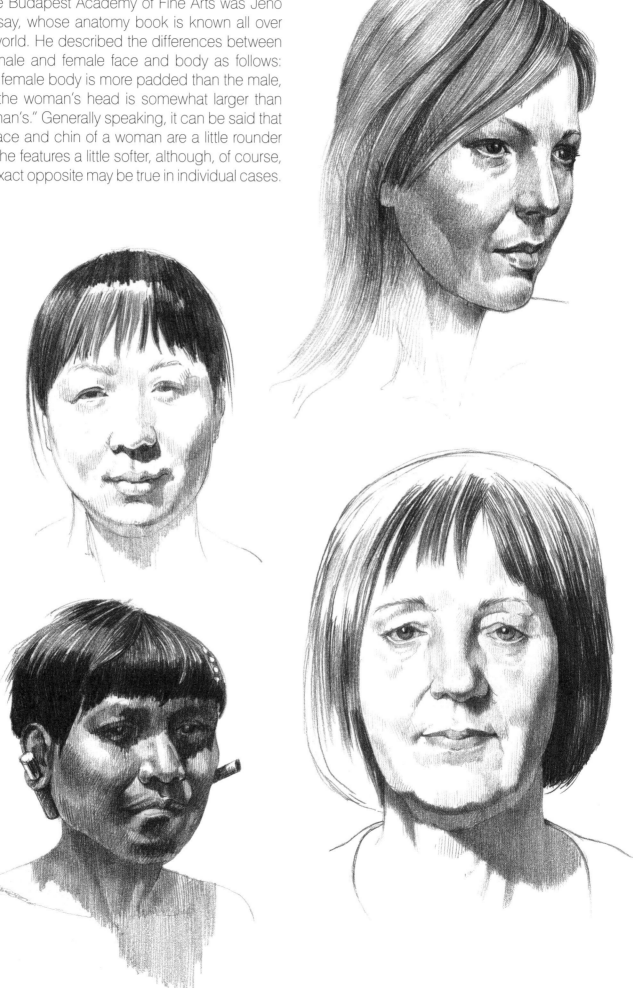

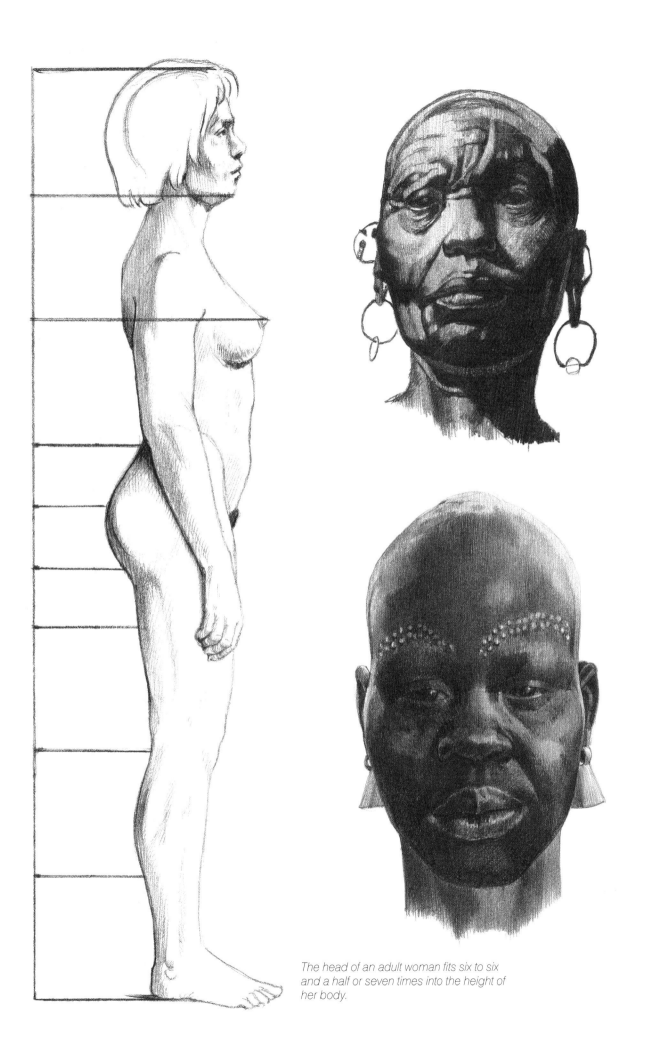

The head of an adult woman fits six to six and a half or seven times into the height of her body.

The man's body is more muscular and his head is smaller in relation to his body than the woman's. Generally, it can be said that everything about the man's physique is a little more angular, the features are harder and more clear-cut, and the muscles stand out beneath the skin.

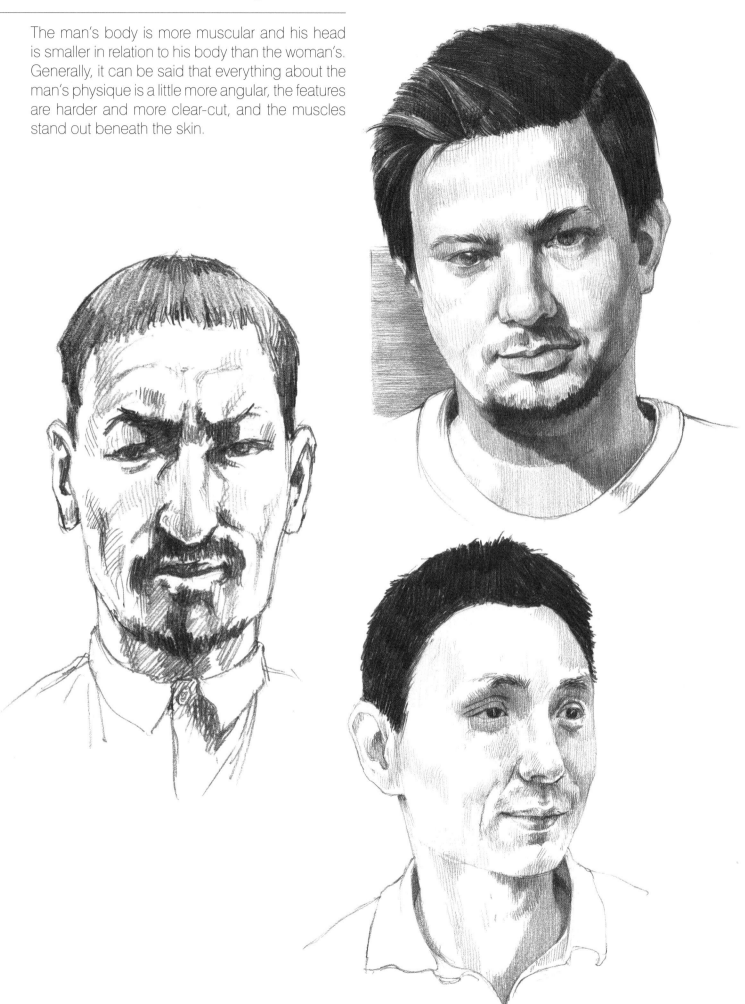

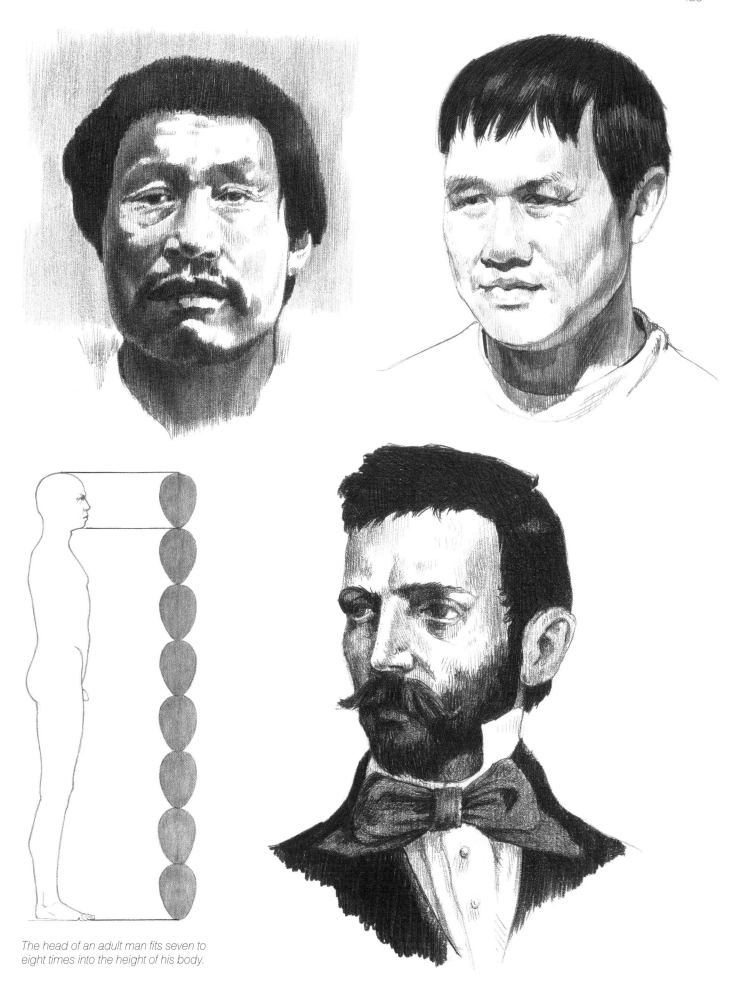

The head of an adult man fits seven to eight times into the height of his body.

Drawing children is a particular challenge because most of the rules that apply to adults do not hold good for them. Small children have special physical proportions: their heads fit three to four times into the height of their bodies and are therefore very large in relation to their height. The height of a two- to three-year-old is four to five times the size of the head, that of a 15-year-old six to six and a half times.

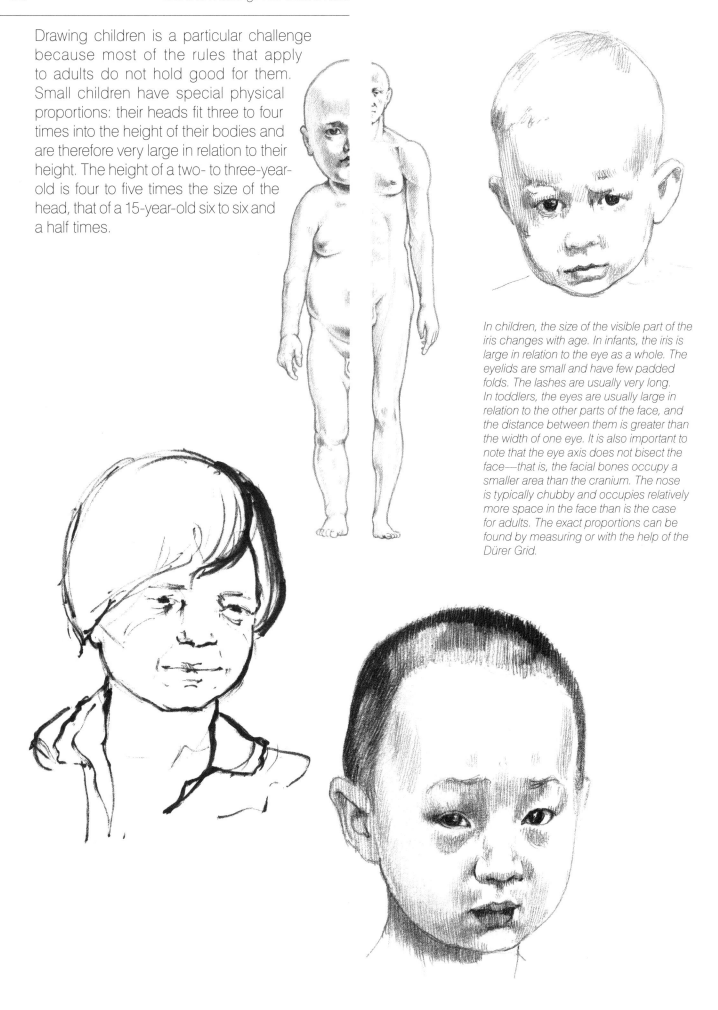

In children, the size of the visible part of the iris changes with age. In infants, the iris is large in relation to the eye as a whole. The eyelids are small and have few padded folds. The lashes are usually very long. In toddlers, the eyes are usually large in relation to the other parts of the face, and the distance between them is greater than the width of one eye. It is also important to note that the eye axis does not bisect the face—that is, the facial bones occupy a smaller area than the cranium. The nose is typically chubby and occupies relatively more space in the face than is the case for adults. The exact proportions can be found by measuring or with the help of the Dürer Grid.

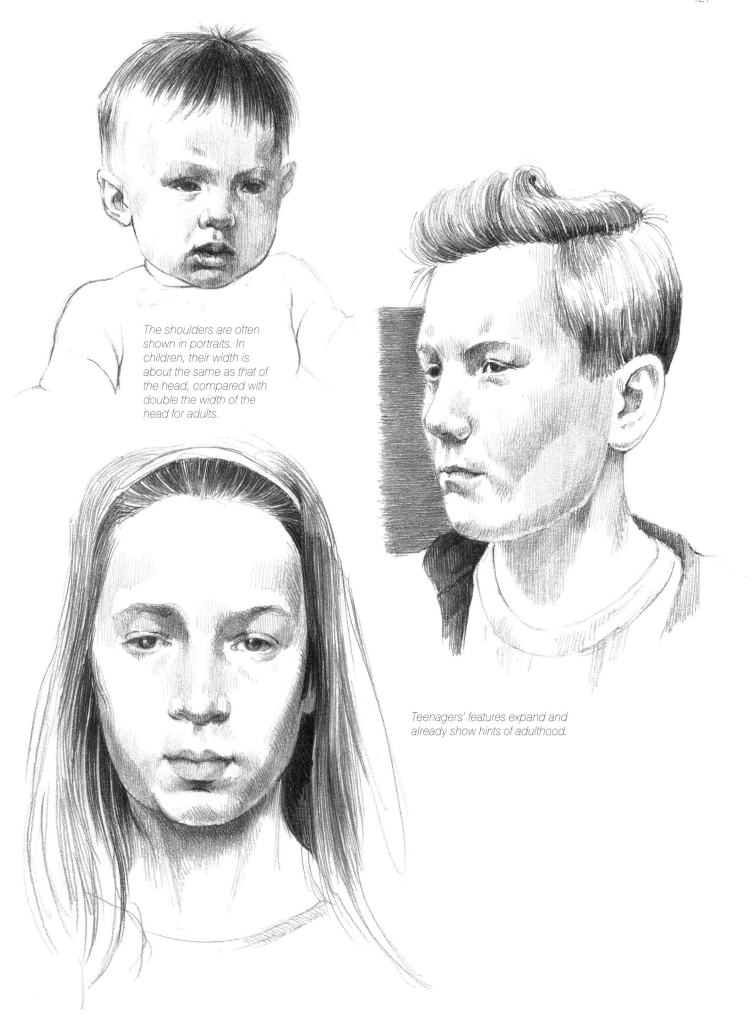

The shoulders are often shown in portraits. In children, their width is about the same as that of the head, compared with double the width of the head for adults.

Teenagers' features expand and already show hints of adulthood.

Some of the lines in the human face are with us from birth; others are acquired (age-related). The characteristic lines we are born with are the naso-labial folds, which run from the outer edges of the nose along the underside of the cheeks, and the oral commissures, which run from the corners of the mouth to the edge of the lower jaw. Sometimes the chin is not a single unit but is divided in two by a vertical cleft. The mental crease runs between the chin and the lower lip, while the philtrum runs from the bottom of the nose to the top edge of the upper lip. Dimples appear when the risorius muscles at the sides of the mouth contract. When the frontal muscle contracts, horizontal folds appear in the forehead. With increasing age, the natural folds become deeper and more pronounced and new ones are added, for instance the crow's-feet radiating from the outer corners of the eyes and the wrinkles around the lips. The skin becomes slacker, the lines in the face become more pronounced.

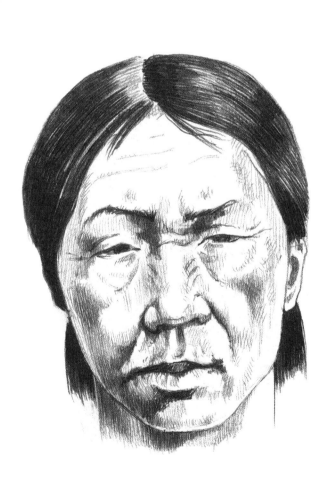

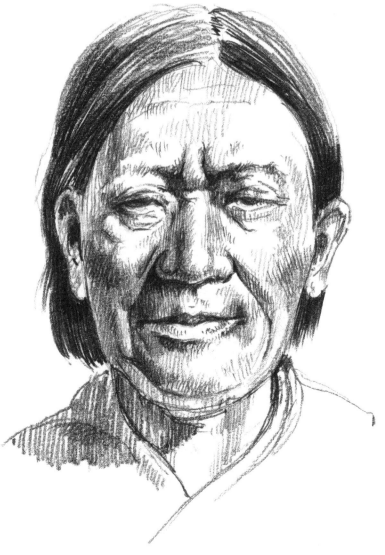

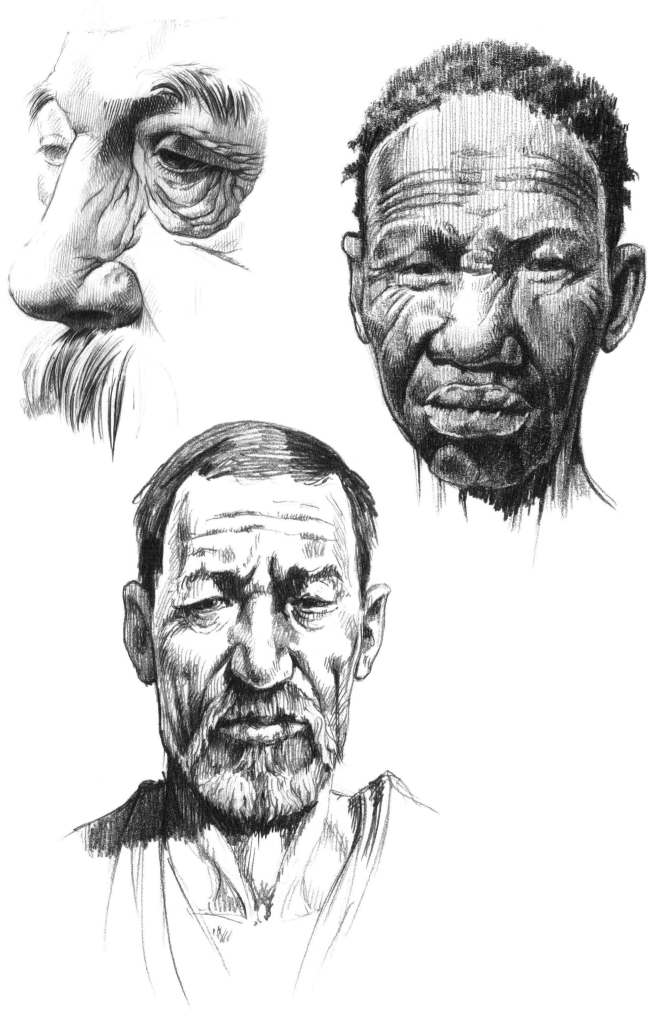

Remarkably, I have never found anything comparable to the European rules for depicting the human face anywhere else in the world, not even when studying Chinese culture, which goes back thousands of years. However, these rules compiled by Leonardo da Vinci, Albrecht Dürer, and other artists, which have remained unchanged for centuries, were developed only for the European (Caucasian or Europid) facial type. There are no references to the inhabitants of other continents. So, when drawing, you must make your own observations to help you portray the eyes, nose, mouth, and shape of a head on paper. When drawing a person of a non-European ethnicity, you should always begin by finding out what the special features are. Measurements and the Dürer Grid are a great help with this.

First draw in the main axis and then the transverse axes using the familiar method, but watch out for any deviations from the usual proportions. Determining the axes is important because it is easiest to use them to help you reproduce the distortions of perspective.

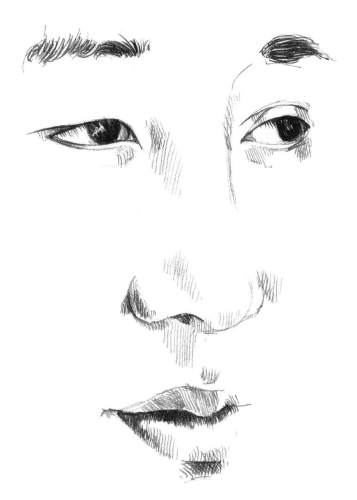

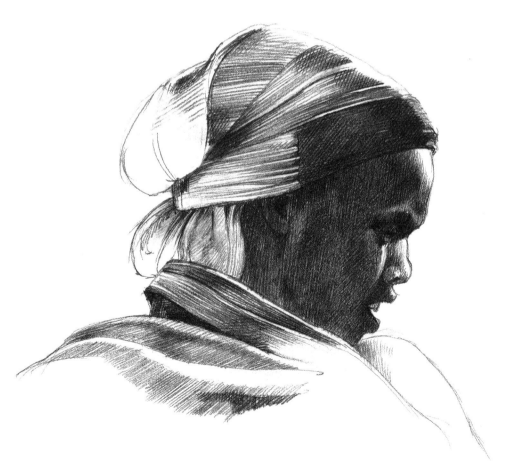

People with very dark skin belong to three main ethnic groups and within these there are many subgroups. With such people, shading is particularly challenging. Even the lighter parts of the skin are much darker than the skin of Caucasian or Asian models. Using the grayscale makes it easier to distinguish the tonal values. However, in this case, and also with other non-European ethnicities, the rule that the nose is about the width of one eye does not apply. You will have to measure the relationship between the width of the nose and one half of the face. The lips are also a different shape; they are much fuller than those seen in Europids. In profile, the lips usually protrude more and the nose less than in most Europids.

The largest of the main ethnic groups is the East Asian. Features that people in this group have in common are the epicanthic fold in the upper eyelid, which gives the eyes their slanted, almond shape, the flatter face, the straight black hair, and the sparse facial hair in men. Another characteristic feature is the pronounced cheekbones. The nose is also mostly broader than the width of one eye and, like the mouth, does not protrude very far in profile (see page 85).

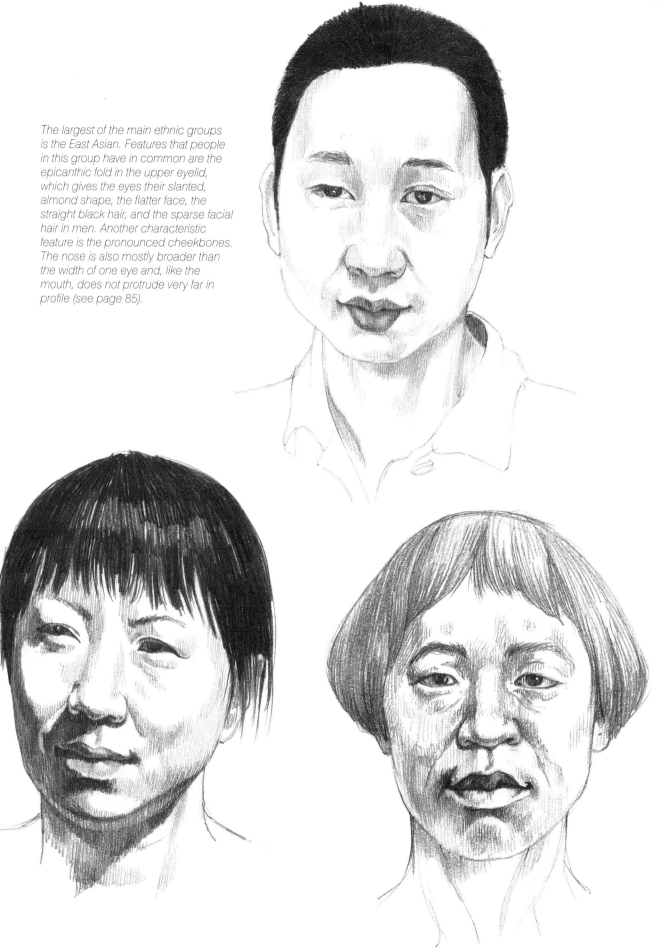

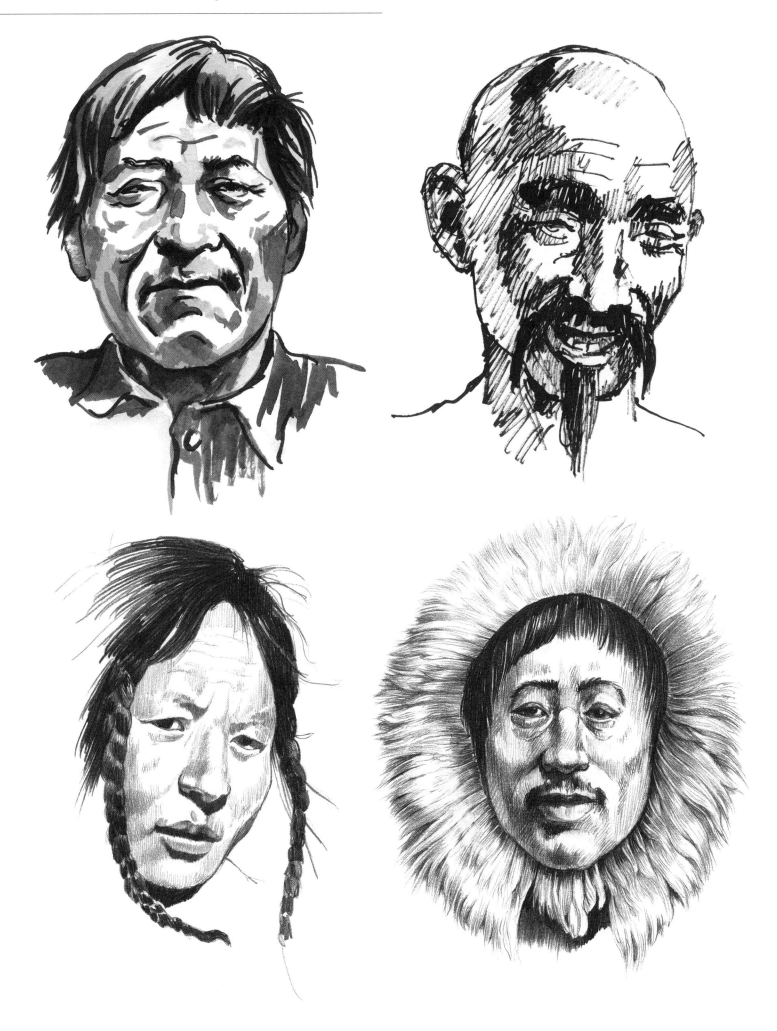

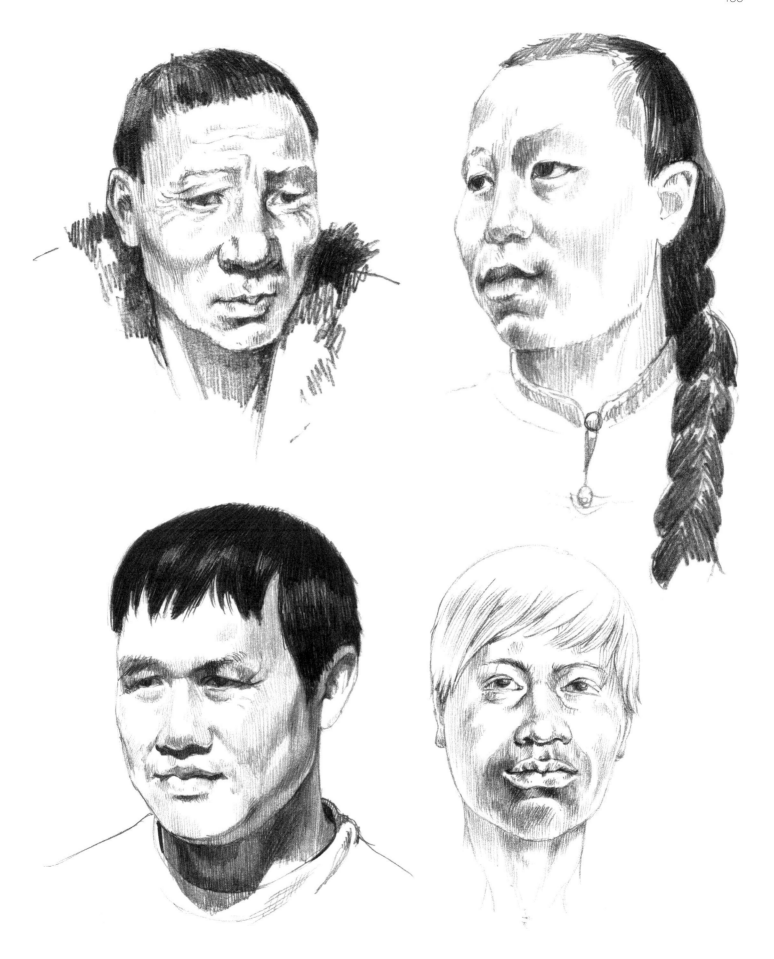

Facial ornaments, which are sometimes quite bizarre, were originally not only for decoration but also proclaimed the individual's status and position and/or membership of a particular community. Nowadays, it is not only traditional peoples who wear this kind of body ornament. It has become a fashion accessory and you can encounter both discreet and very conspicuous forms in the street every day. The most important thing about drawing body ornaments is how you depict the different materials, for example the reflection of light on metals and the smooth, matt surface of bone. You must always determine the outline of the jewelry (sphere, cylinder, etc.) and shade it appropriately. The differences between the human skin and the material of the ornament are also depicted by variations of tone.

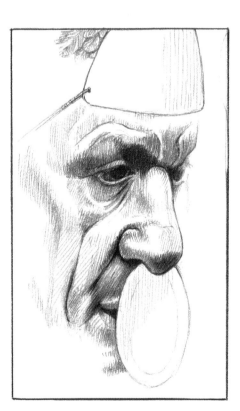

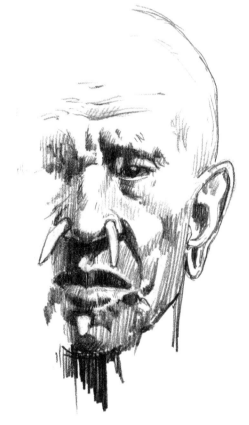

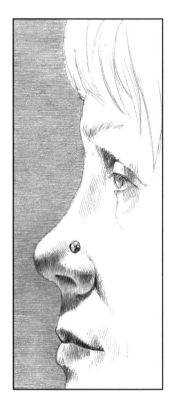

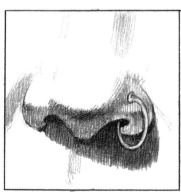

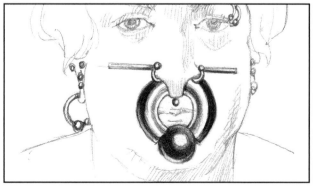

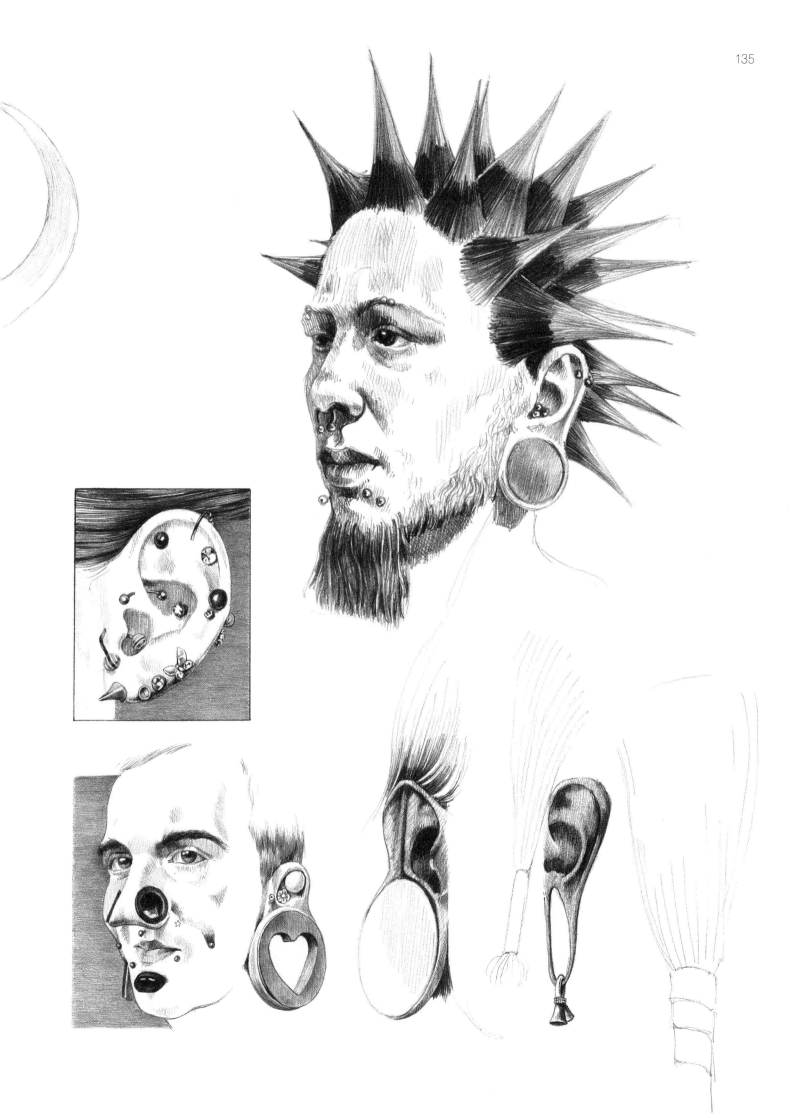

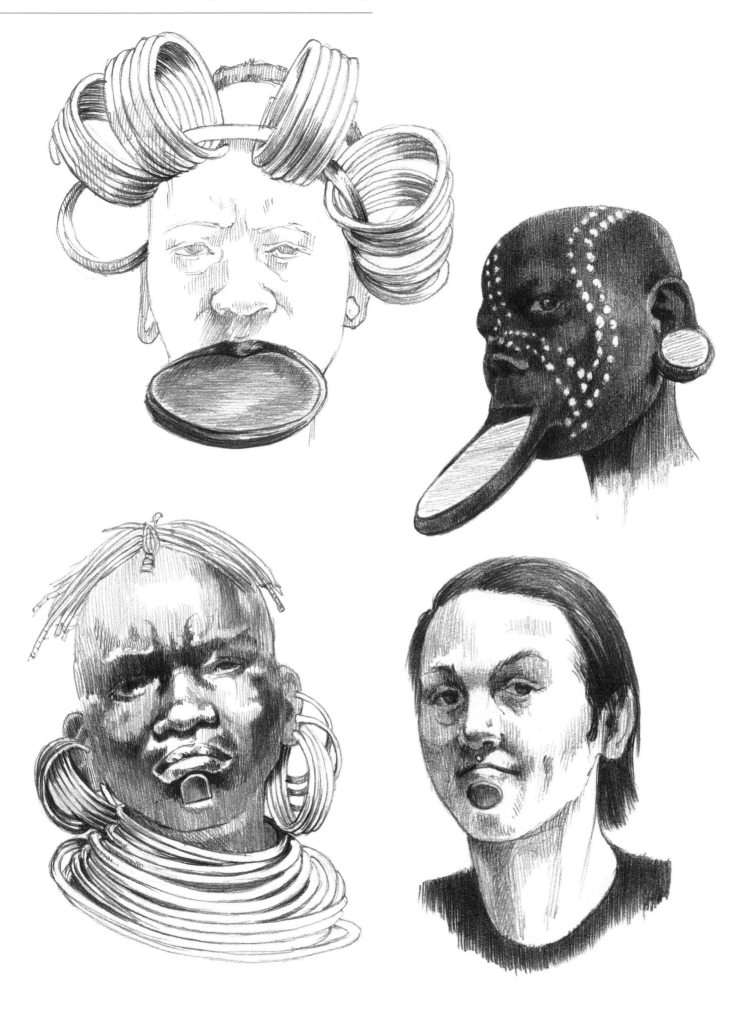

Facial expressions are as good as language for communicating thoughts and emotions. Each movement is the result of coordinated muscle activity; even the tiniest change of expression is produced by delicate movements of the facial muscles. The small hands in some of the drawings (see page 142) indicate where the muscles arise and are attached. We perceive the contractions and extensions of the muscles as changes in the facial expression (e.g. smiling). I have put together the expressions on the following pages, though without claiming that they constitute the complete range. Their only purpose is to demonstrate the movements of the muscles concerned. Facial expressions are a challenge for the artist, as he or she must understand what is happening beneath the skin, even though only the changes to the surface of the skin will be portrayed in the drawing.

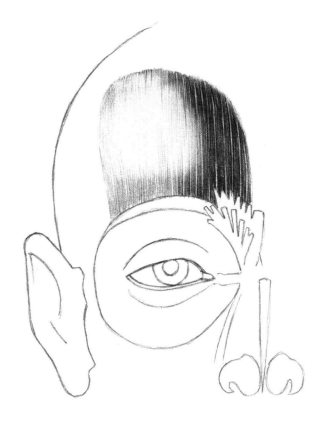

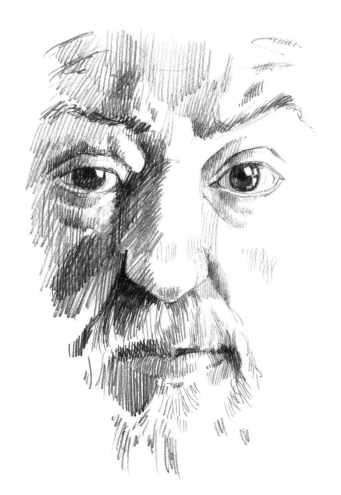

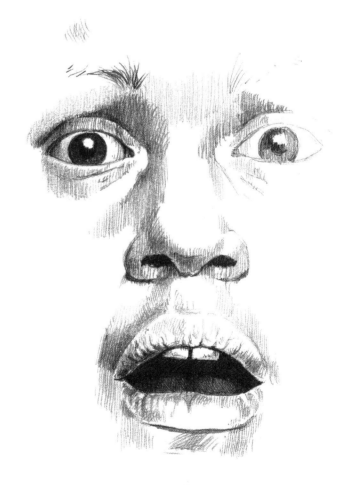

The frontalis muscle arises from the superciliary arch and attaches above the frontal eminence. It wrinkles the brow and raises the eyebrows.

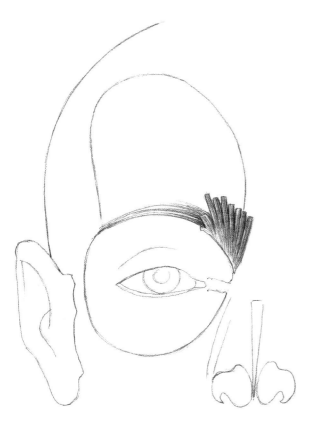

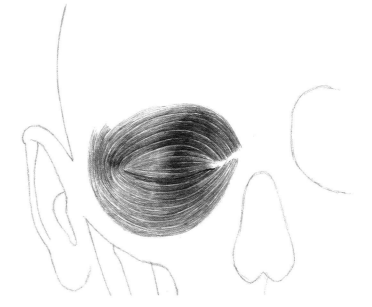

The corrugator supercilii draws the eyebrows inward.

The orbicularis oculi muscle closes the eyelids. We use it to wink, blink, and screw up the eyes.

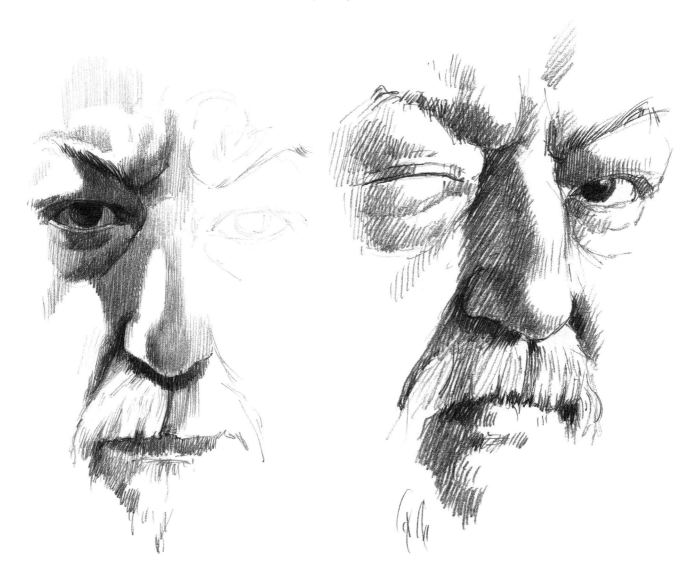

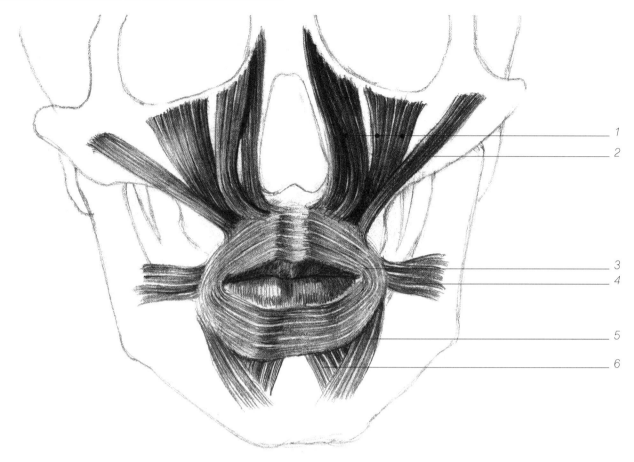

The orbicularis oris is one of the most important muscles of the face. It moves the lips, together with the muscles that "cling to" it: the levator labii superioris, the zygomaticus major, the risorius, the depressor anguli oris, and the depressor labii inferioris.

1 Levator labii superioris
2 Zygomaticus major
3 Orbicularis oris
4 Risorius
5 Depressor anguli oris
6 Depressor labii inferioris

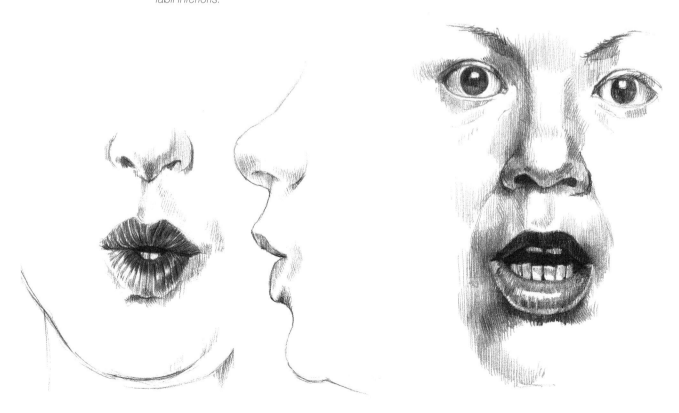

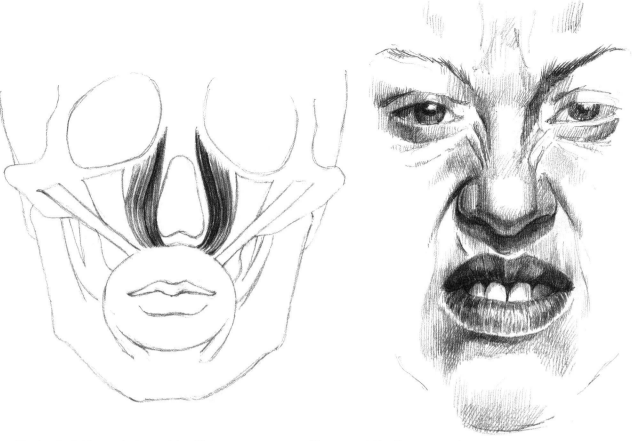

The levator labii superioris consists of three cords that arise in different places and then come together and attach in the same muscle head. The cords can move independently so, for example, the one that arises at the inner corner of the eye wrinkles the nose and pulls up the middle part of the upper lip. The two outer cords, which arise under the eye sockets and on the cheekbones, are also involved in raising the upper lip.

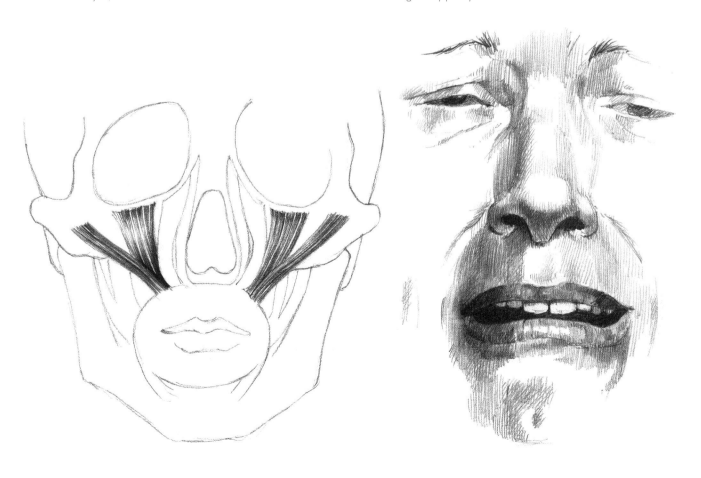

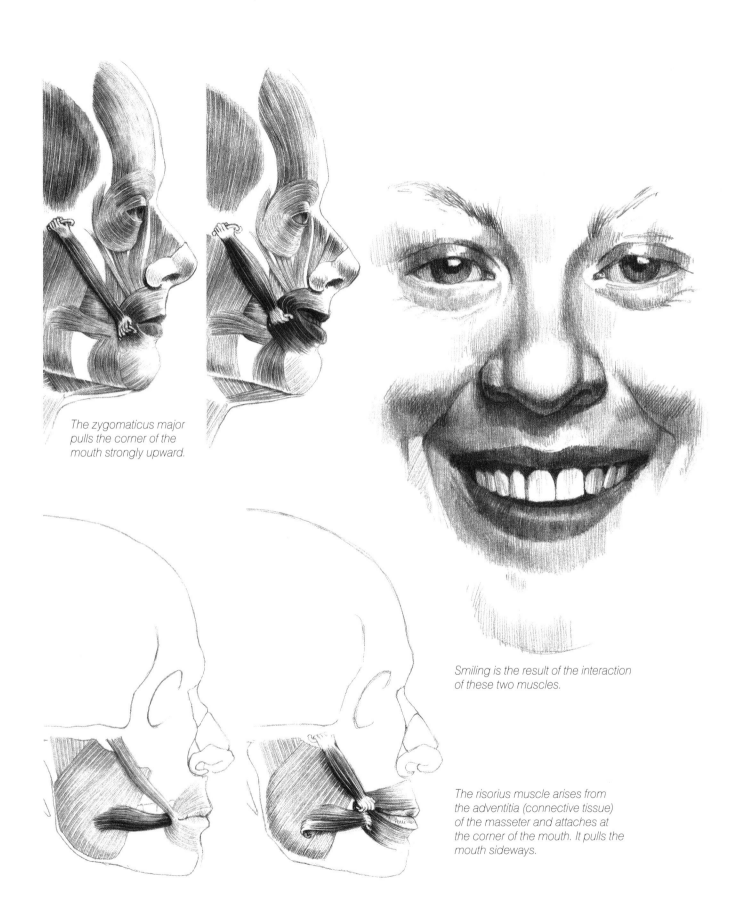

The zygomaticus major pulls the corner of the mouth strongly upward.

Smiling is the result of the interaction of these two muscles.

The risorius muscle arises from the adventitia (connective tissue) of the masseter and attaches at the corner of the mouth. It pulls the mouth sideways.

The depressor angularis oris muscles pull the corners of the mouth strongly downward.

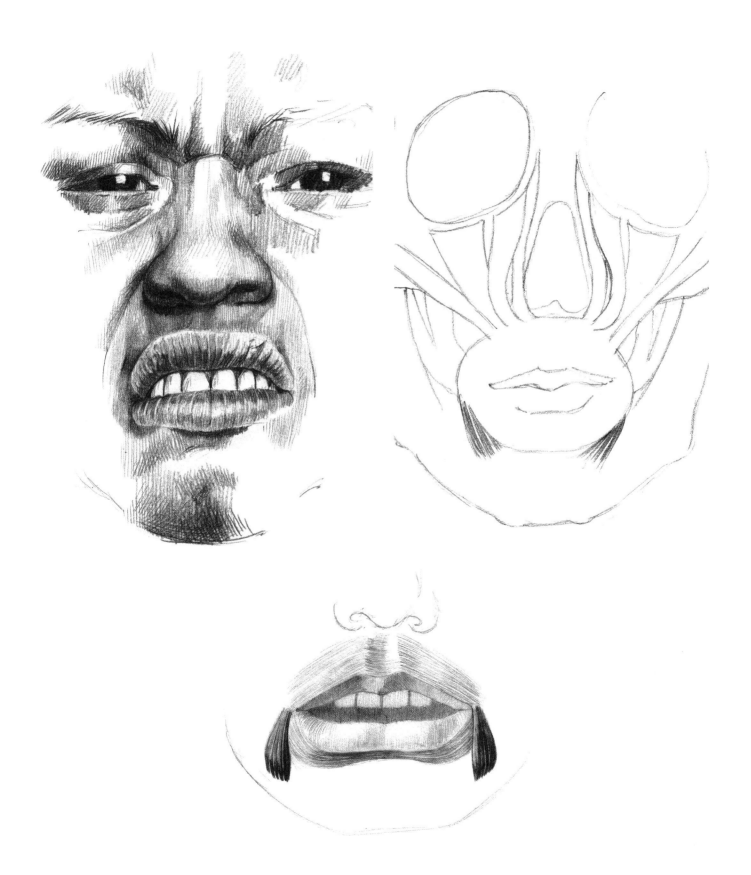

Hats and scarves often appear in portraits. This has inspired me to produce a series of drawings showing what people of different periods have worn on their heads for decoration or as protection against the weather.

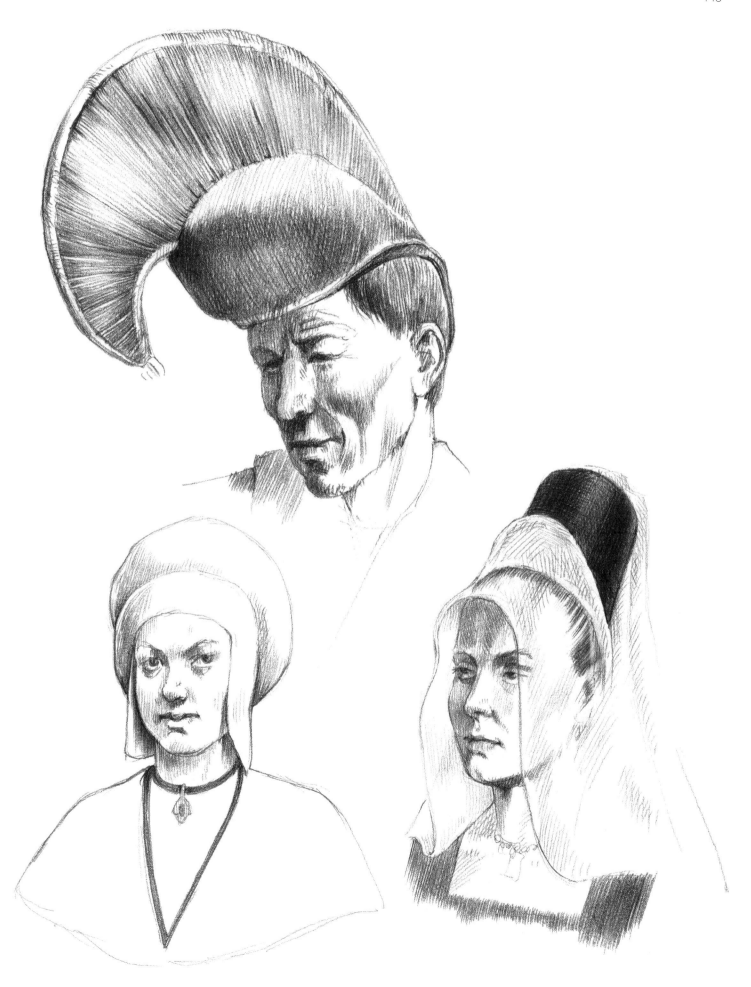

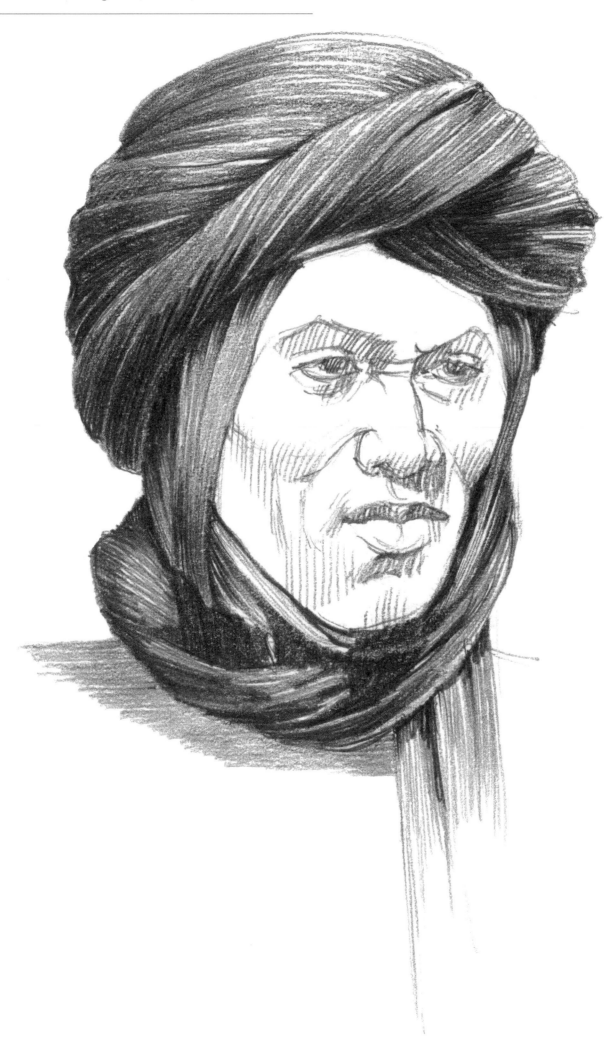

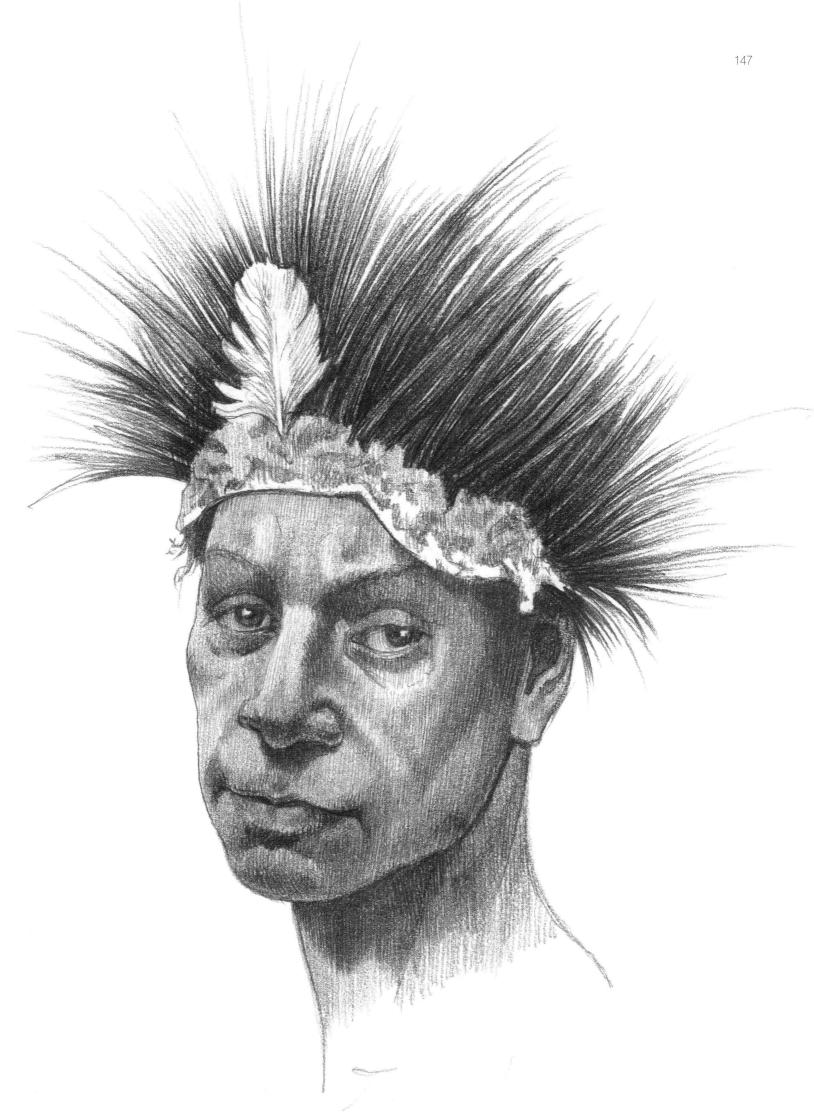

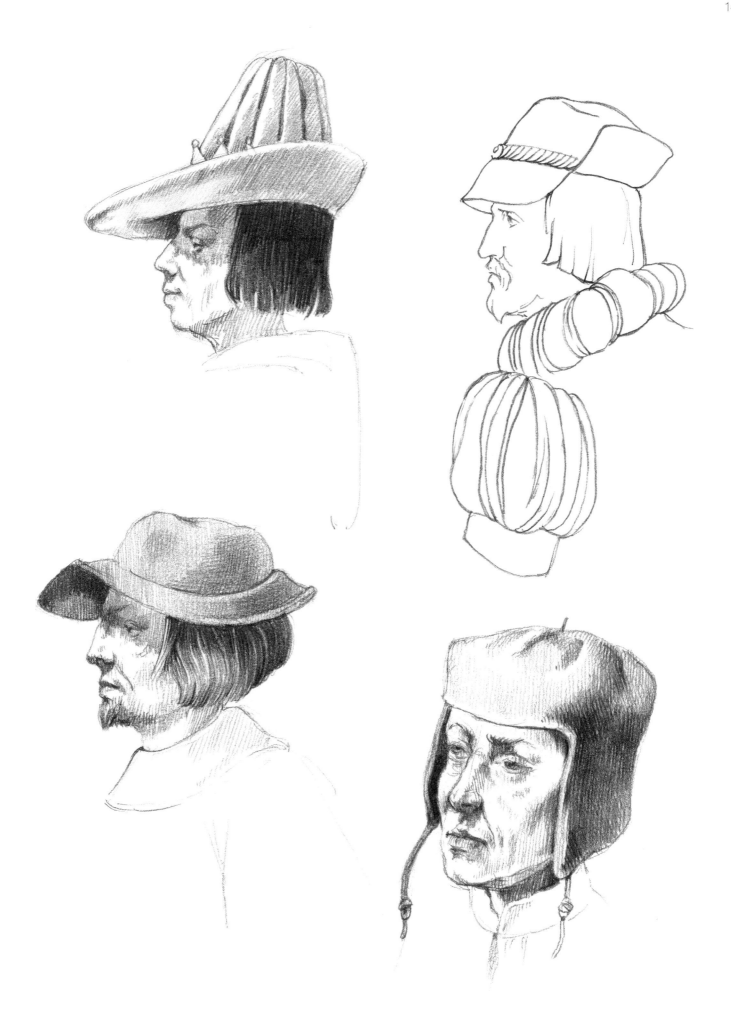

A special task awaits the artist when the model is wearing a headscarf because, in order to depict this, you need to know the rules for drawing drapery. The folds of drapery follow specific rules. With drapery fastened at a single point, the folds run outward and are conical. It is the same with drapery fastened at several points, except that a few additional downward folds form between the fastening points.

Additional rules can be noted when the cloth covers an object because the shape of the concealed object can also be made out. A figure wearing a headscarf can be compared to a drape supported by a sphere. The shape of the object that is the head is apparent at the highest point of the covering drapery, and the folds falling from this point are conical.

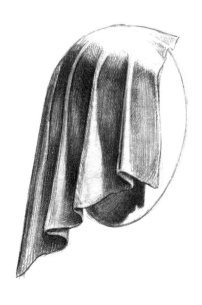
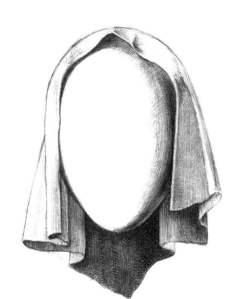
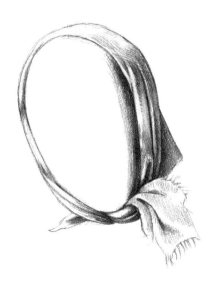

151

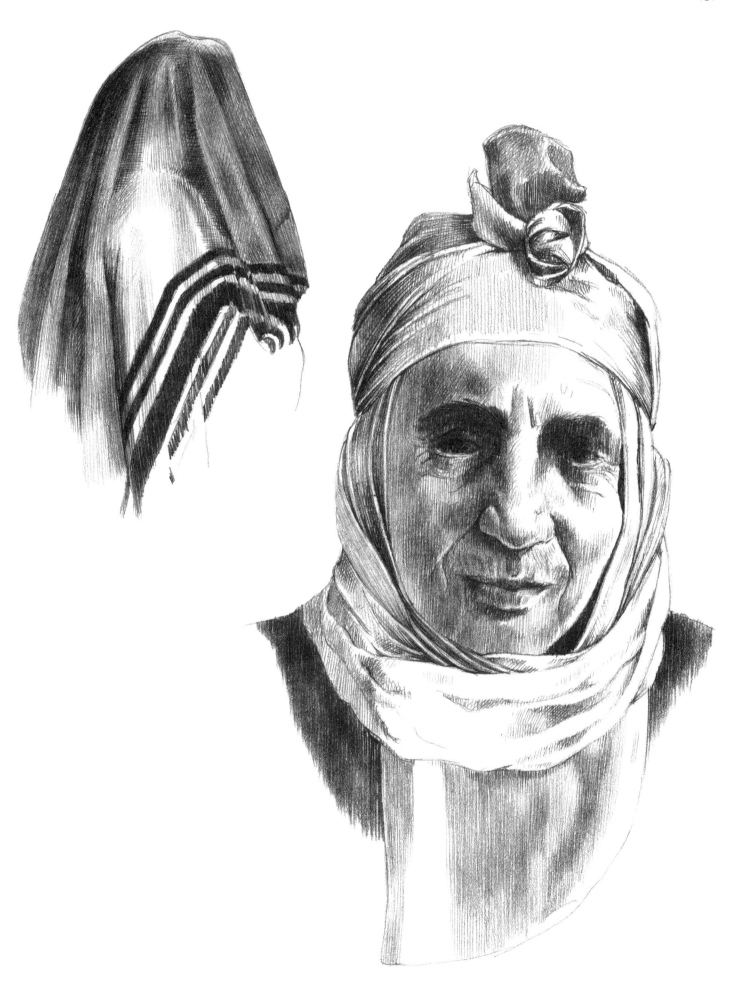

It is particularly difficult to indicate what the fabric is made of. An object under a piece of fine silk fabric is almost visible. Thicker, coarser fabrics allow less of the covered object to be made out. And in addition, of course, the composition of the fabric also determines the nature of the folds.

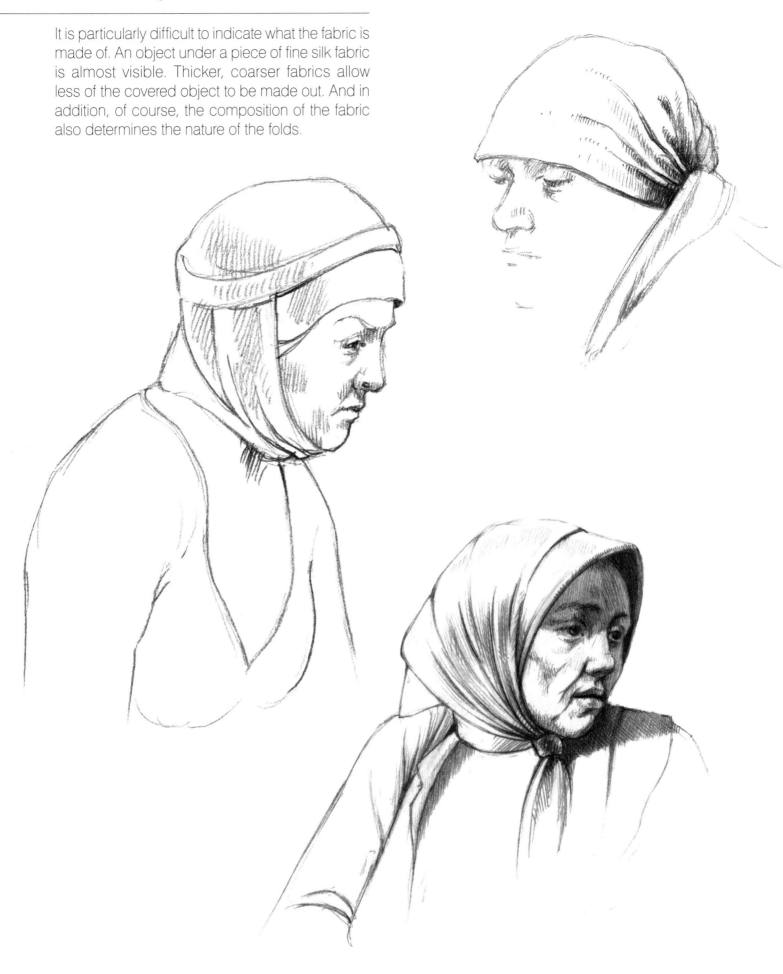

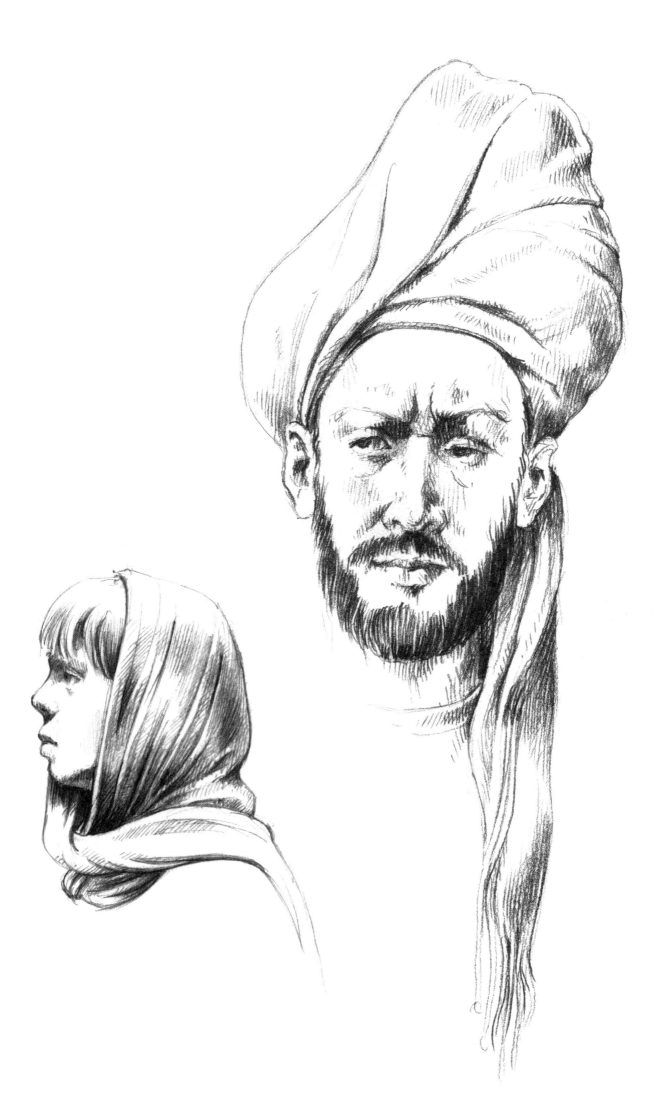

If you have read through the book as far as this and studied the various drawings, you already know a lot about drawing portraits. This is exactly the right moment to review what you have learned and go through the steps of drawing a portrait. The ideal paper size for drawing portraits is 20 x 28 inches (50 × 70 cm), and the head in the drawing should be about 8–10 inches (20–25 cm) long.

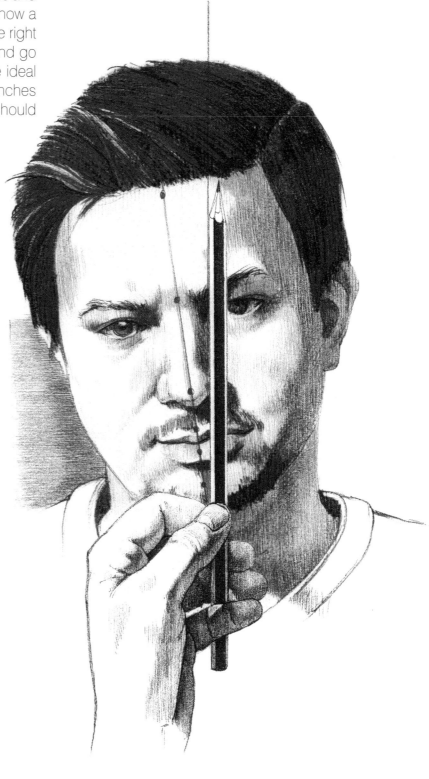

First, you must always establish the angle of the head. Hold your measuring stick along the main axis of the model's face, establish how far it deviates from the vertical, and then mark it on the paper.

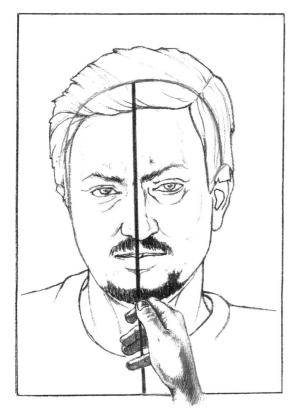

Then measure the length of the head, without the hair, and mark this in.

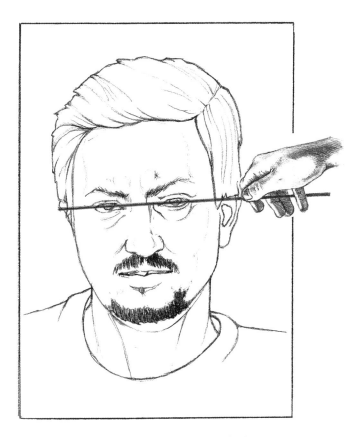

Next, measure the width of the head—that is, the distance between the two outermost points—and mark this in.

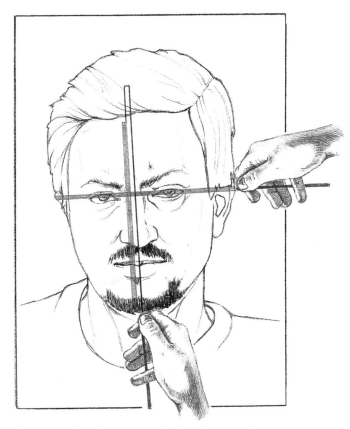

Find the relationship between the length and width, in order to reproduce it in the drawing.

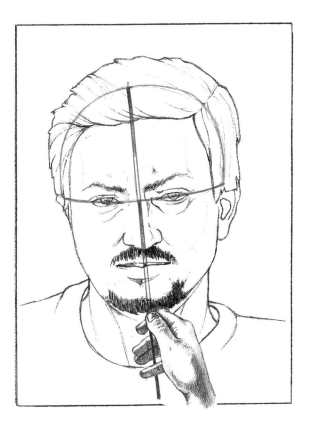

Mark in the transverse axes according to the known rules. As you know, the eye axis bisects the head. You absolutely must check this ...

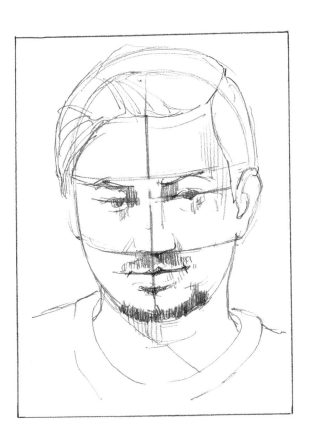

... because, if the model's head is inclined forward or back, the half that is closer to you will appear bigger than the half that is farther away, in accordance with the rules of perspective.

When drawing the head you must do a lot of measuring, but after a time you will develop an intuition and see the relationships very accurately. On this page I will discuss the most important measurements.

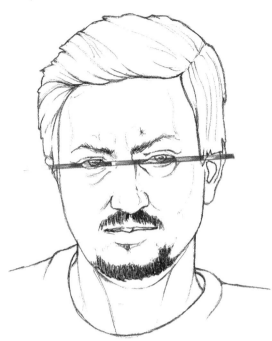

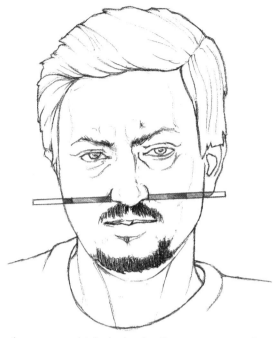

A common mistake is drawing the nose narrower than it actually is. The easiest way to check the width is to measure how many times it will fit into each half of the face.

The distance between the eyes is the width of one eye, and if you are drawing the model from directly in front, the width of the head at the height of the eye axis is about five times the width of one eye. The exact measurements can be found by measuring.

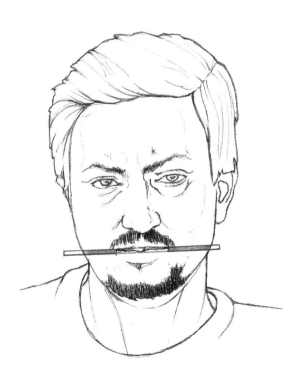

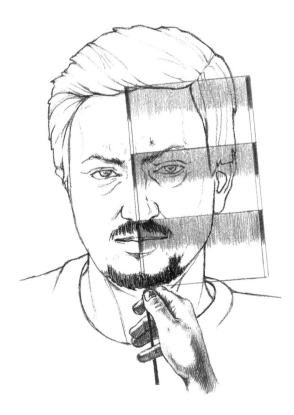

The width of the mouth can be checked using the same method as for the nose.

Check the relationship between the three sections— and whether you have taken account of the changes in perspective for a head that is turned.

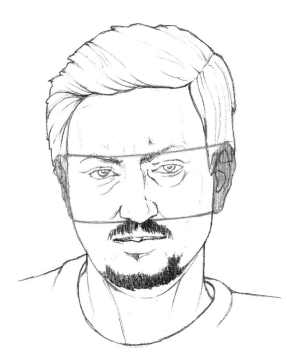

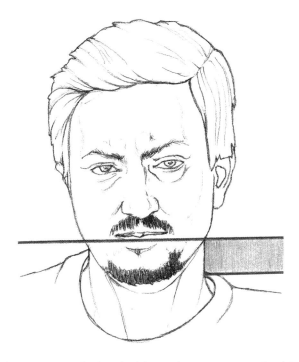

The ears are located in the section between the eyebrow axis and the nose axis. Check that you have positioned them correctly.

It is also easy to get the length of the neck wrong, so you should always check it. Hold a horizontal straight edge at the highest and lowest points of the neck and find out where the top edge crosses the face. Carry out the measurements on both sides. You can also use the Dürer Grid.

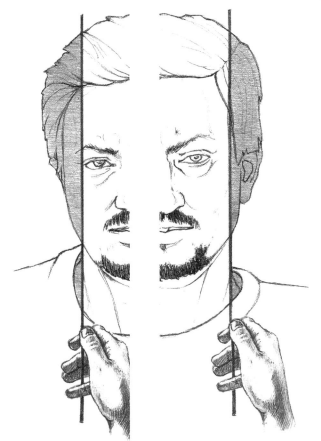

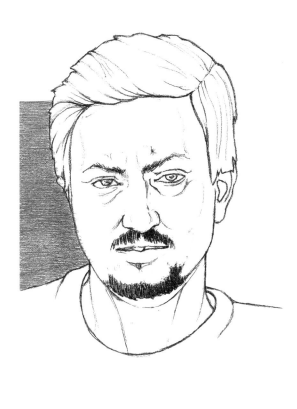

Use the following method to check whether you have drawn the neck in the right place: Hold a vertical straight edge on the line of the neck and find out where it crosses the face on each side.

It is also helpful to check the negative spaces around the head. If they do not match, the drawing must be wrong.

The phases of tonal shading

Line drawing

Marking the darkest spots

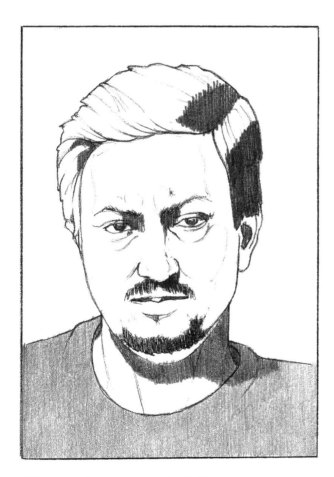

Determining the gray tone of the T-shirt

After determining the gray tone of the T-shirt comes the gray shading of the background surrounding the entire head. After these two large areas have been shaded it is easier to determine the subtler tonal values and transitions.

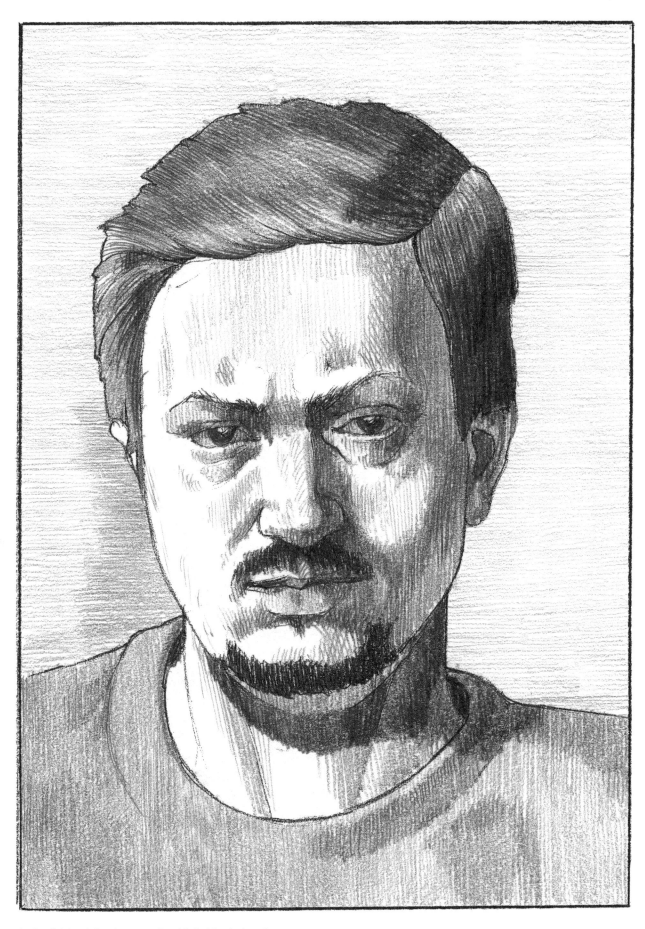

In the finished drawing you should slightly darken the
background shading next to the light part of the face, in order
to make the model stand out more. The darker tonal values
of the T-shirt reproduce the three-dimensionality of the fabric.

However, a portrait does not only consist of depicting the face, as there is often much more of the model to be seen in the drawing. If you are using a paper size larger than 20 x 28 inches (50 × 70 cm), you should definitely draw part of the body as well.

To do this, proceed as previously described, although there are a few additional things to be noted. Apart from that, I recommend revising what you have learned about composition (pages 64–67).

It is always best to begin a drawing with a small sketch in the top right-hand corner of the sheet in which you rough out the composition of the future work and position the figure. Then, when you are working, you can always see what should go where.

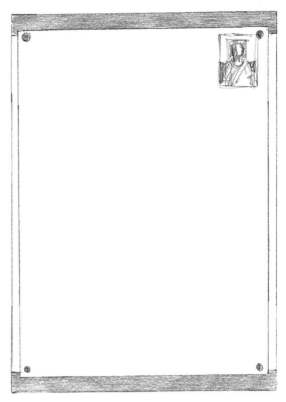

The measured length of the head is roughly equivalent to its actual length, which is a hand span …

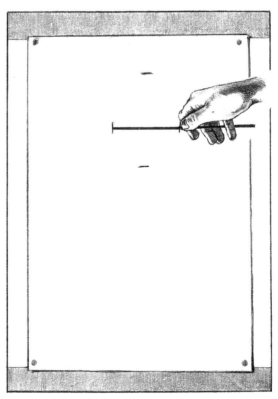

… then you mark in the full width of the head.

161

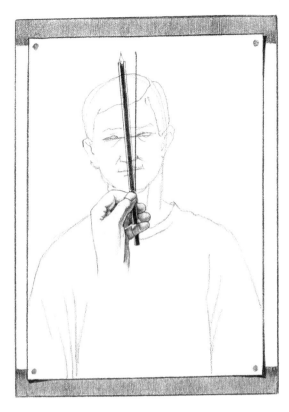

Determine the attitude of the head with the help of the main axis.

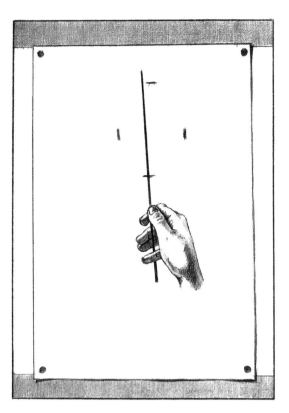

This is very important; otherwise the entire drawing may be wrong.

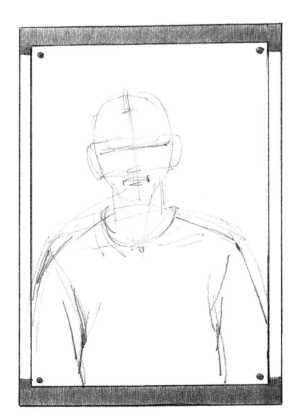

Then mark in the transverse axes running at 90 degrees to the main axis, which must be parallel to each other.

People most often make mistakes with the eye axis—so take particular care with its position!

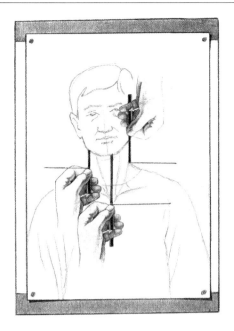

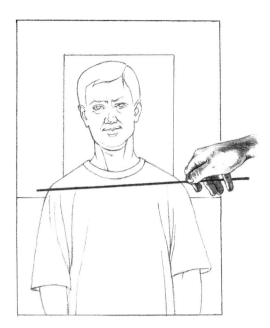

The new element is determining the shoulder line. First, establish the length of the left and right shoulders and their distance from the tip of the chin. By measuring, or with the Dürer Grid, establish the angle of the shoulders relative to the horizontal and to the transverse axes of the head. Transverse axes are also used to help you when drawing the human body. The shoulder and chest axes, which are parallel to one another, always move together in relation to the other transverse axes.

The width of the shoulders is easier to determine if you know that they are usually twice the length of the head. To get more accurate data, you must of course take measurements. Apart from that, this rule applies only if you are looking at the model from directly in front. If the model turns to one side, the more distant part will appear shorter (smaller).

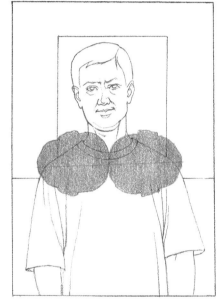

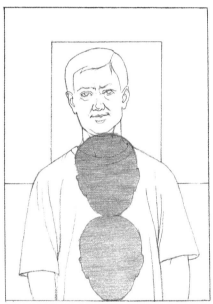

When you are already working with "head lengths," you should also check how many times it will fit below the chin.

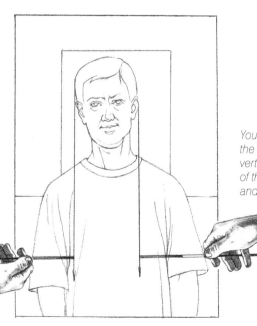

You can also check the accuracy of the drawing by establishing where vertical lines from the outermost points of the head cross the body—in reality and in the drawing.

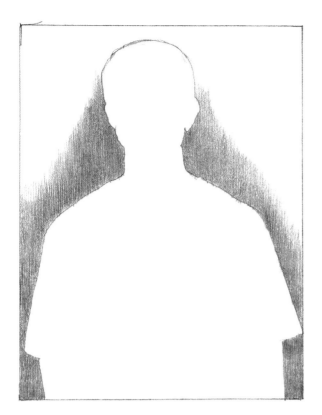

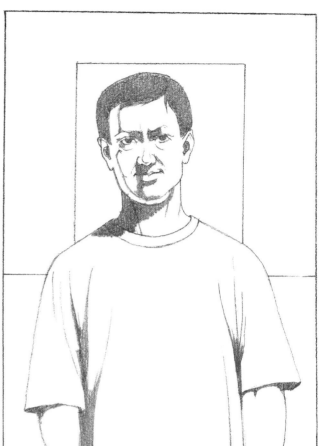

You can also check the drawing with the help of the negative spaces around the head, neck, and shoulders. They should be identical in the drawing and in reality.

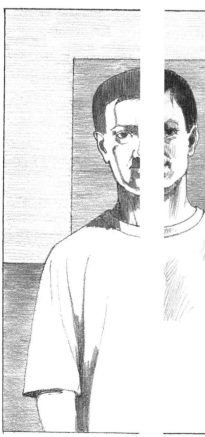

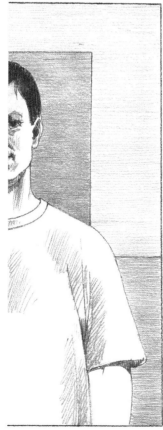

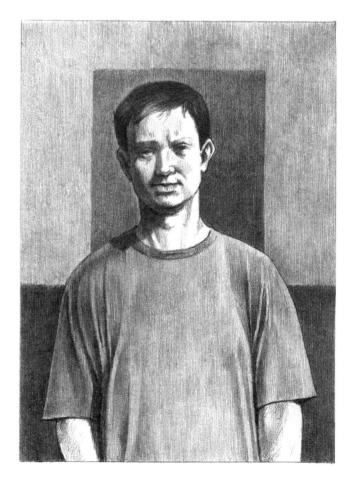

In this case, begin by shading the darkest spots, from which the lighter tones can be determined.

A **croquis** is another word for a sketch. It is all about capturing a situation or a subject with a few quick strokes. This kind of drawing is like taking notes, which you can later use to recall what you have seen. You draw sketches of this kind for yourself—although they transmit certain details, they are still only sketches. They can be line drawings or shaded drawings. Lines are only quick reminders, whereas with a little shading you can capture a lot more.

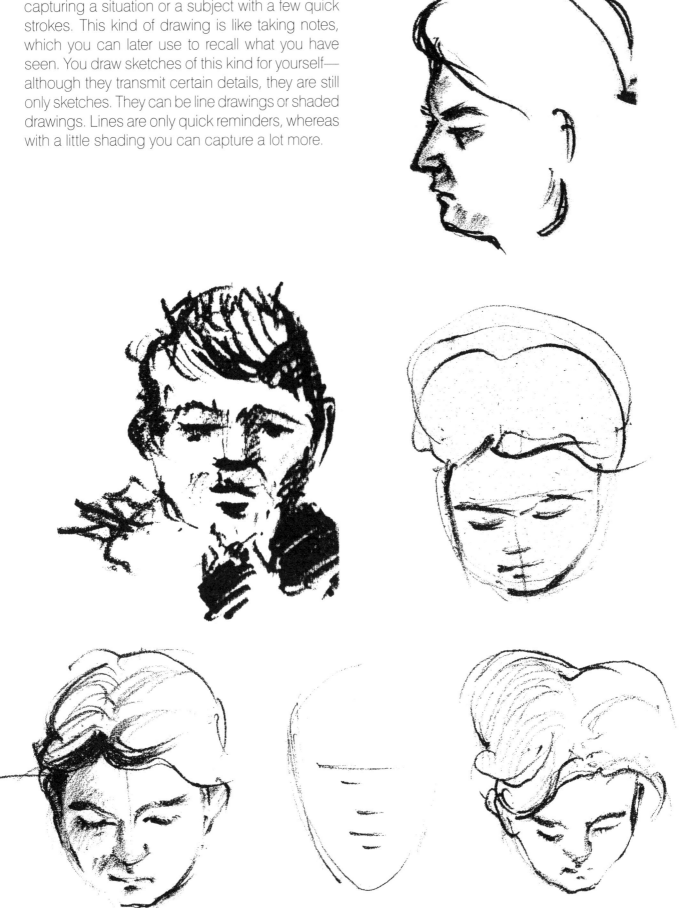

A simple sketch, consisting only of lines, indicates the model's special features.

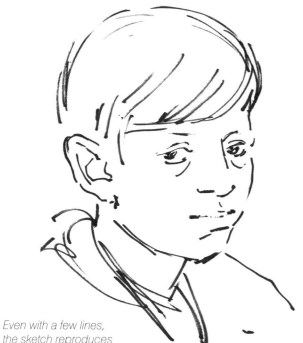

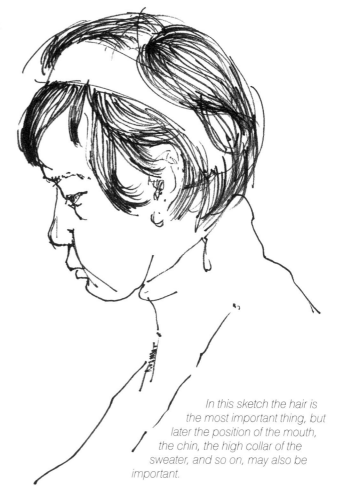

Even with a few lines, the sketch reproduces the exact shape of the eyes, mouth, nose, and head. These few lines are sufficient to capture the boy's mood and his rather sad, attentive gaze.

In this sketch the hair is the most important thing, but later the position of the mouth, the chin, the high collar of the sweater, and so on, may also be important.

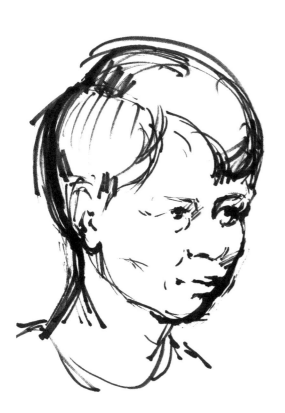

A few quick lines can also indicate the model's pose.

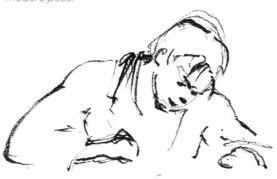

This quick sketch contains a few hints of shading.

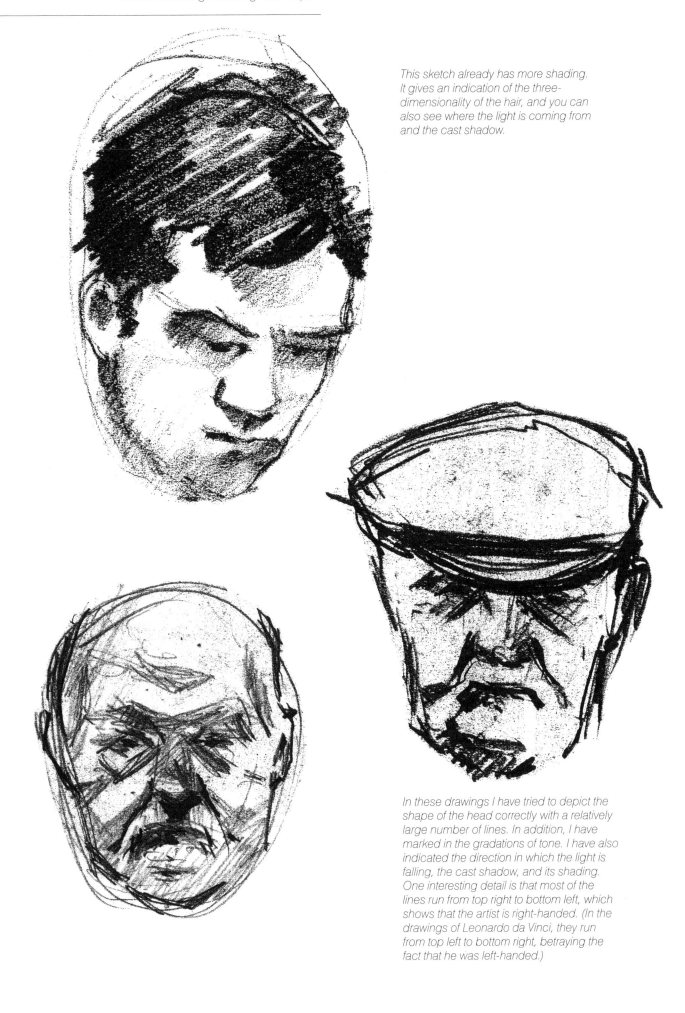

This sketch already has more shading. It gives an indication of the three-dimensionality of the hair, and you can also see where the light is coming from and the cast shadow.

In these drawings I have tried to depict the shape of the head correctly with a relatively large number of lines. In addition, I have marked in the gradations of tone. I have also indicated the direction in which the light is falling, the cast shadow, and its shading. One interesting detail is that most of the lines run from top right to bottom left, which shows that the artist is right-handed. (In the drawings of Leonardo da Vinci, they run from top left to bottom right, betraying the fact that he was left-handed.)

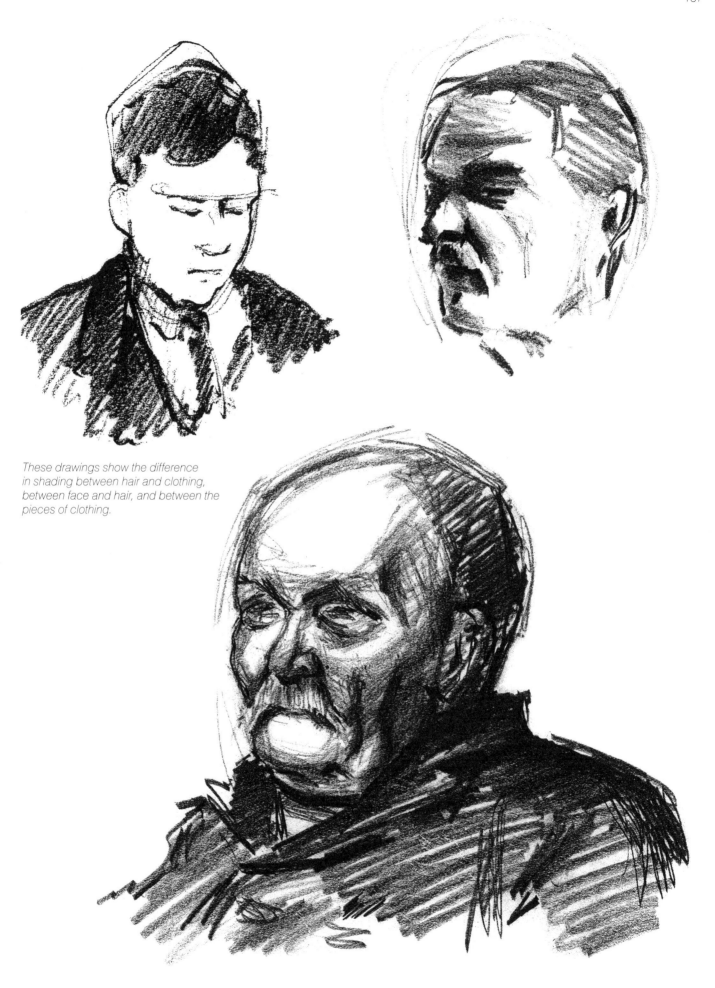

These drawings show the difference in shading between hair and clothing, between face and hair, and between the pieces of clothing.

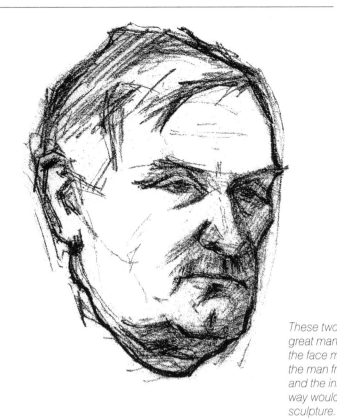

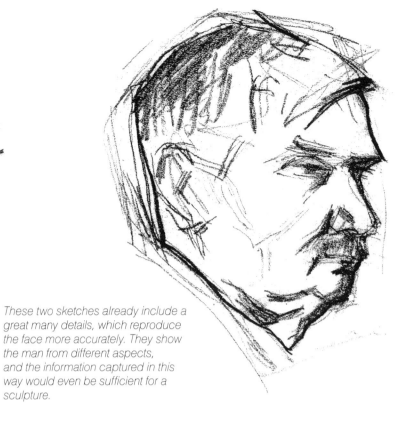

These two sketches already include a great many details, which reproduce the face more accurately. They show the man from different aspects, and the information captured in this way would even be sufficient for a sculpture.

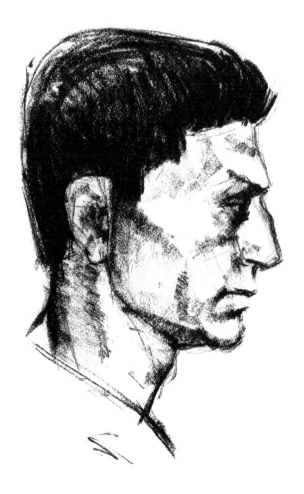

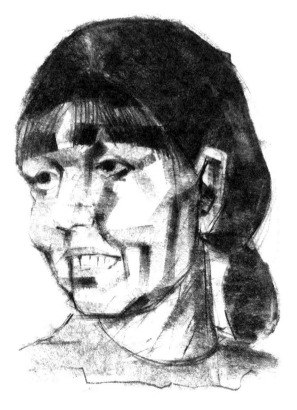

You can use all kinds of drawing implements for sketching, including chalk. If you lay it on flat, you can shade almost the entire head. You can draw lines with the corner, or if you hold it at a slight angle, you can use different amounts of pressure to achieve various gradations of tone. Chalk drawings must be fixed (see pages 184–185), as they smudge easily and rub off onto other drawings.

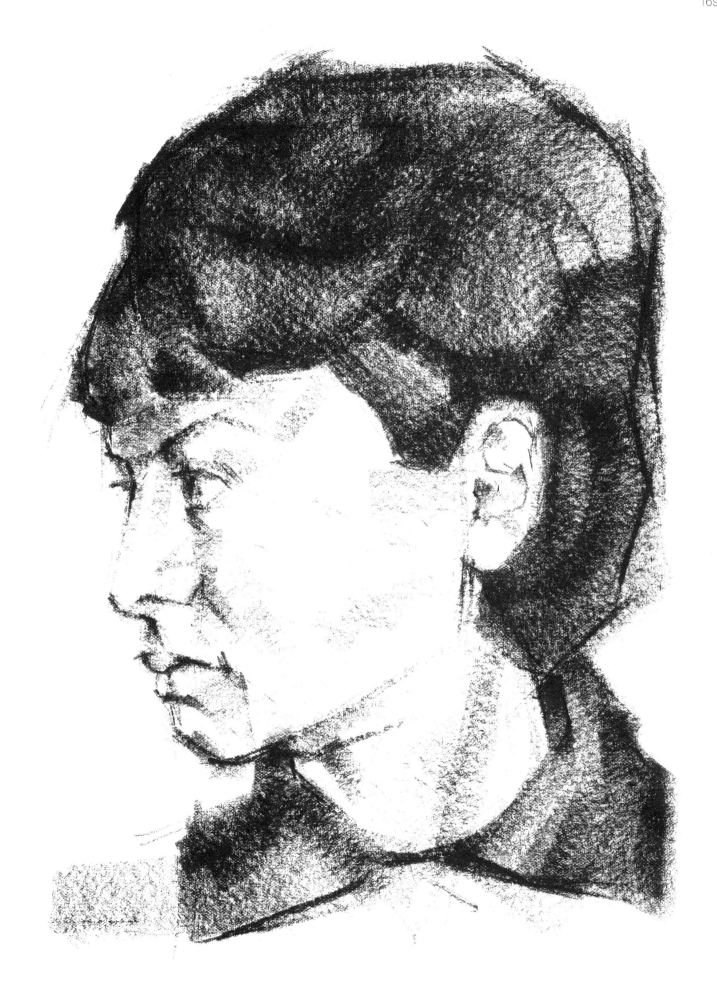

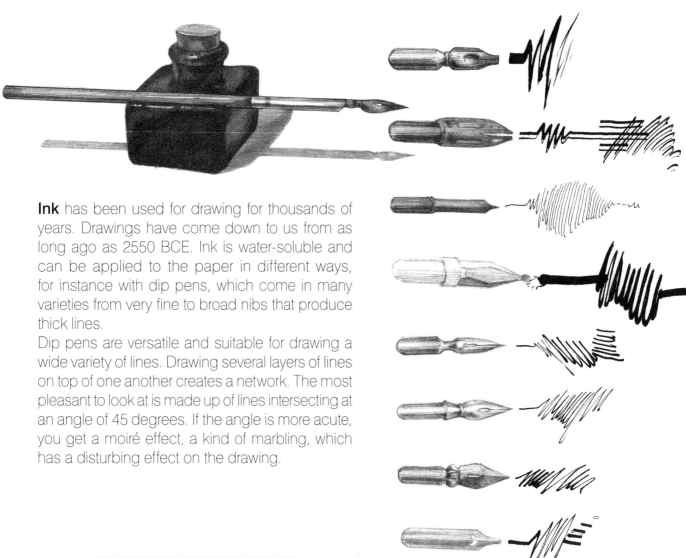

Ink has been used for drawing for thousands of years. Drawings have come down to us from as long ago as 2550 BCE. Ink is water-soluble and can be applied to the paper in different ways, for instance with dip pens, which come in many varieties from very fine to broad nibs that produce thick lines.

Dip pens are versatile and suitable for drawing a wide variety of lines. Drawing several layers of lines on top of one another creates a network. The most pleasant to look at is made up of lines intersecting at an angle of 45 degrees. If the angle is more acute, you get a moiré effect, a kind of marbling, which has a disturbing effect on the drawing.

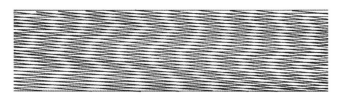

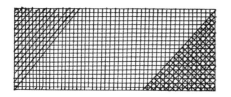

The different forms and interaction of the lines make it possible to create an incredible variety of pen-and-ink drawings. Lines that are parallel and as far as possible equidistant are known as hatching; this makes gray tones darker when the lines are closer together and lighter when they are farther apart. Of course, you can also draw several—two, three, four, etc.—layers of lines on top of one another, creating a network called cross-hatching. When you do this, it is important that the distance between the lines is even and that each layer is drawn at an angle of 45 degrees to the previous layer. You can also use dots (stippling) in the drawing. Dense stippling produces a darker tone, less dense stippling gives a lighter shade. Of course, the drawing can also consist of irregular lines 1–2 millimeters in length or of black and white patches.

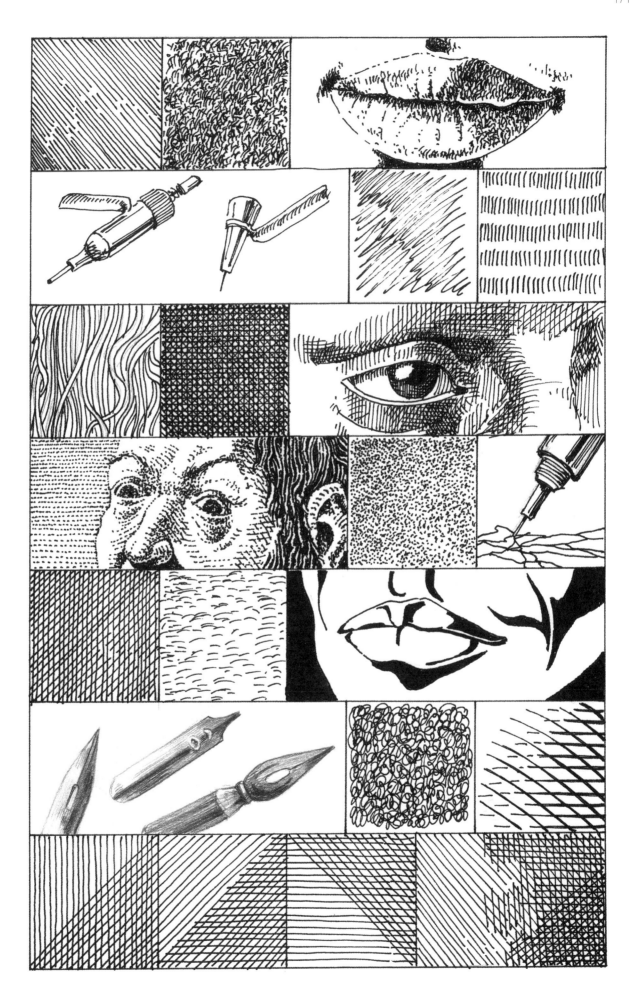

Portraits consisting only of short lines are very time-consuming, but in return they also look very impressive. It is quicker to use a variety of lines. In the second drawing I have reproduced the three-dimensionality and gradations of tone by using layers of parallel lines and short, irregular lines. The third drawing is made up of dots arranged in lines.

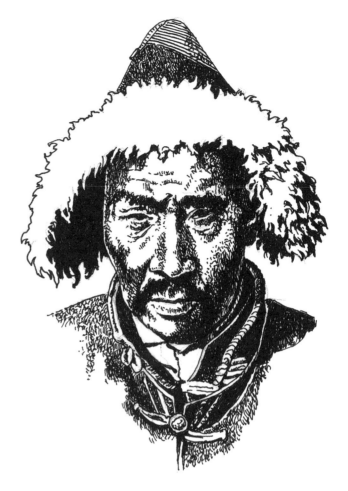

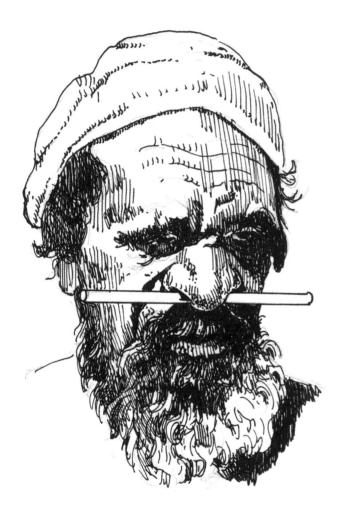

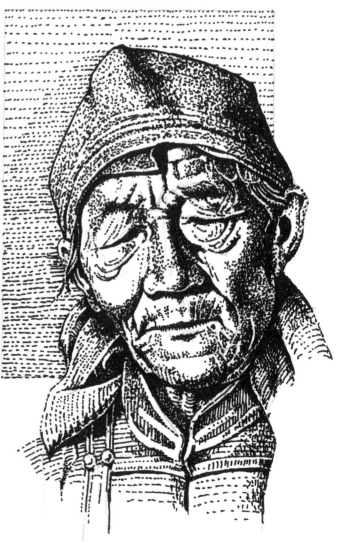

Pen and ink drawings can even be done using a homemade wooden stylus or a pointed drawing tube. Of course, the lines will not be nearly as regular as those drawn with a pen, but therein lies the charm of such drawings. These tools are particularly suitable for sketches.

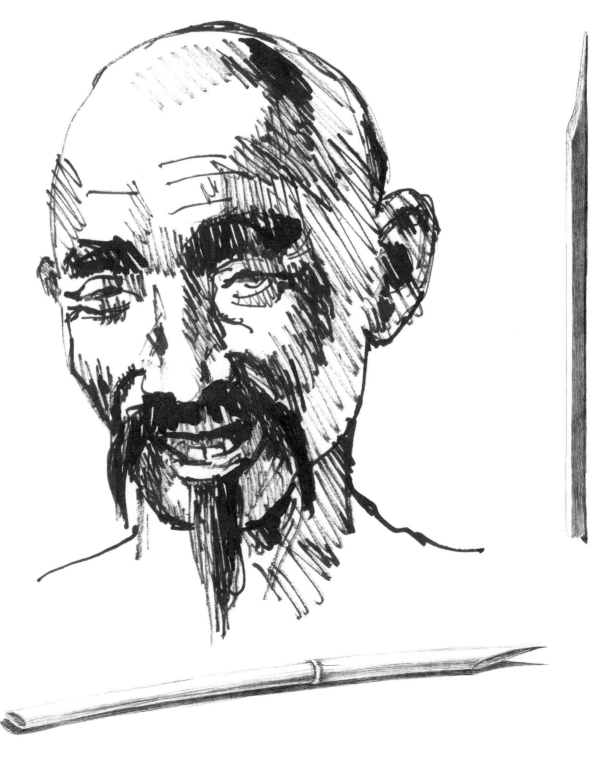

For **ink wash drawings** you use thick and thin brushes. The shades are mixed on a separate sheet of paper, which serves as a palette. You begin work with the light tones and then tackle the darker shades, as mistakes in the lighter shades can still be corrected. The technique of ink wash requires a sound knowledge of drawing. The drawing acquires its beauty from the large areas and accurate lines. Finally, you can round it off with a few strong outlines drawn in pen.

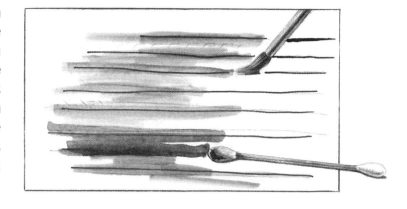

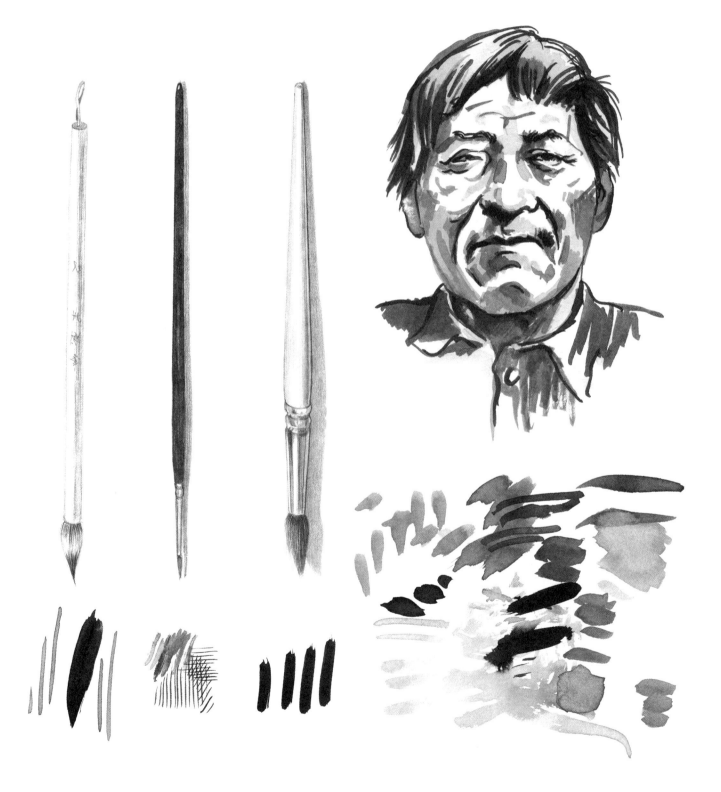

When you are using a technique that involves applying a lot of water and moistening the paper (such as watercolor and pen and ink drawing), the paper must first be stuck to the board and stretched. The moistened sheet is glued to the drawing board with a strip of gummed paper. When it has dried, the paper will be taut and smooth. If you paint on it without stretching it, it will cockle as it dries.

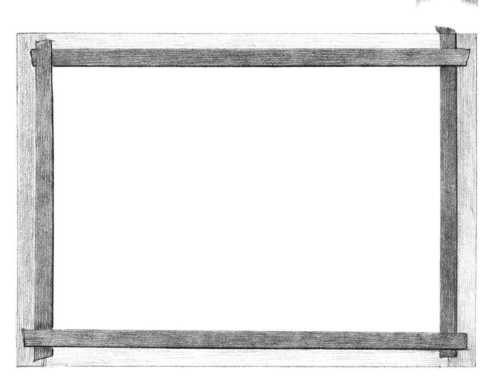

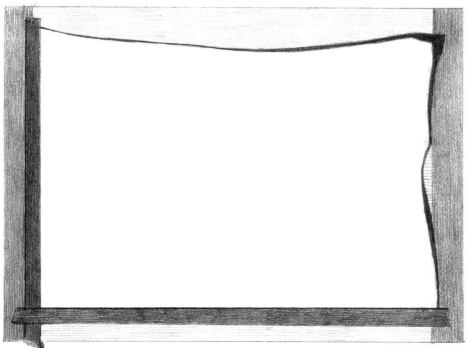

The **pencil** is the first drawing tool you use as a child. There are important rules for pencil drawing, which you must not only know but also be able to apply in practice.

Pencils may be hard or soft. Hard ones are marked with the letter H and soft ones with a B. Use hard pencils marked H, 2H, and 3H. With these you can reproduce very pale gray tones. Lines drawn with pencils marked B, 2B, 3B, 4B, 5B, 6B, 7B, and 8B are almost oily and smudge easily. The softer the pencil, the darker the lines and areas you can draw with it.

Shading determines the quality, gradation, and effect of the colors. When you have decided on the line drawing, which must also correspond to the proportions, you must "color it in"—that is, represent the three-dimensionality of the model with areas or shading of different depths. The gradations of tone must be clear in the drawing. Very similar tones can only be separated by lines.

It is important that the lines and the distances between them follow a rhythm. If you shade with repeated short lines, an unwanted line appears where they meet.

If you draw lines of different lengths, a kind of white line effect is created, which is disturbing to look at.

The closer together the lines are, the "calmer" and more beautiful the surface becomes. It is important always to press equally heavily with the pencil.

The eye finds a confusion of lines disturbing and unpleasant.

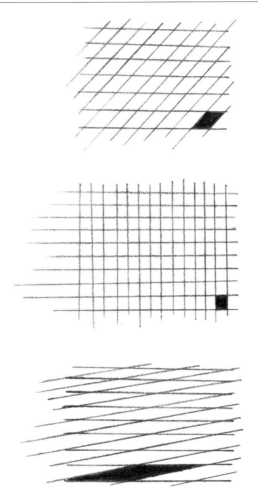

Shading can be made up of one, two, or several layers of lines. Two layers create a network. The best result is achieved when the lines cross at an angle of 45 degrees.

You can also create a network with lines crossing at a right angle, although it is less attractive to look at.

The rhombuses that are created when the lines form an acute angle are irritating to the eye. In addition, a moiré effect is created, producing an unwanted line that has a disturbing effect.

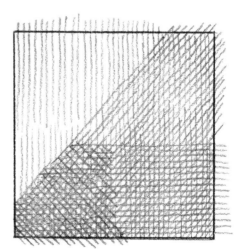

The rhythm of the lines—that is, the amount of distance between them— changes the tonal value.

Confused lines have a disturbing effect, muddle the tones, and are unattractive to look at.

If you draw one, two, three, or four networks of equal density on top of one another, you end up with four different shades of gray.

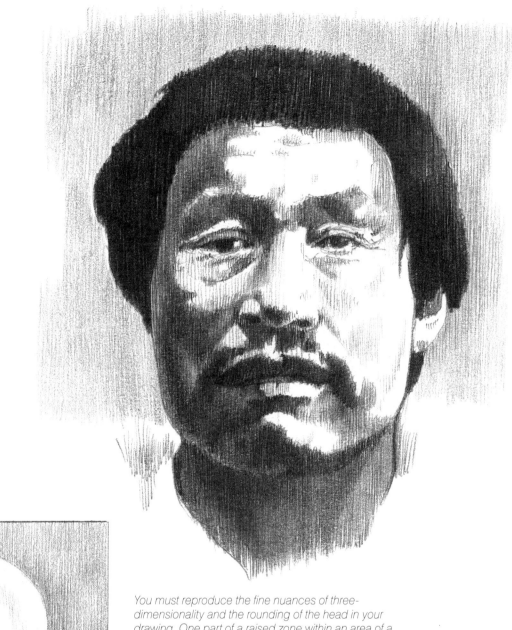

You must reproduce the fine nuances of three-dimensionality and the rounding of the head in your drawing. One part of a raised zone within an area of a specific tone will be lighter and the other darker than the basic tone. This also applies to indentations. In the case of almost indistinguishable differences in tonal values, even if they are very bright, the darker area where the two patches meet is made slightly darker.

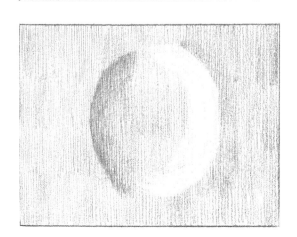

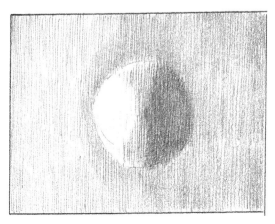

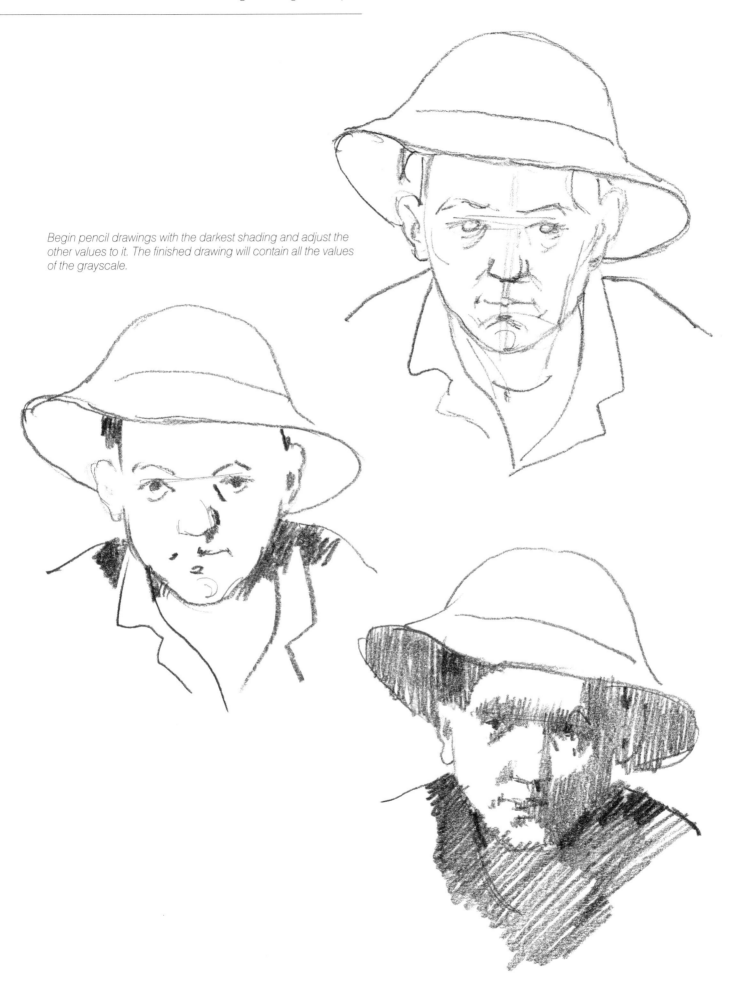

Begin pencil drawings with the darkest shading and adjust the other values to it. The finished drawing will contain all the values of the grayscale.

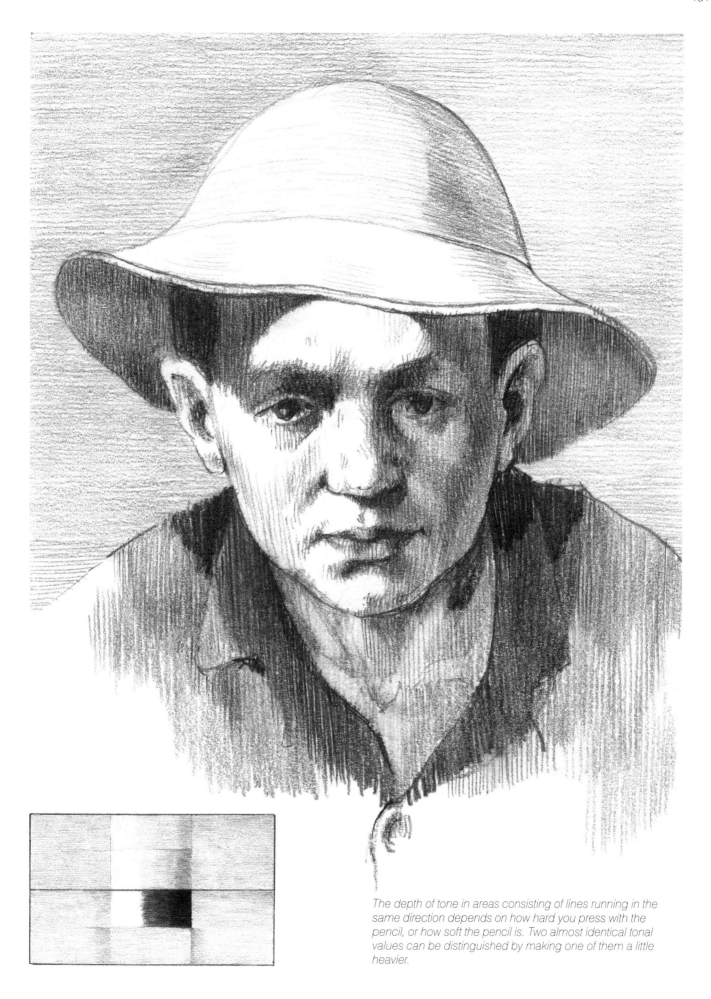

The depth of tone in areas consisting of lines running in the same direction depends on how hard you press with the pencil, or how soft the pencil is. Two almost identical tonal values can be distinguished by making one of them a little heavier.

Charcoal is the oldest drawing medium. Very beautiful, delicately shaded drawings can be created with it—and relatively quickly—because the gradations of gray and black can be applied to large areas of the paper.

Drawing charcoal is used in a different way from a pencil, and, like all others, the technique must be learned. After you have drawn the first lines and areas, you will notice that the white patches on the paper have an unpleasant shine. My recommendation is to blur these first lines and patches. This produces a gray surface, giving the paper a slightly darker tone so there will no longer be any vibrant white patches appearing between the black lines. The charcoal is applied in relatively broad patches using the broad side of the tip, almost as if you were putting the drawing together with mosaic tesserae. Charcoal is easily blurred using a finger, the edge of your hand, a tissue, and so on. I recommend using a piece of felt, with which you can produce lovely even gray tones.

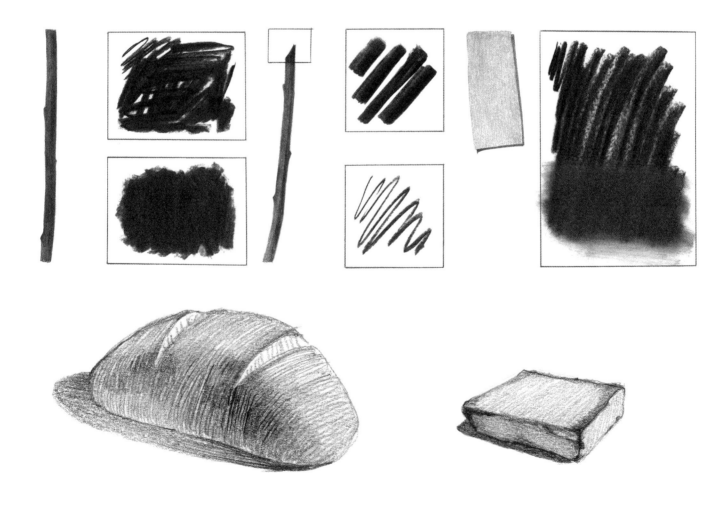

For your first attempt at using charcoal, I recommend energetic movements rather than a timid approach. Begin with quick, sketchy pictures—finish a complete drawing in a quarter to half an hour—while making the tonal values as accurate as possible. This kind of practice will give you confidence, which is important, because using this technique you can finish a very artistic piece of work within an hour. Charcoal drawings can be corrected using a special eraser made of kneaded rubber. However, you will need to be careful because, when it gets old, it can easily stick to the paper. If this happens, you will not be able to remove it and you will no longer be able to use charcoal on these parts of the paper. The other kind of "eraser" is breadcrumbs, with which mistakes can be removed without trace. Finished charcoal drawings must be fixed (see pages 184–185) because they are very delicate and smudge easily.

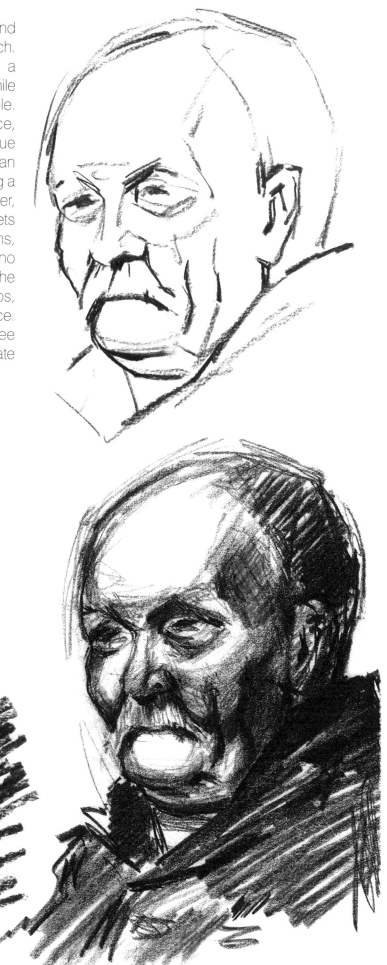

After finishing a drawing there are still several tasks remaining to be done. Pencil, charcoal, chalk, and pastel drawings must be fixed because they are very delicate and may easily be rubbed off the paper.

The simplest, though not the cheapest, solution is to buy a can of fixative and spray the drawing with it from a distance of 8–12 inches (20–30 cm). In order not to soak the paper, you must keep the can moving all the time. Alternatively, you can apply the ready-made fixative with a spray tube as follows: Put the longer, thinner part of the spray tube in the fixative and blow into the shorter, thicker tube, which should be at a right angle to the thinner tube. Make sure it is at a right angle; otherwise the apparatus will not work. Occasionally, the fixative will dry up inside the thinner tube making it unusable. Clean it out with a thin wire.

Lastly, you can also make your own fixative. Dissolve a little under 2 ounces (50 g) of white shellac (be careful, brown shellac will discolor the drawing when it dries!) in 17 fluid ounces (0.5 l) denatured alcohol. It takes several days for the shellac to dissolve. Shake the mixture several times during this period. The finished fixative should be sprayed on with a spray tube.

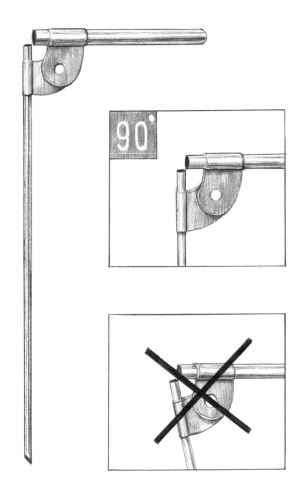

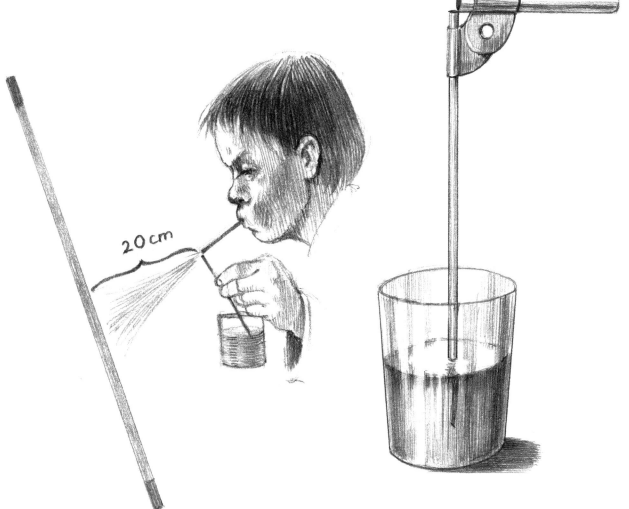

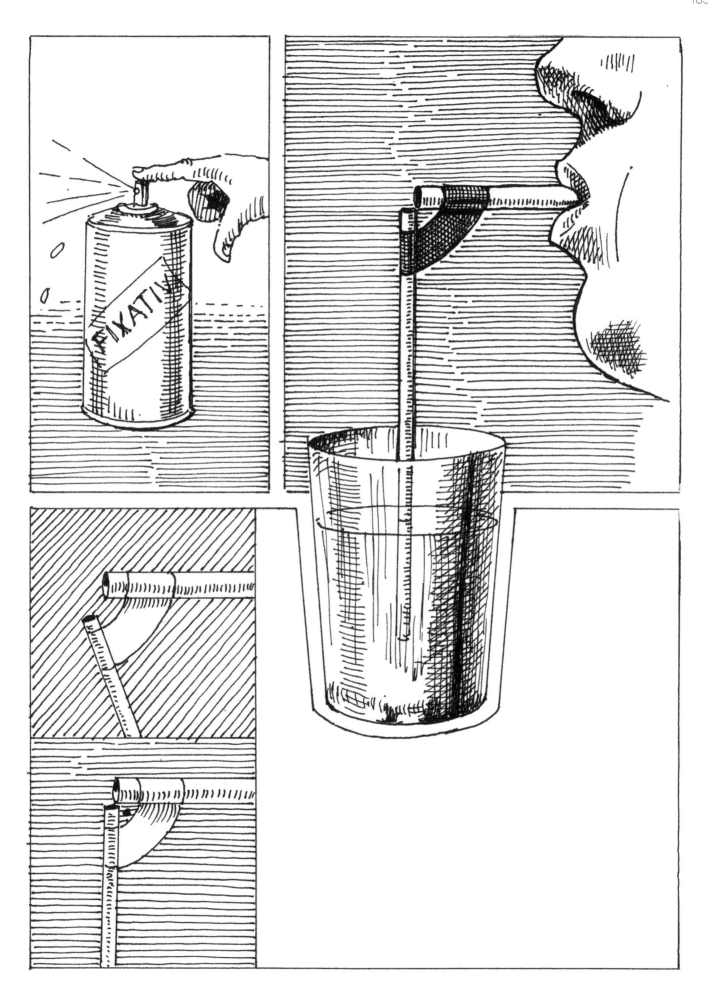

Drawings, duplicated graphics, pastel drawings, and watercolors can be framed using a paper or paperboard mat known as a passe-partout, in which the drawing is positioned so that the edges of the paper are hidden.

According to the rules of composition, you should position a full-face portrait in the middle but leaving slightly more space above the head and slightly more below.

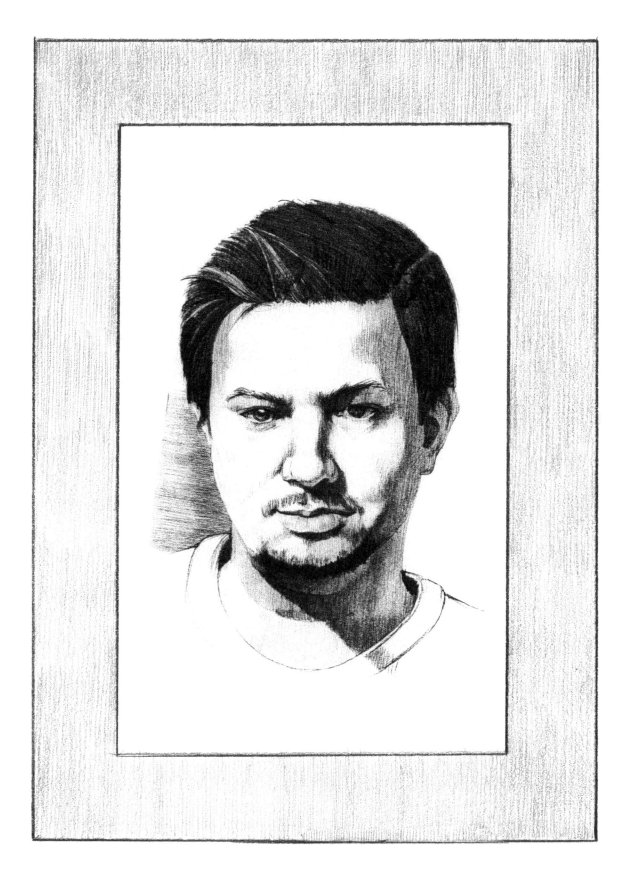

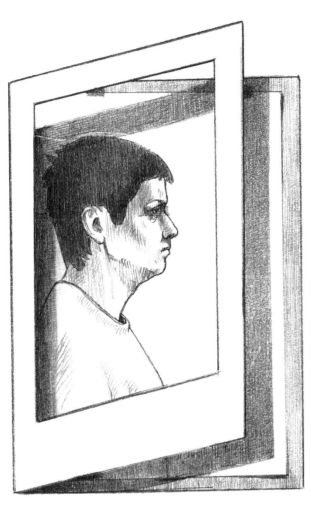

A passe-partout consists of two pieces, the front "page" with the cut-out section and the back "page" to which the drawing is fastened with a few pieces of paper tape. Be careful: After a few years, conventional adhesive tape will cause brown discolorations resembling spots of oil on the drawing!

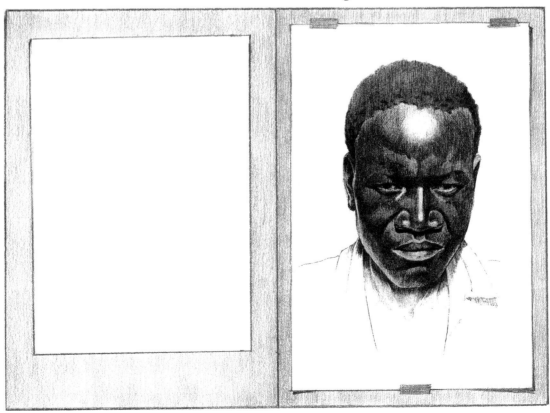

A passe-partout looks nice if the border surrounding the cut-out is the same width all the way round. Sometimes the two side borders and the top border are the same width and the bottom border is wider, or the side borders are the same width but the top and bottom borders are narrower.

An unnecessarily narrow top border is unattractive and distracts attention from the drawing.

You always sign on the drawing itself, never on the passe-partout, because it could be removed at a later date. All drawings, and also watercolors, are signed in pencil, with the exception of pen-and-ink and charcoal drawings, which are signed in their own medium.

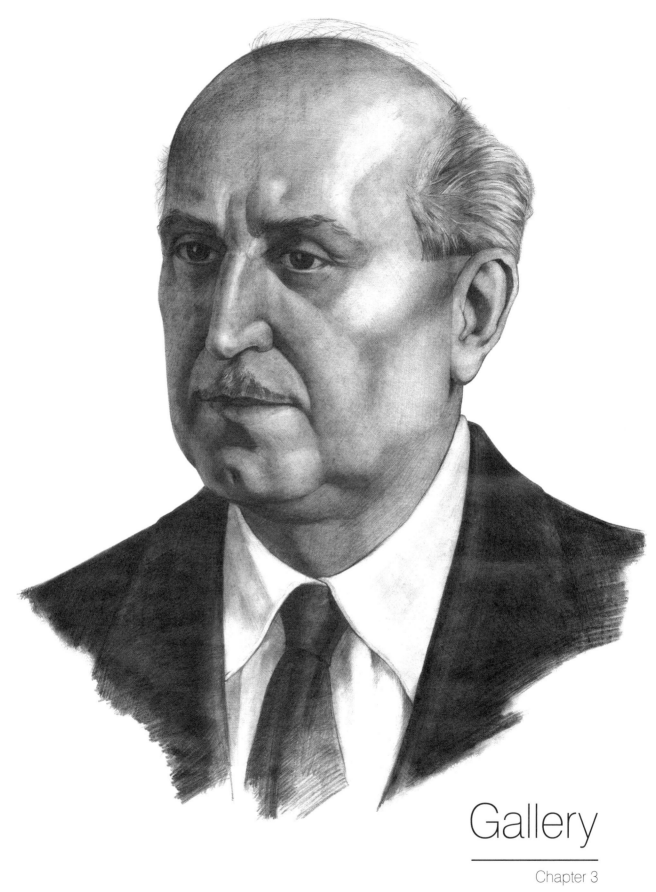

Gallery

Chapter 3

Line drawing in felt pen

Line drawing in felt pen

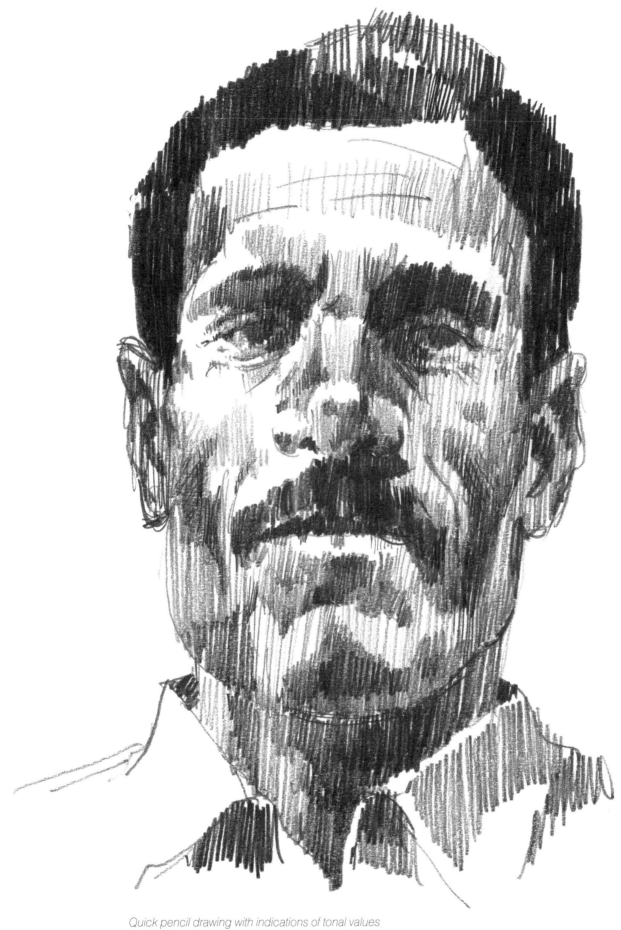

Quick pencil drawing with indications of tonal values

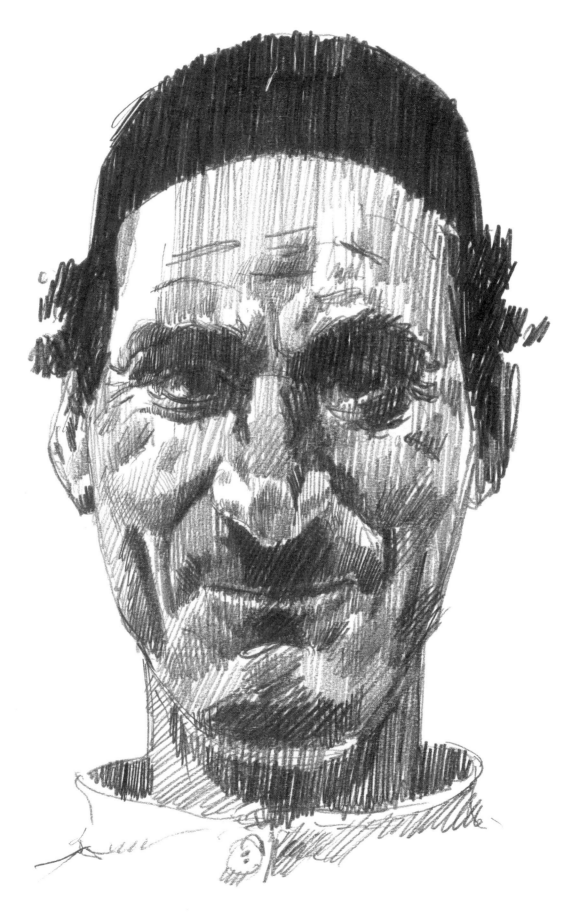

Quick pencil drawing with indications of tonal values

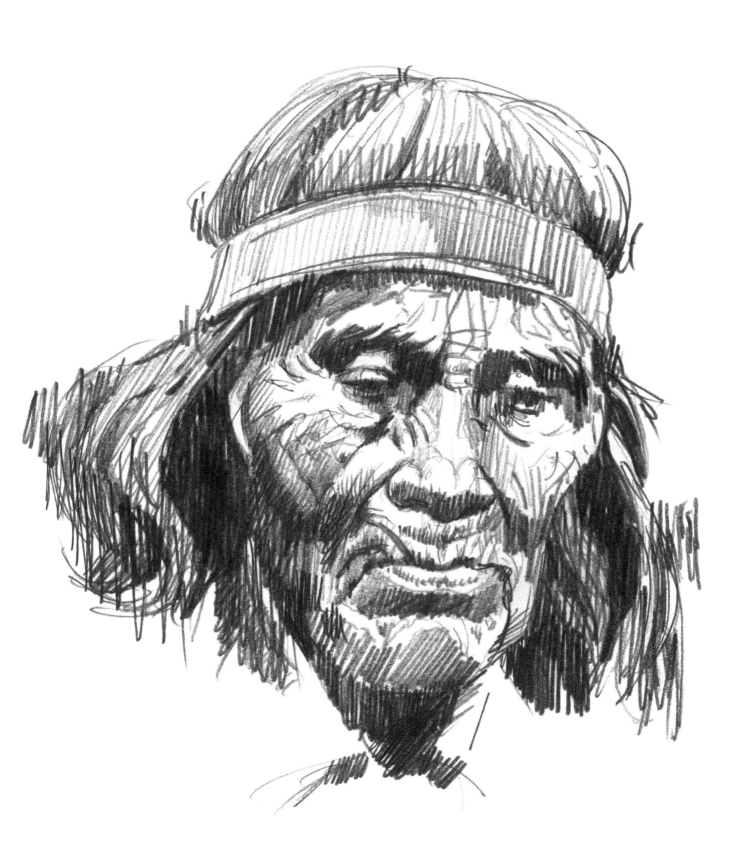

Quick pencil sketch

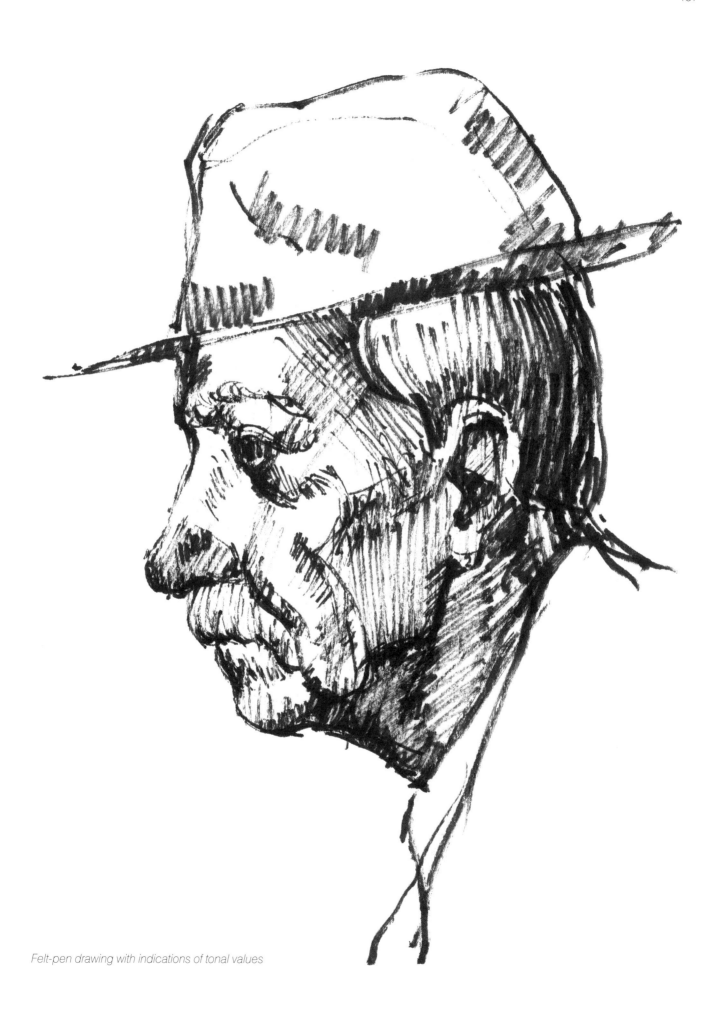

Felt-pen drawing with indications of tonal values

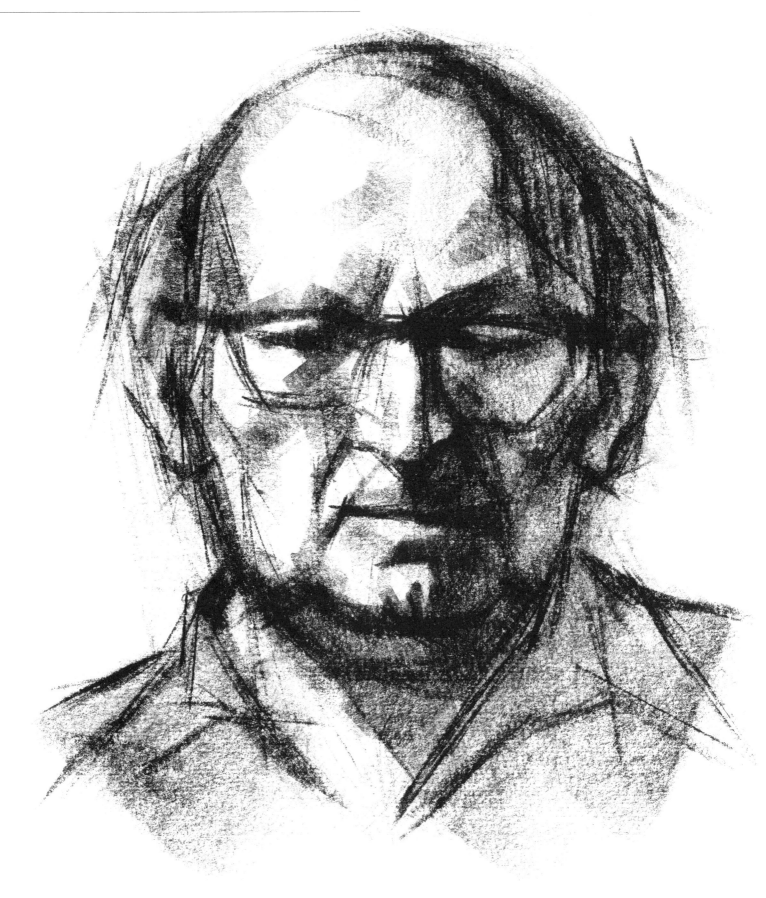

*Chalk drawing with the chalk laid on flat, with quick
guidelines on form and tonal values*

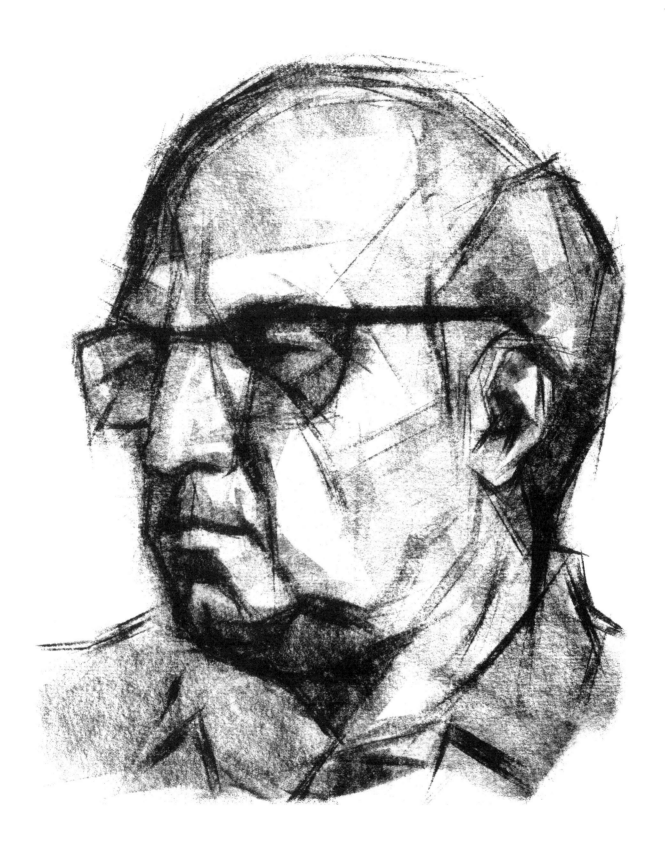

*Chalk drawing with the chalk laid on flat, with quick
guidelines on form and tonal values*

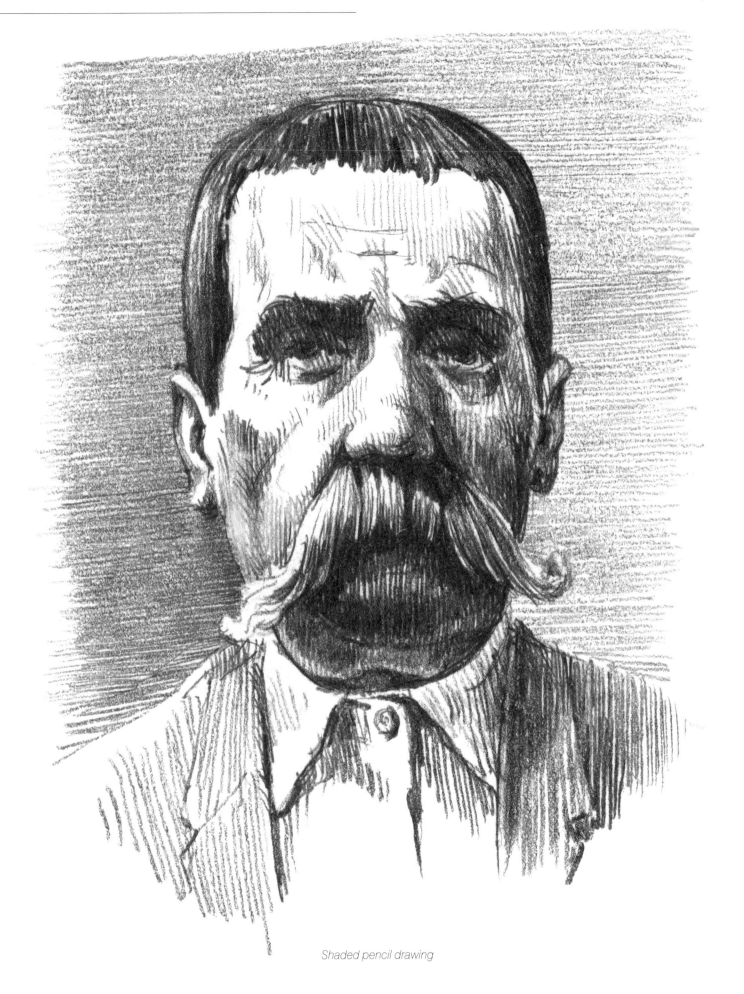

Shaded pencil drawing

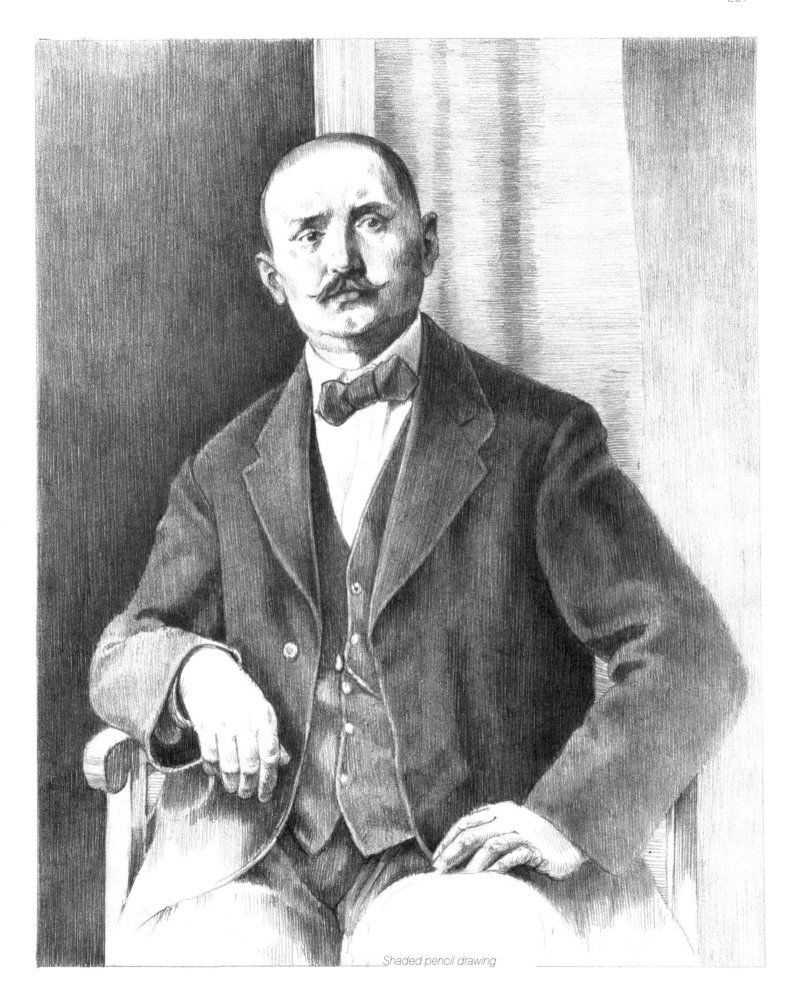

Shaded pencil drawing

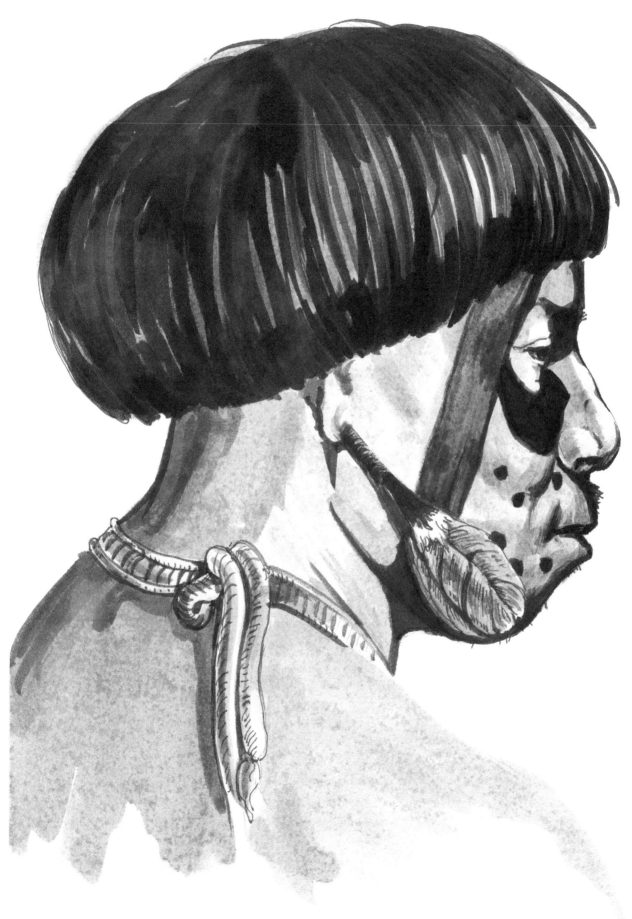

Ink and wash sketch, with indications of tonal values

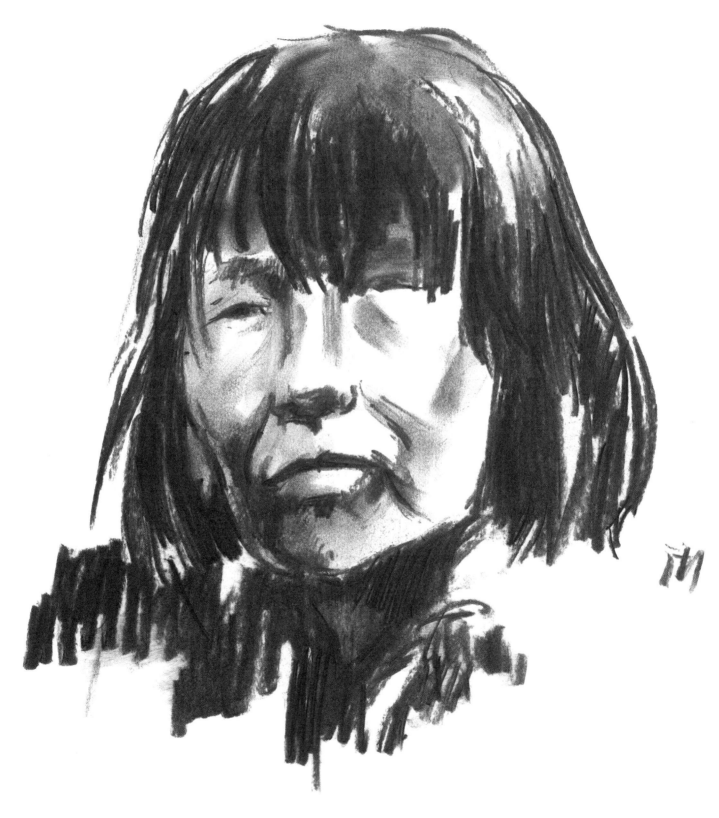

Ink and wash sketch, with indications of tonal values

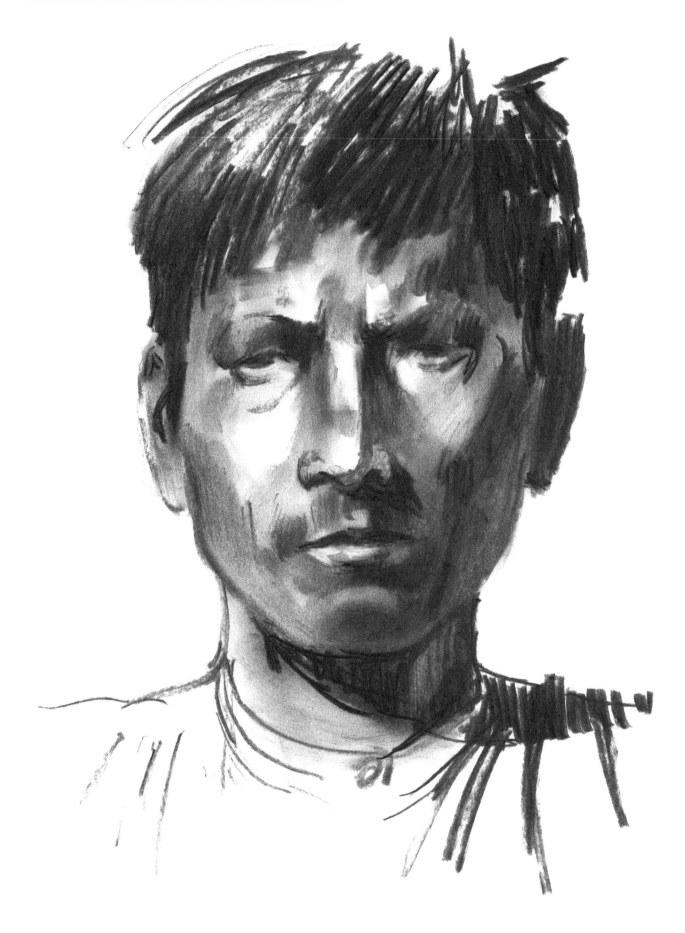

Ink and wash sketch, with indications of tonal values

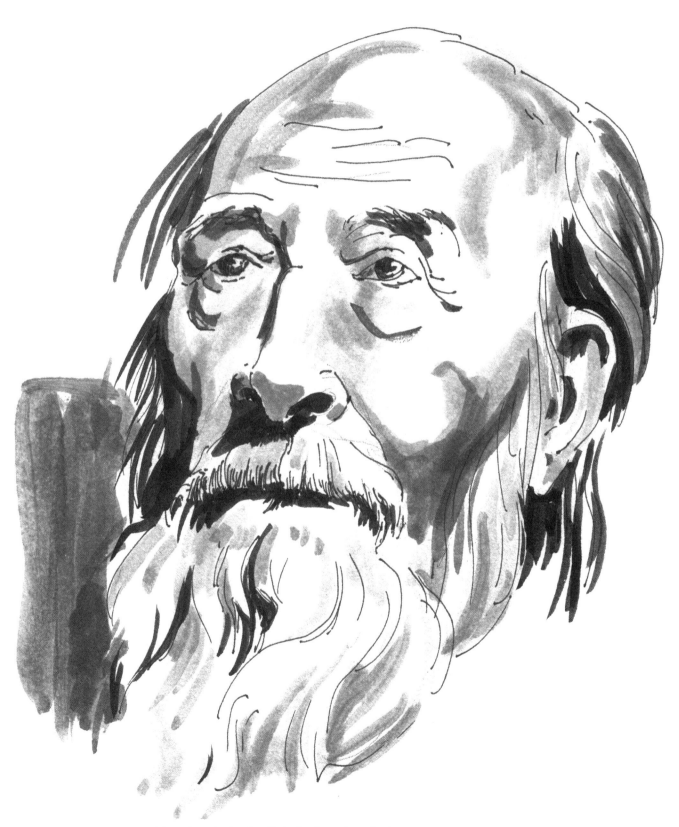

Ink and wash sketch, with indications of tonal values

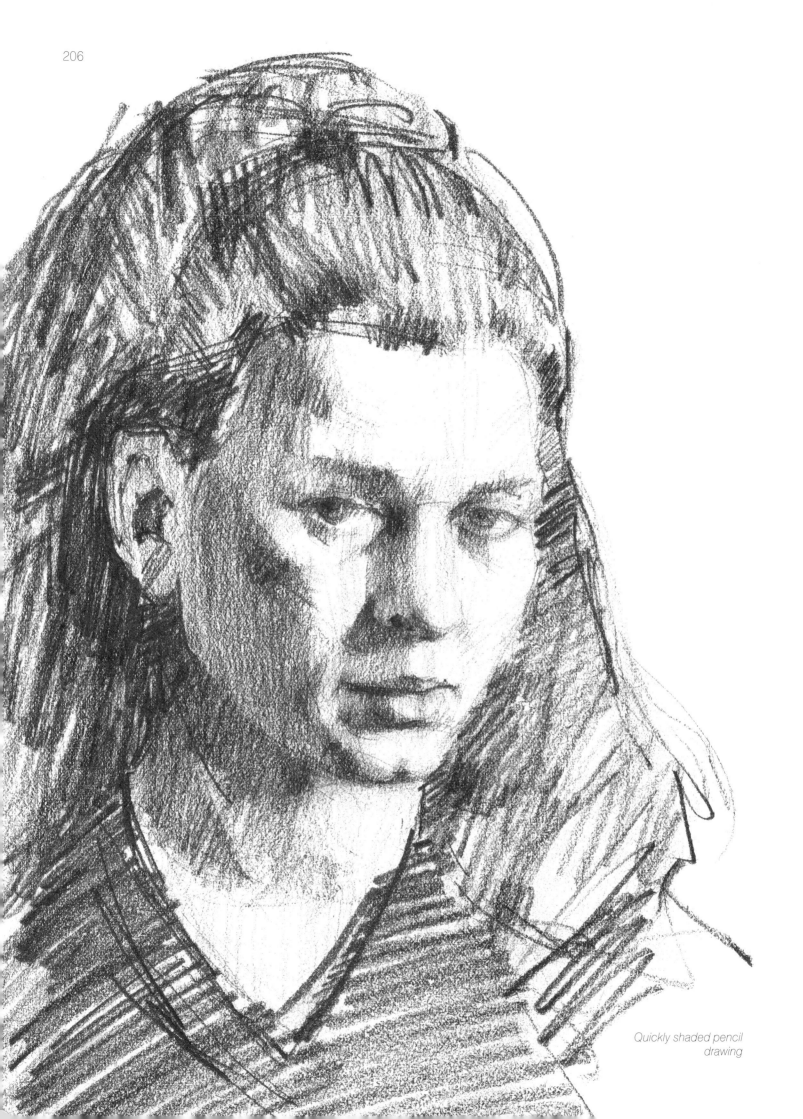

*Quickly shaded pencil
drawing*

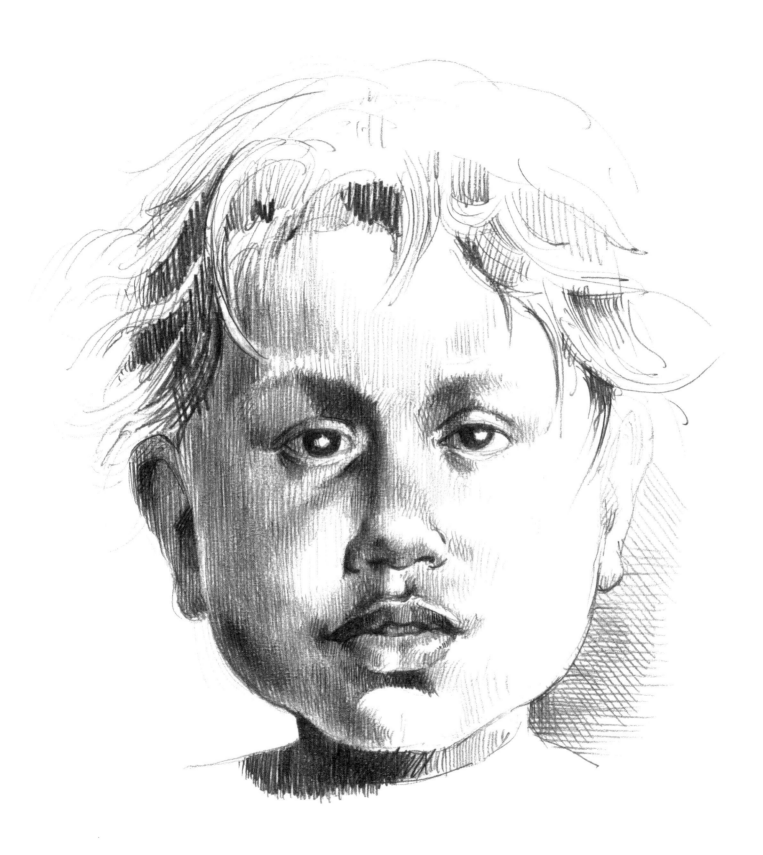

Shaded pencil drawing